HPBooks

SLR PHOTOGRAPHER'S HANDBOOK

Carl Shipman

Photography: Carl Shipman, unless otherwise credited
Cover Photo: Jack Dykinga

Published by HPBooks, A division of Price Stern Sloan, 360 N. La Cienega Boulevard, Los Angeles, CA 90048
© 1985, 1977 HPBooks, Inc. Printed in U.S.A.

Library of Congress Cataloging-in-Publication Data

Shipman, Carl.
 SLR photographer's handbook.

 Includes index.
 1. Single-lens reflex cameras. 2. Photography—
Handbooks, manuals, etc. I. Title.
TR261.S54 1987 770'.28'22 85-62316
ISBN 0-89586-427-4

CONTENTS

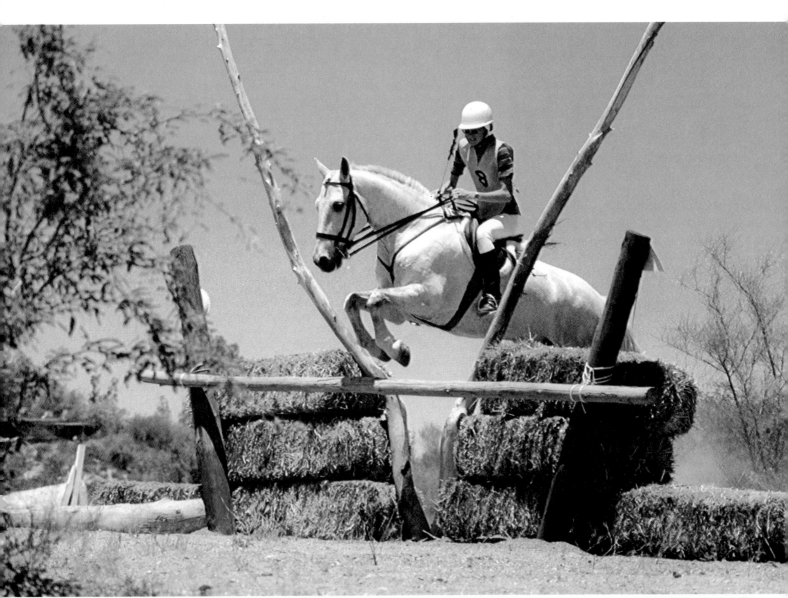

Every good photo requires some artistry and some technical know-how. Choice of viewpoint and composition are part of the artistic control. The technical factors include lens choice, shutter-speed, aperture setting and lighting. This book shows how to make better pictures with your SLR.

1
How an SLR Works

This book will help you understand and use any modern 35mm SLR camera. It explains how SLR cameras and lenses work, and how to use them. It also discusses films and important camera accessories, such as filters, motor drives and special camera backs.

Although specifically for SLR cameras using 35mm film, much of the basic information in this book also applies to other types of SLR cameras.

The abbreviation SLR means *single-lens-reflex*. With an SLR, you view the scene through the same lens that will be used to take the picture. A *single* lens is used for both purposes. This lets you see through the viewfinder exactly what will appear on the film.

SLR cameras have interchangeable lenses. You can remove the lens on the camera and replace it with a different type, such as a telephoto lens to make a photo of a distant scene. Whatever type of lens is mounted on the camera, you view and photograph the scene through it.

VIEWING THE SCENE TO BE PHOTOGRAPHED

The word *reflex* is derived from the word *reflection*. It implies that there is a mirror inside the camera. The mirror allows you to view and photograph through the single lens.

As you can see in the accompanying illustration, light from the scene enters the camera through the lens. When the mirror is in the "down" position, as shown, you can view the scene. Light from the scene is reflected upward by the mirror. It passes through a *viewing screen,* bounces around in a *penta-prism* and emerges at the viewing eyepiece at the back of the camera. The purpose of the pentaprism is to show you a correct view with the top of the scene at the top of the image and the left and right sides not reversed.

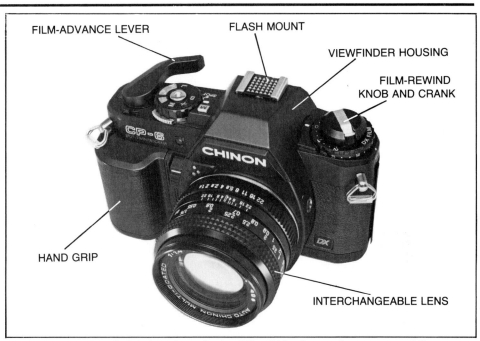

An advantage of an SLR is lens interchangeability. This picture shows some of the camera controls. Each control is explained in this book.

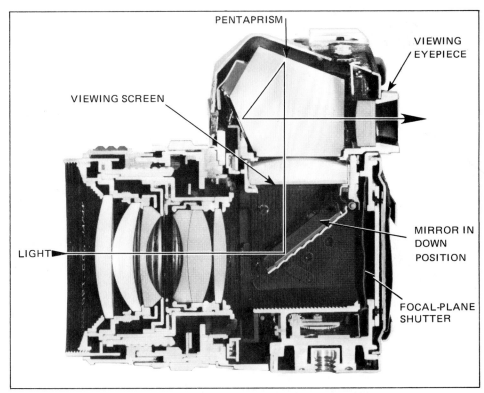

Cutaway photo of Pentax K-type camera shows mirror in down position. The mirror intercepts the image that will later fall on film and reflects it upward into the viewfinder. Just before the shutter opens, the mirror swings up out of the way so the image can reach the film.

If you place your eye at the viewing eyepiece, you see an image of the scene. You can focus that image on the viewing screen, which generally has a frosted or matte surface like ground glass.

You use the image on the viewing screen for two purposes: to compose the photograph and to focus the image. You control focus by turning the focusing ring on the lens.

Some camera manufacturers refer to the viewing screen as the *focusing screen*. In this book, I'll use the two names interchangeably, or just the word *screen*.

The housing on top of the camera, which contains the viewing eyepiece and the pentaprism, is called the *viewfinder*. Some cameras use interchangeable viewfinders, so you can remove one viewfinder from the camera and substitute another type. Viewfinder types are discussed later.

Some cameras use interchangeable focusing screens of various types, shown later in this chapter.

TAKING THE PICTURE

When you are composing and focusing the scene, you are looking at the image formed on the focusing screen. It is the same image that will later strike the film to make the exposure. While you are viewing the scene, the film is protected from light by a shutter directly in front of the film.

When you press the shutter button to take the picture, the mirror swings upward, out of the way. It moves up against the bottom of the focusing screen. This closes the light path through the viewfinder and you can no longer view the scene. It also prevents light from entering the viewfinder eyepiece and traveling downward into the camera body while the shutter is open and the exposure is being made.

When the mirror is up, the shutter opens and the image from the lens strikes the light-sensitive front surface of the film—the photographic emulsion.

Focal-Plane Shutter—The shutter is called a *focal-plane shutter* because it is very close to the surface—or *focal plane*—of the film, where the image will be brought to focus by the lens.

Focusing screen and film surface are optically the same distance from the lens. Therefore, when the image is in focus on the screen, it will also be in focus on the film.

The focal-plane shutter opens and closes a rectangular window just in front of the film. The dimensions of that window determine the size and shape of the frame on the film where the image is formed. In a 35mm camera, the image measures 24mm x 36mm.

For correct exposure, light must strike the film for a specific length of time. The length of time depends on the brightness of the scene, the lens aperture setting, described later, and other factors.

At the end of the exposure time, the focal-plane shutter closes and the mirror moves down again so you can view and compose the image for the next frame. Before you take the next picture, you must advance the film so an unexposed frame is in place behind the lens.

The number of frames you have exposed is displayed by a frame counter on top of the camera.

HOW THE SHUTTER WORKS

It's useful to know how a focal-plane shutter works. There are two shutter curtains, as shown in the accompanying drawings. In the illustration, the first curtain travels from left to right, opening the frame to light. To end the exposure, the second curtain moves across the opening to close the shutter. The speed, or travel time, of the two curtains is about the same.

When the first curtain has just reached the right edge of the opening,

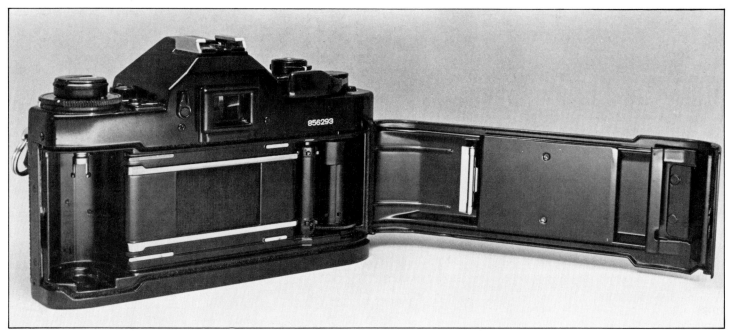

To load film, you place an unexposed cartridge of film in the left chamber. You lead the film across the body and attach it to the takeup spool on the right side. As you advance the film, it is guided and supported by the bright metal rails. The film is held flat by the rectangular pressure plate on the inside of the camera back cover. For exposure, the focal-plane shutter opens and closes the rectangular opening in front of the film. When all of the film has been exposed, you wind it back into the cartridge and remove it from the camera.

the frame has not been uniformly exposed. The left side has received more exposure than the right side. This is counterbalanced by the closing curtain. It begins cutting off the light first at the left edge, while the right side is still receiving exposure. The end result is that all parts of the frame receive the same exposure time.

With Electronic Flash—During the travel time of the first curtain, the film frame is not completely open to light. For shooting with electronic flash, which is a very brief burst of light, the camera is designed so the flash won't fire while the first curtain is traveling, when part of the frame is still covered by the curtain.

The flash fires when the first curtain is fully open. The flash must also fire before the second curtain starts to move, otherwise part of the frame would be covered by the second curtain. In other words, the shutter must be uncovering the entire image frame at the moment the flash fires.

The exposure-time interval is measured from the beginning of the travel of the first curtain to the beginning of the travel of the second curtain. Among current focal-plane shutters, the slowest have a curtain-travel time of about 1/80 second. If the exposure time is 1/60 second or longer, the second curtain won't start to move until after the first curtain is fully open.

At faster shutter speeds, such as 1/500 second, the second curtain must start to cover the frame again before the first curtain has fully uncovered it. In that case, there is never a time when the frame is fully open to light. Under such conditions, you can't use electronic flash.

If the travel time of the first shutter curtain is made shorter, then faster shutter speeds can be used with electronic flash. This can be achieved in two ways. The first is to build the shutter so the curtains move faster. The standard shutter-curtain material is cloth. Higher-speed shutters usually have curtains made of metal —sometimes metal blades that fan open and closed.

The second method is to move the curtains vertically across the frame, rather than horizontally. Because the

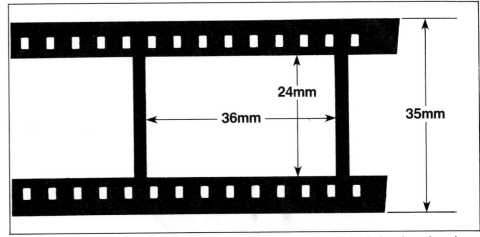

The film that fits your 35mm SLR camera is 35mm wide and has sprocket holes along the edges. Each film frame is approximately 24.5mm tall and 36.3mm wide, usually stated as 24mm x 36mm.

HOW A FOCAL-PLANE SHUTTER WORKS

Second curtain First curtain

(1) Ready to make an exposure. Film frame is covered by first curtain.

Opening in camera body determines size of film frame.

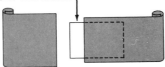

(2) First curtain begins to travel across frame, opening frame to image from lens.

(3) First curtain travel completed. Film frame is fully open to light.

(4) Second curtain begins to travel across frame, closing frame to image from lens.

(5) Second curtain travel completed. Film frame covered by second curtain. Exposure completed. Advancing film to next frame resets shutter to (1) ready to make another exposure.

This drawing shows a two-curtain focal-plane shutter. When exposure time begins, the first curtain starts its travel. The curtain passes across the film frame, allowing light to fall on the film. When the first curtain has completed its travel, the film frame is fully open as far as this curtain is concerned. To end exposure time, the second curtain is released to begin its travel and close off light to the film. Exposure time is measured from *release* of the first curtain to *release* of the second curtain. In this example, exposure time was long enough that the second curtain did not begin to move until after the first curtain had reached the end of its travel.

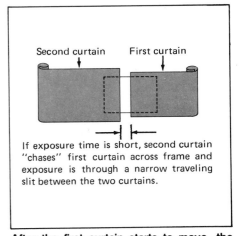

If exposure time is short, second curtain "chases" first curtain across frame and exposure is through a narrow traveling slit between the two curtains.

After the first curtain starts to move, the second curtain waits for the selected exposure-time interval to elapse before it starts to move. For short exposure times, such as 1/500 second, the second curtain follows so closely behind the first that the entire frame is never completely open to light. The film frame is exposed by a traveling slit formed by the gap between the two curtains.

vertical dimension is smaller than the horizontal, a vertical focal-plane shutter travels a shorter distance. This can happen in a shorter time.

The fastest shutter speed at which electronic flash can be used is called the *X-sync speed*. A fast X-sync speed is desirable. Cameras with vertical-travel shutters typically have a faster X-sync speed than those with horizontal shutters. This is discussed more fully in Chapter 6.

THE VIEWFINDER

The viewing system of an SLR camera includes the following main parts:

● *A mirror,* which reflects the image upward into the viewfinder.

● *A viewing or focusing screen,* which displays the image from the lens. Most focusing screens incorporate an optical focusing aid which helps you determine when the image is in focus.

● *A pentaprism,* which causes you to see a correctly oriented image.

● *A viewfinder eyepiece,* whose lens helps your eye focus on the image displayed by the focusing screen.

● *Information displays* are also shown in the viewfinder—usually in the area outside the image frame. The information includes camera settings, such as shutter speed and aperture values, and an exposure indication to tell you if the film will be correctly exposed.

In this section, I'll discuss viewing and focusing the image. The viewfinder information displays are discussed in Chapter 4.

When you are viewing and focusing the image, the viewing screen serves as a substitute for the film surface. Optically, it is the same distance from the lens as the film. Therefore, if the image is in focus on the viewing screen it will also be in focus on the film when the mirror moves out of the way.

Viewfinder Image Area—Even though we say that you see the same image that will later strike the film, that may not be precisely true. Usually, the image in the viewfinder is a little narrower and a little less tall than the image on film.

Camera makers specify viewfinder image coverage in two ways. Some give height and width. For example,

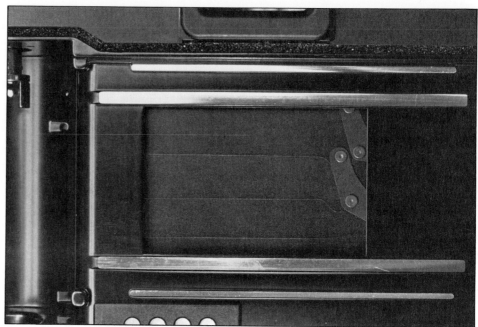

Shutter curtains are made of cloth or metal. Some travel horizontally, across the wide dimension of the film frame. Some travel vertically, across the short dimension. Pictured is a metal shutter that travels vertically.

METRIC AND ENGLISH UNITS

1 meter	= 39.37 inches
	= about 1.1 yard
1 centimeter	= 1/100 of a meter
	= about 3/8 inch
1 millimeter	= 1/1000 of a meter
	= about 1/25 inch

the specs may say that the viewfinder shows 94% of the image horizontally and 97% vertically. Others specify the area of image coverage, such as 91% of the area.

Slides typically have cardboard or plastic mounts that cover a small part of the image at each edge of the frame. If you see a little less than the actual frame in the viewfinder, that is approximately what you see when you project a slide. It will be less than you see on a print made from the full frame.

Focusing Screens—Most screens are precision-molded plastic with a matte surface resembling ground glass. The matte surface intercepts light rays from the lens to form a visible image. If the image is in focus, it will appear sharp. If it isn't, it will appear blurred. It's easy to judge focus on a screen with a matte surface.

Aerial Image—Some special screens are clear and don't have a matte surface. They are called *aerial-image screens.* The lens can still make a focused image in the screen, although it is not as easy to see without an additional aid—a magnifier focused at the viewing-screen surface.

6

A *split-image* focusing aid uses a *biprism*, which is two wedges of clear glass or plastic that taper in opposite directions. If the image is not in focus, the biprism splits a line or edge in the image and separates the two halves. Focusing the image causes the two halves to move together.

FOCUSING AIDS

Judging focus by observing image blur on the focusing screen is often satisfactory, but there are more precise ways of focusing. Most screens have an additional *focusing aid* in the center of the image area.

Split Image—This focusing aid uses two transparent wedges, tapering in opposite directions as shown in the accompanying drawing. The wedges are set into a circular area in the center of the screen.

Optically, these wedges "split" lines or edges in an image when the image is not in focus. One wedge moves part of the line in one direction and the other wedge moves an adjoining part of the line in the opposite direction.

To obtain correct focus, turn the lens focus control so the two parts of the line move toward each other. When you see one continuous line, you have the best focus setting. Another name for this type of focusing aid is *biprism*.

The human eye is better able to distinguish separation of lines in an image than general blurring due to being out of focus. Consequently, a biprism focusing aid gives a more positive indication of focus than a plain matte screen.

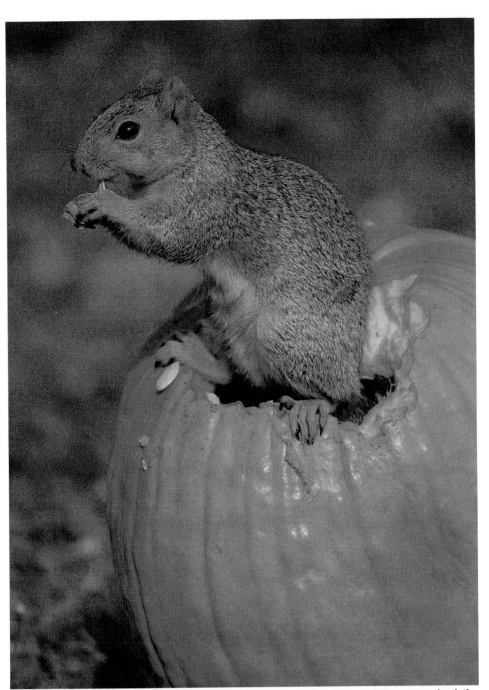

You can focus on a subject like this in a variety of ways. You can use the split-image method, the microprism ring or the groundglass screen. However, with a telephoto lens a split image or microprism image may partially black out. When this occurs, use the groundglass image for focusing. Photo by Jack Dykinga.

If the biprism is oriented so it splits vertical lines, and there are only horizontal lines in the image, it won't help you. Turn the camera 90° so the biprism splits the horizontal lines. After focusing, turn the camera any way you want it, to take the picture.

Some viewing screens have a biprism oriented at 45° so it has some effect on both vertical and horizontal lines in the image.

Microprism—On a textured or patterned surface, such as foliage or a wall, there are often no clearly visible straight lines to split with a biprism. For such surfaces, a *microprism* is a better focusing aid.

A microprism consists of an array of

tiny three- or four-sided pyramids. Their intersections work like small biprisms. When the image is in focus, you are unaware of the microprism. When the image is out of focus, it breaks up into a grid pattern caused by the tiny pyramids. If the camera jiggles a small amount, as it usually does when handheld, the image seems to scintillate when out of focus.

Combination Focusing Aids— Some screens have a circular biprism surrounded by a microprism ring. You can use either or both, depending on the scene.

Focusing-Aid Blackout—The angles made by the surfaces of biprisms and microprisms is important. A relatively wide angle gives a very strong focusing indication when the image is only slightly out of focus.

However, large angles don't work when the lens aperture is small. Depending on where your eye is at the viewfinder eyepiece, part of the biprism or microprism area will become dark. Move your eye only slightly and a different face blacks out. When that happens, the focusing aid is not useful.

Some camera manufacturers offer interchangeable focusing screens with different biprism and microprism face angles, for use with lenses having different maximum aperture sizes.

Field Lens—When looking into the viewfinder, you may sometimes notice faint circular rings in the image. These rings are caused by a *Fresnel* lens, which is molded into the bottom of the focusing screen. It makes the image uniformly bright across the screen. Because the Fresnel lens produces a uniformly bright image field, it is sometimes called a *field lens*.

Although you may see the rings in the viewfinder, they don't appear in the image on film because they are only on the focusing screen.

INTERCHANGEABLE FOCUSING SCREENS

Some manufacturers offer a selection of interchangeable focusing screens for certain camera models. A typical assortment of screens is shown in the accompanying illustration.

With many camera models, you can interchange focusing screens. If the viewfinder is removable, you change the focusing screen through the top of the camera body by first removing the viewfinder. If the viewfinder is fixed in place, you change the focusing screen through the lens opening after removing the lens.

Some camera models have interchangeable screens that can be changed only by a factory service center.

VIEWING AIDS

Some attachments, designed to fit on the viewfinder-eyepiece frame, make viewing easier or more convenient.

Rubber Eyecup—A rubber eyecup fits over the eyepiece and makes viewing easier by excluding stray light. With some cameras, stray light entering the eyepiece can cause incorrect exposure metering. If you wear eyeglasses, an eyecup is especially helpful.

Eyepiece Correction Lens—The viewfinder optics provide an image of the focusing screen that appears to be about one meter distant—about arm's length. If your vision is good at that distance, you can judge focus accurately. If your unaided eye can't focus at that distance, you'll see a blurred image, no matter how well the camera is focused.

This removable focusing screen has a biprism in the center. Notice how it splits the line on the surface below it. In the camera, this would be an indication of incorrect focus.

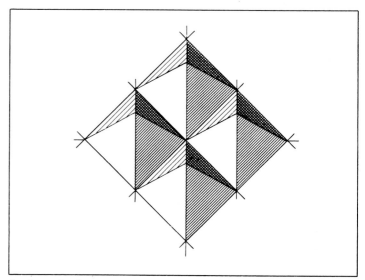
A *microprism* is an array of tiny pyramids. They make the image fuzzy when out of focus, sharp when in focus. Many focusing aids combine a biprism in the center with a surrounding microprism ring.

User-interchangeable focusing screens are usually removed through the lens opening, using a special tool packaged with accessory screens.

A rubber eyecup makes viewing easier by excluding stray light. With some cameras, it makes exposure readings more accurate, too.

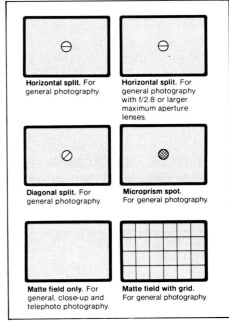

Horizontal split. For general photography.

Horizontal split. For general photography with f/2.8 or larger maximum aperture lenses.

Diagonal split. For general photography.

Microprism spot. For general photography.

Matte field only. For general, close-up and telephoto photography.

Matte field with grid. For general photography.

For cameras with interchangeable focusing screens, manufacturers offer an assortment of types, such as these by Minolta. These replace the standard screen, which is usually a biprism surrounded by a microprism ring.

To overcome this problem, camera makers offer clip-on accessory lenses to fit over the viewfinder eyepiece. With them, you can adjust the viewfinder optics to match your vision. These accessories are often called *dioptric correction lenses*. They are available in a range of strengths. The best way to select one is by going to your camera dealer and trying several.

Right-Angle Finder—This accessory fits on the viewfinder eyepiece and "bends" the light path, as shown in the accompanying photo. It is useful when you're using the camera in a location where it's difficult to put your eye to the camera eyepiece—for example, when the camera is on the floor.

Eyepiece Magnifier—This accessory is used for precise focusing. It magnifies the central part of the focusing screen. Usually, an eyepiece magnifier is hinged so it can be flipped up out of the way, allowing you to view the entire focusing screen.

INTERCHANGEABLE VIEWFINDERS

The standard viewfinder is the eye-level finder that you hold up to your eye. Some cameras can use interchangeable viewfinders.

A waist-level finder allows you to view the image vertically downward while you hold the camera at waist level.

There are finders that do not require you to hold your eye close to the eyepiece to see the complete focusing screen and adjacent information displays. Called *sports finders*, *action finders* and *high-eyepoint finders*, they are useful for wearers of eyeglasses.

High-magnification finders that magnify the image are useful for critical focusing.

Some cameras providing automatic focusing do so by a special viewfinder with a built-in autofocus system. Some cameras use different finders to provide different automatic features, such as automatic exposure.

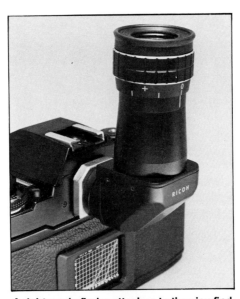

A right-angle finder attaches to the viewfinder eyepiece. It can be rotated so you can view from above, as shown here, or from any other angle that is more convenient. Rotating the eyepiece adjusts the optics for your eyesight.

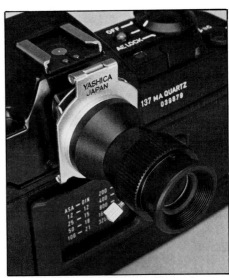

A magnifier attachment fits over the viewfinder eyepiece and magnifies the central part of the frame to assist in precise focusing. The magnifier flips up out of the way when you want to see the entire frame. Rotating the eyepiece adjusts the optics for your eyesight.

Select a film speed that suits the shooting environment. If you want to take photos by available light, indoors, use a relatively fast film. Photo by J. Berndt, Stock Boston, Inc.

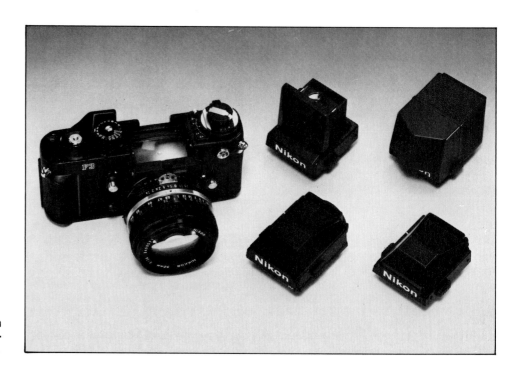

Some cameras, such as this Nikon F3, can use interchangeable viewfinders. The focusing screen is mounted in the camera body.

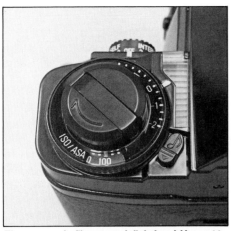

The camera's film-speed dial should be set to the film-speed rating of the film in the camera. This Ricoh is set for a film speed of 100. To change the setting, lift the outer rim of the control and turn it to bring the correct number into the window. Most film-speed controls are similar.

A DX-coded film cartridge has a "checkerboard" of light and dark squares. The light squares are electrically conductive; dark squares are insulated. Electrical "feeler" contacts in a DX-coded camera read the checkerboard pattern. This automatically "tells" the camera the film speed and number of frames in the cartridge.

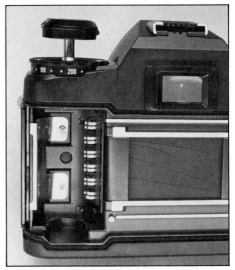

A row of electrical contacts in the film-cartridge chamber of this DX-coded Chinon camera reads the DX code on a film cartridge. With DX-coded film, film speed is set automatically.

Exposure

When you have composed and focused the image, the next step is to set exposure so the image will be correctly exposed on film. This can be done by setting camera controls manually, using the viewfinder exposure display as a guide. Or, an automatic camera can set exposure automatically.

Correct film exposure depends on three factors: the sensitivity of the film, the brightness of the light reaching the film, and the length of time that light is allowed to strike the film.

FILM SENSITIVITY

To form a correctly exposed image, some types of films require less exposure than others. This characteristic is referred to as *film speed* and expressed by a number called the *film-speed rating*.

Fast films, having speed numbers such as 400 and 1000, form an image quickly, with a relatively small amount of exposure. Slow films, with speed numbers such as 25 and 32, require more exposure. More information on film-speed ratings is in Chapter 3.

Setting Film Speed Manually— When loading film into your camera, you should set the film-speed number on the camera film-speed dial. For ex-

ample, if the film speed number is 200, you should set the film-speed dial to 200. Otherwise, incorrect exposure will probably result.

Automatic Film-Speed Setting— Some film cartridges are imprinted with a checkerboard code pattern of silver and black rectangles. Such film is called *DX-coded*. This code conveys to the camera the film-speed number of the film in the cartridge and the number of exposures available.

The code can be read automatically by cameras designed for DX coding. Electrical contacts in the film-cartridge chamber read the code and transfer the film-speed setting to the camera. The setting is displayed for you to see.

Such cameras also have a manual film-speed control. You have to use this control with film cartridges that are not DX-coded.

LENS APERTURE

Most lenses have an adjustable opening inside the lens to control the amount of light from the scene passing through to the film. The larger the opening, the more light it will transmit.

This opening is called the lens *aperture*. Its size may be adjusted manually by turning the *aperture ring* on the lens

body. Some automatic cameras set aperture automatically using a mechanical linkage between camera and lens.

Aperture Size—The size of the aperture is indicated by a number, such as 2 or 8, called the *f-number*. These numbers appear on the aperture scale on the lens. The aperture setting is also displayed in the viewfinder of some cameras.

***f*-Number Scale—**As you can see in the table on page 12, each larger number on the *f*-number scale is approximately 1.4 times the preceding value. Smaller *f*-numbers represent larger apertures. On this scale, the largest aperture shown is *f*-1, and the smallest is *f*-22. Some lenses have even smaller apertures, such as *f*-32 or *f*-45.

The *f*-number settings on a lens are usually called *f-stops*. The aperture scale is arranged so that each aperture setting transmits twice as much light as the next smaller. For example, a setting of *f*-4 will transmit twice as much light as an *f*-5.6 setting, but half as much as an *f*-2.8 setting.

For any lens, the *smallest* aperture size is represented by the *largest f*-number, and vice versa.

Setting Aperture—The lens aperture setting is one of the exposure controls.

An adjustable aperture inside the lens controls the amount of light that passes through to expose the film.

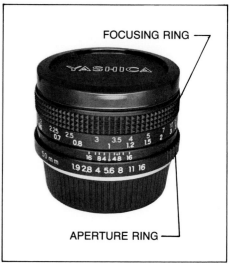

The *f*-number settings on a lens aperture ring are also called *f-stops*. This lens has an aperture range of *f*-1.9 to *f*-16. To set aperture manually, turn the aperture ring to place the desired *f*-number opposite the central index mark. This lens is set to *f*-5.6. The focusing ring is near the front of the lens, with a scale of distances in feet and meters.

To set aperture manually, turn the aperture ring on the lens. The aperture scale will show the *f*-number the lens is set to.

Some automatic cameras set aperture automatically. To prepare for this mode of operation, the lens aperture ring usually must be turned to a special setting— typically a symbol such as **A** or to the smallest aperture of the lens, such as *f*-22. In this case, the actual aperture size is not indicated by the setting of the aperture ring. The camera sets aperture and may display the *f*-number setting in the viewfinder.

Intermediate Settings—Most lenses have click-stops, or detents, on the aperture ring at each marked *f*-number—such as *f*-2, *f*-2.8, *f*-4 and so forth. Some lenses also have detents at settings that are halfway between the marked *f*-numbers.

When you are setting aperture manually, it is not necessary to set the aperture ring exactly on a marked *f*-number or a detent. You can use any aperture size.

If the camera is setting aperture automatically, it can use any aperture value. If the setting is displayed, it will normally be shown to the nearest half-stop, such as *f*-3.5, which is halfway between *f*-2.8 and *f*-4.

The accompanying table shows the values of fractional *f*-stops from *f*-0.7 to *f*-64. These numbers may be rounded off in the camera display. For example, *f*-4.9 may appear as *f*-5.

SHUTTER SPEED

As mentioned earlier, the shutter-speed setting determines how long the focal-plane shutter remains open. This determines how long light from the scene is permitted to strike the film emulsion. Shutter speed may be set manually, using the *shutter-speed* control on the camera. An automatic camera may set shutter speed automatically.

Shutter-Speed Scale—The standard shutter-speed scale is shown in the accompanying illustration. The numbers on the scale are time intervals, measured in seconds. For example, 1/500 is an exposure interval of 1/500 second.

As you can see, each longer speed holds the shutter open for double the length of time of the next shorter

VALUES OF FRACTIONAL *f*-STOPS			
f-Number	+1/3 Stop	+1/2 Stop	+2/3 Stop
0.7	0.8	0.87	0.9
1.0	1.1	1.2	1.3
1.4	1.6	1.7	1.8
2.0	2.3	2.5	2.6
2.8	3.3	3.5	3.7
4	4.6	4.9	5
5.6	6.5	6.9	7
8	9	9.8	10
11	13	13.9	15
16	18	20	21
22	26	28	29
32	37	39	41
45	52	55	59
64	74	78	83

Between standard *f*-stop numbers, such as *f*-1.4 and *f*-2, are intermediate values. This table shows intermediate values in 1/3 steps and 1/2 steps.

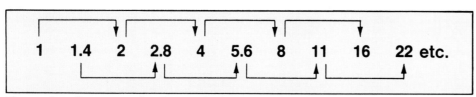

It's easy to write or remember the standard series of *f*-numbers. Start with the numbers 1 and 1.4. Then, double them alternately as shown by the arrows.

STANDARD SHUTTER SPEEDS										
30	15	8	4	2	1	1/2	1/4	1/8	1/15	1/30
1/60	1/125	1/250	1/500	1/1000	1/2000	1/4000				

So-called "shutter speeds" are actually *exposure times.* This series doubles or halves the time at adjacent values. For convenience, some values are rounded off, such as the step from 1/8 to 1/15. This series can be extended in either direction. The next slower speed would be 60 seconds and the next faster 1/8000 second.

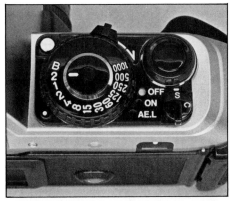

On a camera shutter-speed dial, the numerators of fractions are omitted. A shutter speed of 1/2 second appears as 2. A shutter speed of 2 seconds also appears as 2. To avoid confusion, most cameras show shutter speeds below 1 second in a different color than those above. This Konica has shutter speeds from 2 seconds to 1/1000 second, plus a B setting.

speed. The fastest and slowest available shutter speeds vary among camera models.

A shutter-speed range of 1 or 2 seconds to 1/1000 second is common. Some cameras will time exposures as short as 1/4000 second and some as long as 30 seconds.

On the camera shutter-speed control, the numerators of the shutter-speed fractions are omitted. The value 1/500 is shown as 500. Therefore, a speed of 2 seconds and a speed of 1/2 second are both shown by the numeral 2. By examining the overall scale, you can easily see which is the longer time.

Setting Shutter Speed—When setting shutter speed manually, using the control on the camera, you should set the control exactly on one of the the numbered shutter speeds. Detents on the control help you make those settings.

When an automatic camera is setting shutter speed, it may select intermediate speeds, such as 1/325 second. Some cameras display the set speed in the viewfinder to the nearest step or half step.

B Setting—Shutter-speed controls also have a setting labeled B, which stands for *Bulb.* The name comes from early studio cameras that had a rubber bulb which held the shutter open as long as the bulb was squeezed.

At the B setting, modern cameras will hold the shutter open as long as the shutter button is depressed. You can use this setting to make "time" exposures longer than the slowest setting of the shutter-speed dial.

One reason to use very long exposure times is to get enough exposure in very dim light. If you anticipate shooting in dim light, using high-speed films is generally better than making long time exposures.

An unusual application of long exposure times is to keep moving objects from recording as recognizable images on film. During a 30-second exposure, for example, moving cars and people walking may not be at any specific location long enough to create sufficient exposure for a visible image. Stationary objects, such as buildings and trees receive full exposure at one location on the film and their images are visible. This is a photographic trick, but sometimes useful.

A problem with unusually long exposures is *reciprocity failure,* discussed in Chapter 3.

EXPOSURE STEPS

Standard exposure steps are spaced in multiples of two. Doubling or halving of exposure represents a change of one exposure step.

The formula for exposure is:

$$EXPOSURE = INTENSITY \times TIME$$
$$\text{or}$$
$$E = I \times T$$

INTENSITY is the brightness of the light striking the film and TIME is how long the shutter is held open.

Because exposure is the *product* of intensity and time, doubling either will double the exposure received by the film—producing one more step of exposure. Dividing either factor by two will cut the exposure in half—producing one step less exposure.

That's the reason for the arrangement of the aperture and shutter-speed scales. Changing the aperture to the next larger value on the scale doubles the amount of light reaching the film and thereby increases exposure by one step. Changing aperture to the next smaller value halves the amount of light and reduces exposure by one step.

Changing the shutter-speed setting to the next slower value doubles the length of time that the shutter is open, thereby increasing exposure by one step. Changing to the next faster value cuts the time in half, reducing exposure by one step.

Because the standard steps of aperture size and shutter speed have the same effect on exposure—doubling or halving— these two controls can be used to counterbalance each other. Changing to the next *larger* aperture and the next *faster* shutter speed will not change the exposure.

Other Effects of Exposure Controls

The main purpose of the exposure controls—shutter-speed and aperture size—is to obtain good exposure of the film. The camera has a built-in exposure meter that will help you set the controls. An automatic camera can set one or both of the controls for you. This is discussed in Chapter 4.

In addition to setting exposure, these controls have other visible effects on the photo. They are not only *technical* controls that affect exposure but also *artistic* controls that affect the image on film.

DEPTH OF FIELD

You have seen photos in which not everything is in sharp focus. The background behind the subject may be blurred, or the foreground may be blurred. The zone of sharp focus is called the *depth of field*. For example, if good focus begins at a distance of 3 feet from the camera and ends at 8 feet, the depth of field is 5 feet.

Aperture size controls depth of field. Small apertures provide more depth of field. You can control depth of field by setting aperture size to give the desired effect and then choosing a shutter speed to give correct exposure. For less depth of field, use a large aperture with the appropriate shutter speed. More information on depth of field is in Chapter 2.

SUBJECTS IN MOTION

With a moving subject, you may want to totally stop the motion on film to get a sharp image. This is called "freezing" the image. Or, you may wish to allow the image to blur to give the impression of movement.

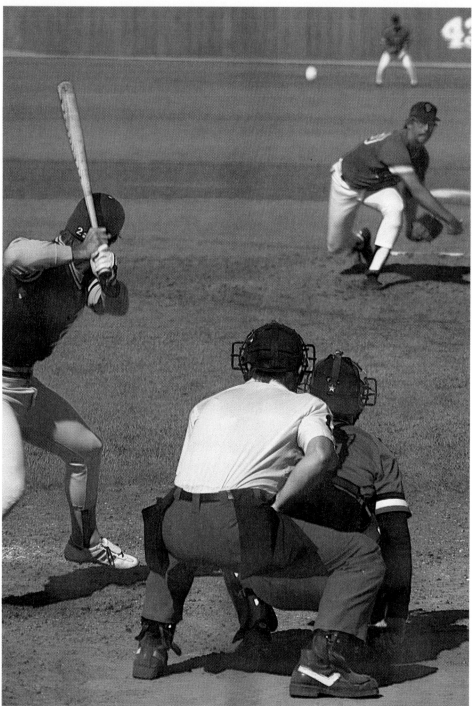

You can use depth of field creatively. Here, your attention is drawn to the batter. The remainder of the image is progressively less sharp. In a similar manner, you could get the pitcher sharp, with the batter and the oufielder less sharp. Photo by Kent Knudson.

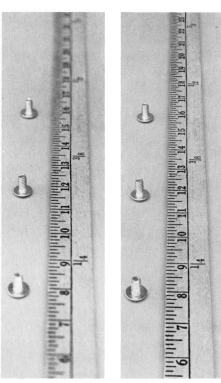

The larger the aperture, the more limited the depth of field. Objects nearer and farther than the zone of good focus are blurred (left photo). Using a smaller aperture increases the depth of field (right photo).

How to "Freeze" Action—To stop action with your camera, use a shutter speed short enough so the subject doesn't move perceptibly while the shutter is open. For many purposes, you can figure the stop-action shutter speed with this formula:

$$T = D/(1000 \times S)$$

T is shutter-open time in fraction of a *second*.

D is distance between camera and subject in *feet*.

S is subject speed in *miles per hour*.

This formula applies to a subject crossing at 90° to the direction your are pointing the camera and a 50mm lens. If you double focal length, use half the calculated time, and so forth.

Here are some other ways to reduce blurring due to subject motion:

● Switch to a film with a higher speed rating so you can use shorter exposure times.

● Move the camera so the subject is traveling more nearly toward or away from line of sight.

● Move back and accept a smaller image of the subject. If you subsequently enlarge to get the same image size, however, moving back won't do any good.

● Shoot at the peak of action. Many activities have a dramatic point at which motion ceases or is greatly reduced: A jumper at the top of his jump; a golfer at the top of his back swing; the instant before throwing a ball; a diver at the apex.

In photo literature, you'll see a wide range of recommended shutter speeds to stop action. It depends on how much image blur is considered tolerable. You may be able to use 2 to 3 steps slower shutter speed than recommended by some and still get acceptable results.

Panning with the Subject—With a horizontally moving subject traveling at a fairly uniform speed, swing or *pan* the camera horizontally. Move the camera *smoothly* so you keep the subject centered in the viewfinder. *Smoothly* click the shutter and keep the camera *smoothly* panning with the subject until after the exposure is made.

Panning transfers blur from subject to background. When you are moving the camera with the subject, the sub-

TYPICAL SPEED OF SUBJECTS IN MOTION (MPH)	
Person strolling	2
Brisk walk	3
Person running	8
Bicycle rider	15
Bicycle racing	30
Horse walking	4
Horse running	10
Cars racing on dirt track	40
Motocross racing	40
Indy racers on straight	200
Indy racers in turn	100

SHUTTER-SPEED CORRECTION FOR SUBJECT CROSSING ANGLE	
If subject is crossing at 90°	Use table or formula
If subject is crossing at 45°	Use one step slower shutter speed
If subject is moving directly toward or away from camera	Use two steps slower shutter speed

STOP-ACTION SHUTTER SPEED FOR SUBJECTS CROSSING AT 90 DEGREES					
SPEED (MPH)	DISTANCE TO SUBJECT (FEET)				
	5	10	25	50	100
1	1/250	1/100	1/60	1/30	1/15
2	1/500	1/250	1/125	1/60	1/30
4	1/1000	1/500	1/250	1/125	1/60
8	1/2000	1/1000	1/500	1/250	1/125
15		1/2000	1/1000	1/500	1/250
30			1/2000	1/1000	1/500
60				1/2000	1/1000
125					1/2000

This table applies to a 50mm lens. Every time you double the focal length, you must halve the exposure time.

By holding the camera stationary, you can blur fast-moving objects in a photo. The background is sharp, as you can see by the cracks in the pavement.

By *panning* the camera with moving objects, you can record them sharp against a blurred background.

ject appears stationary but the background seems to move.

Effective Speed Blur—You don't always want to stop action completely. Subjects in motion look static when frozen by high shutter speed. A little blurring, or sometimes a lot, can make a picture more interesting and exciting.

To blur a moving subject deliberately, hold the camera still during exposure, while the subject moves in the viewfinder.

Estimating Degree of Blur—The amount of blur recorded has an important effect on the image. Too much blur softens the image and makes details hard to recognize. Too little doesn't give the desired effect.

Decide how much blur you want. A good way is to pick a fraction of the length of the moving subject. For example, a long blur is half the length of the subject. If a car is 20 feet long, the blur would be 10 feet long. A more limited blur for a speeding car would be about half the diameter of a wheel—about one foot. For a runner, you may want about six inches of blur.

Use this formula:

$$T = B/(1.5 \times S)$$

T is time of exposure in *seconds*.
B is desired length of the blur in *feet*.
S is speed of the subject in *miles per hour*.

Here's a typical example: A car is moving at 80mph and you want to record one foot of subject blur on the film.

$$T = 1/(1.5 \times 80) \text{ second}$$
$$= 1/120 \text{ second}$$

Use the nearest shutter speed offered by your camera—1/125 second.

This formula is for a subject crossing the field of view at an angle of 90°. With a subject crossing at 45°, use one step slower shutter speed.

If the subject is moving directly toward or away from the camera, the result may not look like a speed blur. Consider changing camera position to get the subject crossing in front of the lens.

Exposure Metering

While you are viewing and focusing the image, a metering system in the

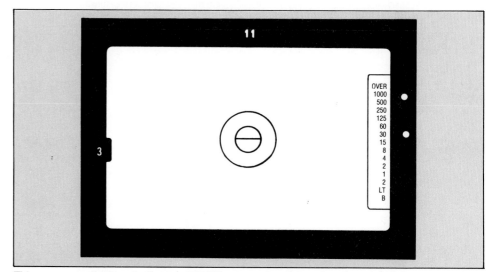

This exposure display of a Contax 137 MA camera is set for manual exposure control. At left is the frame number being exposed. At the top, the *f*-number setting of the lens is shown. At right, is a scale of shutter speeds from 2 seconds to 1/1000 second. Above the scale is an over-exposure warning. Below the scale, LT means that exposure will be longer than 2 seconds. The B symbol indicates that the shutter-speed dial is set to B. On the shutter-speed scale, the blinking LED indicates the shutter speed actually set on the camera. The steadily glowing LED indicates the shutter speed "recommended" by the camera metering system for correct exposure of an average scene.

camera measures the light coming through the lens. The camera already "knows" the sensitivity of the film in use because you have set the film-speed number on the camera—or it's been set automatically, if the camera reads DX-coded film cartridges.

By measuring light from the scene, the camera calculates suitable exposure settings—aperture size and shutter speed—to give correct exposure of the film. What it does with this data depends on the camera and its mode of operation.

If you are setting the exposure controls manually, the camera will display the recommended exposure settings in the viewfinder as a guide. The method of displaying exposure information varies among camera models. One display is shown here. Others are in Chapter 4.

If the camera is on an automatic mode, it may set either shutter speed or aperture automatically while you set the other control manually. Or, it may set both controls for you. Automatic-exposure modes are discussed in Chapter 4.

OPEN-APERTURE METERING

While you are viewing the scene, the lens aperture is held wide open so you see the brightest image. This is called *open-aperture* or *full-aperture* metering.

Even though the light is measured with the lens wide open, the camera makes the exposure calculation based on the aperture size that will actually be used to make the exposure. This setting will have been made manually by turning the aperture ring on the lens, or automatically by the camera.

EXPOSURE SEQUENCE

When you press the shutter button, the following sequence of events occurs:

● The mirror swings up out of the way.
● The lens aperture is closed to the set value.
● The focal-plane shutter opens.
● The duration of the exposure is timed internally by the camera.
● The focal-plane shutter closes.
● The mirror moves down so you can view again.
● Film is advanced to the next un-

exposed frame, either manually or automatically by the camera.
● The frame counter displays the number of the next frame to be exposed.

Camera Controls

This is a general discussion of camera controls and features. Not all cameras have *all* of the items listed here.

On-Off Switch—Some cameras have a switch to turn the camera electronics on and off. Switch it on to use the camera. Remember to turn it off when you are not using the camera.

Some cameras turn on automatically when the shutter button is depressed partway and then turn themselves off automatically if an exposure is not made in a certain time period, such as 20 or 30 seconds. This is a battery-saving feature.

Shutter Button—When the camera is turned on and the controls are set, press the shutter button to make an exposure.

Mode Selector—The mode selector enables you to select one of the exposure-control methods offered by the camera. Most cameras offer manual exposure control and one or more automatic modes. A few cameras have only a single mode.

Shutter-Speed Dial—Use it to set shutter speed manually. Some cameras also have mode settings on this control, such as A for automatic.

Lens Aperture Ring—Use it to set aperture size manually. If the camera sets aperture automatically, you must turn the lens aperture ring to a special setting, usually marked A, or to the smallest aperture.

Lens Focusing Ring—Use it to focus manually. Some cameras focus the lens automatically, using a motor built into the camera body or the lens. Auto-focus is discussed in Chapter 2.

Film-Advance Lever—Each time the film-advance lever is operated, film is advanced so the next frame is brought into place behind the lens. Also, the camera mechanism is reset so the shutter can operate to make the next exposure.

After loading film, use the film-advance lever and shutter button to advance to frame 1. After exposing

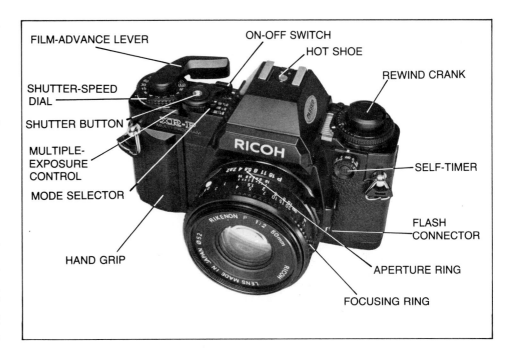

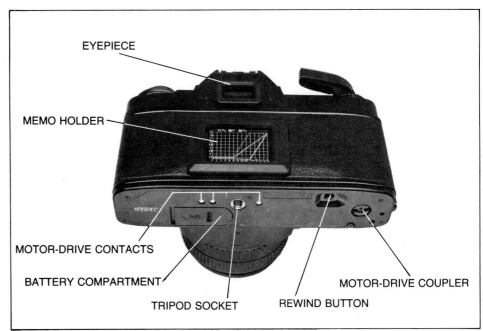

Although there are differences among camera brands and models, many of the controls and control locations are similar. This camera is generally representative of those with manual film-advance levers.

each frame, use the lever to advance the next frame. Some cameras do both of these things automatically, using a built-in motor in the camera or an accessory motor drive unit attached to the bottom of the camera.

Rewind Button—To prepare the camera for rewinding an exposed film back into the cartridge, depress this button.

Rewind Crank—Tip this crank up and turn it clockwise to rewind the

With most modern SLRs, you have a choice between automatic and manual exposure control. Many creative photographers prefer to work on manual, especially in unusual lighting conditions. Photo by Jack Dykinga.

film. Some cameras rewind using motor power.

Self-Timer—This feature enables you to take a picture of yourself. When the self-timer is set, a delay of about 10 seconds occurs between the time you press the shutter button and the time the exposure is made. Some cameras operate a beeper or flashing light during self-timer countdown.

Multiple-Exposure Control— SLR cameras are designed to prevent you from accidentally making more than one exposure on the same frame. After making an exposure, normally you must advance the film before you can make another exposure.

Some cameras have a multiple-exposure control to allow you to operate the film-advance lever without actually advancing film. This enables you to make another exposure on the same frame.

If your camera has a film-advance lever but no multiple-exposure control, there is an alternate procedure that usually works. The procedure and how to set correct exposure for multiple exposures are both discussed in Chapter 4.

Stop-Down Control—Depth of field, discussed in Chapter 2, is controlled by aperture size. Because viewing is normally done at open aperture, you do not see the actual depth of field that will record on the film.

Setting aperture to any size smaller than maximum is called *stopping down* the lens. Some cameras have a stop-down control to stop down the lens to the aperture that has been set on the aperture control ring. This enables you to see and adjust depth of field before making a shot.

Mirror Lockup Control—In a normal exposure sequence, the mirror moves up and the aperture is closed to the desired size just before the shutter opens. In some shooting circumstances, this may cause mechanical vibration that persists into the exposure interval, thus contributing to image blur.

Vibration is most likely when shooting at high magnification or with telephoto lenses. To prevent it, some cameras have a mirror-lockup control to move and lock the mirror up before you press the shutter button. This may also stop down the lens to shooting aperture.

Cameras without mirror-lockup controls may have another way of eliminating possible vibration. When

the camera is operated with the self-timer, the mirror moves up long enough before the actual exposure for vibrations to dissipate before the shutter opens.

Modern cameras with no method of locking up the mirror are designed with special care to minimize vibration due to mirror movement.

Hot Shoe—The hot shoe provides a place to mount a flash unit equipped with a mounting "foot." Electrical contacts in the hot shoe mate with contacts on the flash and convey control signals between flash and camera. The standard hot-shoe and flash-foot designs are specified by the International Standards Organization (ISO).

Flash Connector—In addition to a hot shoe, some cameras also have a connector to accept an electrical cord from a flash unit. The standard connector has two concentric metal rings and is called a *PC socket*. The mating cord is called a *PC cord*. The end of the PC cord presses into the PC socket and is held in place by friction.

When connected by a PC cord,

Some cameras have a built-in motor to advance the film and therefore don't have a film-advance lever. The motor will advance single frames or a rapid sequence of frames. The motor drive requires larger batteries which, in this model, are housed in the hand grip.

some automatic features of modern flash units cannot be used. Some manufacturers preserve automatic flash features by using flash cords with several wires inside them. These require special multiple-pin connectors.

2
Lenses

Lenses are creative tools. By proper lens selection, you can get a photo with exaggerated or relatively "flat" perspective. You can record a wide or narrow field of view. The image you make can be sharp or in soft focus. And, there are lenses that enable you to come very close, to get a large image of small objects. Photo by Patrick Ward, Stock Boston, Inc.

A major advantage of SLR cameras is the interchangeability of lenses. You can select from a long list of lenses with different characteristics, capable of producing a variety of pictorial effects. Learning to use different lenses will add interest to your photography and improve your pictures.

LENS MOUNTS

A lens attaches to a camera body quickly and conveniently, using one of three types of lens mounts.

Screw Mount—The first SLR cameras used screw-mount lenses. Lenses screwed onto camera bodies, usually requiring three or four full turns. To remove a lens, it was simply unscrewed. Today, most cameras do not use this type of mount.

Breechlock Mount—This mount is not in common use any longer, either. To use it, you hold the lens in position against the camera body and turn a *breechlock* ring on the back of the lens by about 60°. The lens itself need not be turned. To remove the lens, simply turn the ring in the opposite direction.

Bayonet Mount—This is the common lens-mounting method for modern SLRs. The lens is placed in position on the camera body. Then, the lens is turned about 60° until it clicks into place.

To remove the lens, press the *lens-release* button on the camera or on the lens body and turn the lens in the opposite direction.

MECHANICAL AND ELECTRICAL COUPLINGS

In addition to holding the lens securely, the mount also provides mechanical, and sometimes electrical, connections between camera and lens. These are around the periphery of the mount, so they don't extend into the light path between lens and camera.

The couplings provide several functions. A lever holds the lens aperture wide open for viewing, then stops it down to shooting aperture just before the shutter opens. A lever on the lens tells the camera the setting of the aperture ring, including an automatic setting if there is one. If the camera is designed to set lens aperture automatically, a lever does that. Some-

times the aperture range of the lens is communicated to the camera. Depending on brand and camera model, there may be other coupling functions.

HOW A LENS FORMS AN IMAGE

It isn't very difficult to understand how a lens makes an image. It's useful to know, particularly in special situations, such as close-up photography.

Light Rays—For all practical purposes, light *rays* travel in straight lines. The rays do not deviate from their straight path unless they are acted on by something with optical properties capable of deviating that path—such as a lens or mirror.

Light rays that come from a distant location, such as the sun or a mountain, appear to be parallel when they reach you, as shown in Figure 2-1. The simplest way to explain how lenses work is with light rays that have traveled far enough so they appear to be parallel.

Converging Lens—Light rays from a single point on a distant scene are *effectively* parallel when they enter a camera lens. Rays coming from the *same* point in the subject converge and are brought to focus at a *single* point on the film, as shown in Figure 2-2. Rays from every other point in the scene are brought to a focus at a corresponding point on the film.

In Figure 2-2, all light rays entering the lens are from the same point of the scene. Light rays from a different point of the scene will be brought to focus at a different location on the film. Thus, all points of the scene are imaged at the appropriate locations on the film.

Figure 2-2 shows a simple lens, convex on both sides. It is called a *converging* lens because light rays passing through it converge and meet at a point behind the lens.

Focal Length—This is the distance behind a lens at which parallel, or effectively parallel, light rays are brought to focus.

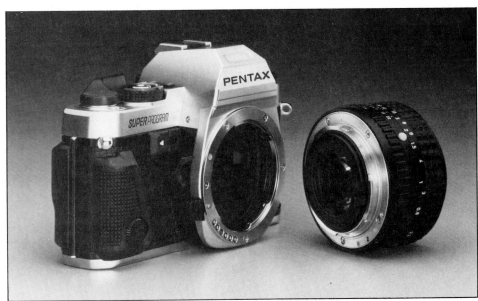

This is a bayonet-mount lens. Lens and camera interact through mechanical levers and by electrical contacts near the bottom of the lens mount.

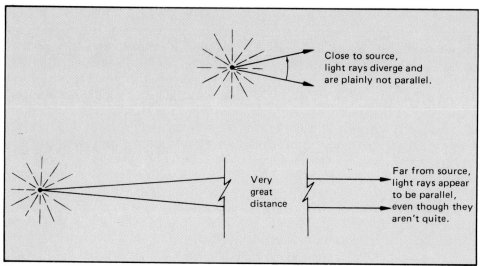

Close to source,
light rays diverge and
are plainly not parallel.

Very
great
distance

Far from source,
light rays appear
to be parallel,
even though they
aren't quite.

Figure 2-1/Light rays from a point diverge. When viewed from a location that is close to the point, they are plainly not parallel. At a great distance from the point, they still diverge but the divergence is so small that they appear to be parallel.

Focus

Focal Length

Figure 2-2/Light rays entering a lens from a distant point appear to be parallel and are treated by the lens as though they were actually parallel. A converging lens brings parallel rays to focus at a distance behind the lens that is equal to the focal length of the lens.

The greatest conceivable distance is called *infinity* and is represented by the symbol ∞. Light rays reaching a lens from infinity are parallel. Rays reaching a lens from a *relatively* long distance, such as 100 yards, are *effectively* parallel. Photographically, any such distant subject is considered to be at infinity.

As shown in Figure 2-3, light rays from a point that is not distant will not appear to be parallel when they enter the lens. They will diverge. The lens will still change their paths so they come to focus. Because they were diverging rather than parallel when they came into the lens, it takes a greater distance behind the lens to bring them all together at a point.

To focus a subject at infinity on the film, the lens must be placed at a distance from the film equal to the focal length of the lens. To focus on a nearer object, the lens is moved farther away from the film. The *shortest* distance ever required between lens and film is the focal length of the lens.

Focal length is a specification that describes an important characteristic of a lens. However, unless the lens is set to focus at infinity, the distance between lens and film is always greater than its focal length.

Instead of the single lens component shown in the accompanying drawings, practical photographic lenses have

If light rays are parallel, from a distant source, lens brings them to focus at a distance equal to the focal length.

If light rays are diverging, from a nearby source, lens brings them to focus at a distance longer than the focal length.

Figure 2-3/Light rays entering a lens from a nearby point are not parallel. They diverge. More distance is needed behind the lens to bring the diverging light rays into focus.

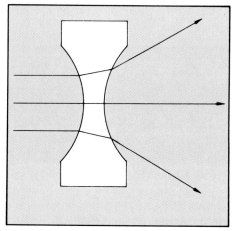

Figure 2-4/A diverging lens causes light rays to diverge as they pass through the lens.

more than one glass element. However, the basic principles involved are the same.

Diverging Lens—Diverging lenses have at least one concave surface and are thinner at the center than at the rim. They behave in a manner opposite to that of convex lenses. Rays passing through the lens are caused to diverge, as shown in Figure 2-4.

FOCUSING

Focusing involves placing a lens at the correct distance from the film to produce a sharp image. This is done by a control on the lens called the *focusing ring*. Turning the focusing ring moves the glass elements of the lens away from or toward the film surface. Most lenses have a telescoping barrel that becomes longer or shorter as you focus the lens.

Engraved on the focusing ring is a distance scale, calibrated in feet and meters. It shows the focused distance of the lens. The distance is measured from the film plane in the camera to the location in focus.

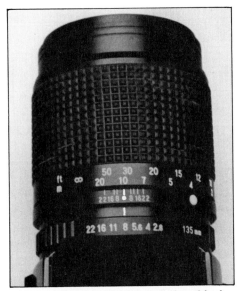

The focusing ring on this lens is the wide ring with a textured rubber grip. The distance scale is marked in feet and meters. Focused distance is indicated by the central index mark. This lens is focused at 10 meters, or about 33 feet.

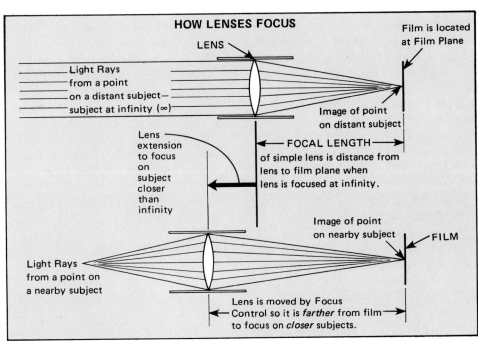

The closer a subject approaches to the lens, the farther you must move the lens from the film to maintain a sharp image.

When the lens is moved to the closest possible distance from the film, it is focused at infinity. This is shown by an ∞ on the distance scale. When the focusing ring places the lens as far from the film as possible, it is focused at the shortest possible distance for that lens.

Internal Focusing—Lenses with internal focusing are designed so the lens body does not change length as it is focused. The lens elements move inside the lens.

Rear Focusing—This is similar to internal focusing, except that only the rear elements move. If you look at a rear-focusing lens from the back while turning the focusing ring, you can see the movement.

Floating Elements—Ordinary lenses are designed to make the best image of distant subjects. As subjects come closer, image quality deteriorates. However, even at the closest focusing distance of the lens, image quality is still satisfactory. If the lens were built so it could focus even closer, image quality at the shortest distance would be unacceptable to the lens designer.

To improve image quality with close subjects, lens designers incorporate *floating* lens elements. Turning the focusing ring causes the floating elements to move inside the lens independently of each other.

Close-Distance Compensation—This is another name given to the compensation provided by floating elements, as just described.

Film-Plane Location—In high-magnification photography it is sometimes useful to measure the distance from the film to the subject. Some cameras show the location of the film plane by a ⊖ symbol engraved on top of the camera.

Focusing with Infrared Film—Different wavelengths of light have different colors. The visible-light spectrum is composed of all the colors we can see. In the visible spectrum, blue light has the shortest wavelength and red light has the longest. Wavelengths shorter than blue are invisible and are called *ultraviolet* or *UV*. Wavelengths longer than red are also invisible and are called *infrared* or *IR*.

There are two kinds of infrared film—color and b&w. Infrared color film responds to both infrared light and visible light. When using this film, focus in the usual way.

Infrared b&w film is also sensitive to infrared and visible light. To expose it only to infrared radiation, you must use a dark red or opaque infrared filter on the camera lens so only the infrared reaches the film.

Infrared radiation does not focus in the same plane as visible light but a little farther from the lens. Therefore, you must use a special focus setting to ensure an image of optimum sharpness. Most lenses have a special IR focusing mark. It's usually a small red dot.

Focus with visible light first. Notice the focused distance. Then, rotate the focusing ring to place that distance opposite the IR focusing mark. This moves the lens a small distance farther from the film. Place the IR filter over the lens and make the exposure.

AUTOMATIC FOCUS

Autofocus systems use an electronic focus detector. A small rectangular

portion of the center of the scene is examined electronically to check focus. The corresponding image area is marked in the viewfinder. It may be the horizontal line of a biprism "split-image" focusing aid or a small visible rectangle.

The autofocus system can be turned off, or not selected, if you don't want to use it.

One of two locations is used for the electronic focus detector. One is in the viewfinder, above the focusing screen. The more common location is in the bottom of the camera. Some of the light passes through a semi-transparent area of the viewing mirror. A second mirror reflects the image downward to the focus detector. If the image is in focus at the detector, it will also be in focus at the film.

One way to check focus electronically is similar to the way we do it with our eyes. An edge or line looks fuzzy when out of focus. The focus detector tests sharpness of a line or edge. Other methods are optically more complicated.

Focus Confirmation—The simplest use of electronic focus detection relies on manual focusing, using the focusing ring. A viewfinder display tells you when the image is in focus. The accompanying illustration shows a typical display. Any lens can be used.

Auto Focus—Some cameras actually focus the lens automatically. This requires special lenses, usually called *autofocus* or *AF* lenses. An electrical signal from the focus detector operates a small focusing motor that focuses the lens.

Some manufacturers put a focusing motor in the body of each autofocus lens. Electrical contacts on the lens and camera body transmit control signals to the motor. The lens can also be focused manually.

Another design incorporates the focusing motor in the camera body. A mechanical connection in the lens mount allows the motor to focus the lens. You can also focus this lens type manually.

To use electronic autofocusing, move the camera to place a *vertical* line or edge of the scene in the focus-test area at the center of the frame. Autofocus action is started by touching the shutter button or depressing it partway, or by a control on the lens. When focus has been accomplished, the image in the viewfinder appears in focus and the viewfinder focus display indicates good focus.

There are two focusing modes. One mode focuses and then will not change focus as long as you hold your finger on the shutter button—or on a *focus-lock* button, depending on the camera brand. That allows changing composition after focusing. The other mode is called *follow-focus* and changes focus continuously, to follow a moving subject.

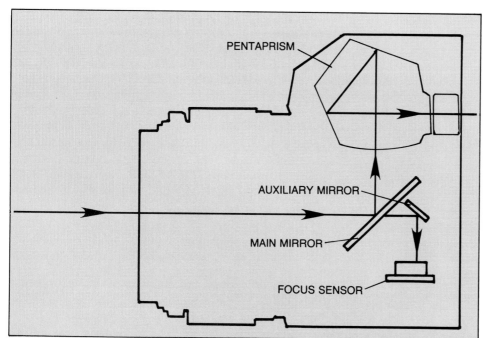

Most autofocus cameras have an electronic focus detector in the bottom of the camera. Some of the light from the scene passes through the main mirror to an auxiliary mirror that reflects it downward to the focus detector. Most of the light is reflected upward by the main mirror. The "lost" light is usually not noticeable in the viewfinder.

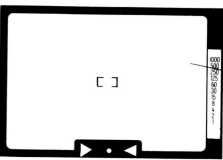

A typical focus display in an autofocus camera uses a green dot to indicate good focus. The adjacent red triangles indicate poor focus. Only one symbol glows at a time. If you focus manually, a glowing red triangle is an arrow indicating which way you should turn the lens focusing ring. The area of the scene affected by autofocus is marked, sometimes by a rectangle as shown here. On some cameras, it is the horizontal line of a biprism focusing aid.

Self-Contained Autofocus Lens—
Some manufacturers offer special zoom lenses with an entire autofocus system built into the lens—focus detector, motor and batteries. Autofocusing is done by pressing a button on the lens. If the autofocus system is turned off, you can focus the lens manually.

Possible Problems—There are some scenes for which focus cannot be detected electronically. Because the detector checks focus on a vertical line or edge in the test area, it will not work if there is no vertical line to check. If there are several vertical lines at different distances from the camera, the autofocus system may search back and forth or focus in between. If there is insufficient contrast between a line or edge and the background, or if the image is too dim, autofocus may not work.

Purchase Considerations—Obviously, an autofocus system is useful for people who have difficulty focusing due to eyesight problems. For those who are capable of focusing manually, there may be two reasons to consider autofocus—in addition to convenience.

One is focusing speed. Sometimes an autofocus system can focus faster than you can manually. However, not all autofocus systems are that fast.

Another is focusing in dim light, when it is difficult to judge focus with your eye. However, some autofocus systems don't work in dim light.

The range of scene brightnesses over which an autofocus system works well is specified by EV numbers, which are discussed in Chapter 4. At the time of this writing, the most sensitive available autofocus camera worked from EV 3 to EV 18. A dim-light limit lower than EV 3 would be even better.

If you are shopping for an autofocus camera, I suggest that you try before you buy—at least in the camera shop—and compare different brands.

HOW DIFFFERENT LENSES FIT ON THE CAMERA

All lenses designed to fit on the same camera body must meet a basic requirement: When focused at infinity,

The Minolta 7000 Maxxum focuses the lens automatically using a small motor built into the camera body. Special Minolta AF lenses are required. Lenses of earlier design cannot be used. The autofocus system can be turned off and the AF lens focused manually.

The Canon T80 focuses the lens automatically, using a small built-in motor in each autofocus lens. Earlier lens types can be used with manual focusing. Either way, good focus is indicated by an audible beep, rather than a display.

This picture could have been made with an autofocus camera. The girl in the foreground is in the central area affected by autofocus and is in sharp focus. If the camera had been centered on the child on the right, maximum image sharpness would have occurred there. Photo by Kent Knudson.

Lenses with different focal lengths require different minimum distances between the optical rear node and the film plane. The minimum distance is the focal length of the lens. It is provided in the design of each lens, which places the rear node where it needs to be.

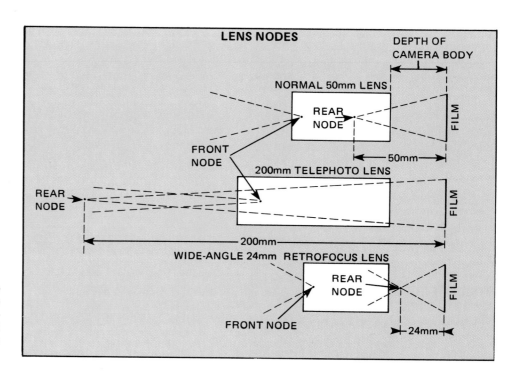

LENS NODES

DEPTH OF CAMERA BODY

NORMAL 50mm LENS

REAR NODE

FILM

FRONT NODE

50mm

200mm TELEPHOTO LENS

REAR NODE

FILM

200mm

WIDE-ANGLE 24mm RETROFOCUS LENS

REAR NODE

FILM

FRONT NODE

24mm

the distance between lens and film must equal the focal length of the lens. Lens focal lengths range from about 15mm, or less than an inch, to as much as 2000mm, or about six feet.

Optical Nodes—Compound lenses, having more than one element, have two optical locations that you should know about. They are called *nodes,* or *nodal points.* Knowing about them is useful when performing high-magnification photography with a bellows or extension tubes, as discussed in Chapter 8.

If a lens is mounted normally on the camera, the lens-to-film distance is measured from the rear node of the lens. There is also a front node. If the lens is reversed—for purposes explained later—the front node becomes the rear node.

The lens designer can place these invisible, but very real, nodes where they need to be when he designs a lens.

Lens-to-Film Distance—The actual requirement is that the distance from the rear node to the film is equal to the focal length of the lens.

Some of that distance is inside the camera body—the distance from the lens mount back to the film. A 50mm lens needs a total of 50mm, or about two inches, between its rear node and the film. For this reason the lens designer places the rear node near the back of the lens where you would expect it to be. That lens is called a *normal* lens.

A lens with a long focal length, such as 1000mm, requires a distance of 1000mm—about three feet—between the rear node and the film when it is focused at infinity. The lens itself need not be that long because a designer places the rear node out in front of the lens, in space. That kind of lens design is called *telephoto.*

A lens with a short focal length, such as 15mm, requires 15mm between the rear node and the film for the lens to focus at infinity. To meet this requirement, the rear node is placed behind the lens, 15mm from the film. That design is called *reversed telephoto* or *retrofocus.*

By using normal lenses, telephotos and retrofocus lenses, the designer can produce a set of lenses with a wide range of focal lengths that will all work on the same camera body.

Long-focal-length lenses can be made using the normal lens design, with the rear node near the rear glass element and a long, empty tube behind that. The purpose of the long tube is to provide enough distance between film and node. The advantage of the telephoto design is that it allows long-focal-length lenses to be physically short.

Lenses with focal lengths shorter than the depth of the camera body are nearly always retrofocus. In the past, the normal design has sometimes been used. This required the back of the lens to extend into the camera body, which interfered with the mirror. The lens was used with the mirror locked up and an accessory viewfinder mounted on top of the camera.

FIELD AND ANGLE OF VIEW

A lens "sees" a circular part of the scene and makes a circular image, although not all of it is included in the film frame. The *field of view* is simply the circular part of the scene that the lens sees.

If a lens has a wide field of view, then it also has a wide *angle of view.* The angle of view is the angle between the outside rays that form the image, with the lens node at the "tip" of the angle. The angle of view is the same on both sides of the lens—for rays coming in and going out.

HOW ANGLE OF VIEW IS SPECIFIED

The image frame on the film is a rectangle that fits closely inside the image circle. The *diagonal* of the frame is approximately the same as the

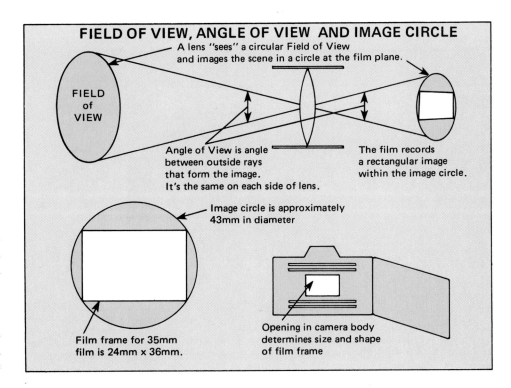

FIELD OF VIEW, ANGLE OF VIEW AND IMAGE CIRCLE

A lens "sees" a circular Field of View and images the scene in a circle at the film plane.

FIELD of VIEW

Angle of View is angle between outside rays that form the image. It's the same on each side of lens.

The film records a rectangular image within the image circle.

Image circle is approximately 43mm in diameter

Film frame for 35mm film is 24mm x 36mm.

Opening in camera body determines size and shape of film frame

DIFFERENT FOCAL LENGTHS AT SAME CAMERA LOCATION

15mm

50mm

100mm

300mm

600mm

When focal length is changed, but the camera remains at the same location, all photos have the same perspective. A wide-angle lens takes a wide view. If the center portion of the wide view were enlarged, it would be identical to the image taken with a longer lens. From the same camera location, changing lens focal length changes image magnification and angle of view, but not perspective.

diameter of the image circle. Therefore, the angle of view is sometimes also called the *diagonal angle of view*.

Because the film frame does not include everything in the image circle, some people define two other angles of view: horizontal and vertical. The horizontal angle of view is determined by the width of the film frame. It is smaller than the diagonal angle of view. The vertical angle of view is determined by the height of the frame. It is smaller still.

Some lens specifications state all three angles of view. If only one is given, it is the diagonal angle.

FOCAL LENGTH

In the drawing on page 27, the angle of view is shown by an arrow drawn between the outside rays that form the image circle. When you use a different focal length, the diameter of the image

circle in the camera does not change and the dimensions of the film frame do not change.

It is obvious that the angle of view must become smaller as the lens is moved farther from the film. Therefore, long-focal-length lenses have narrow angles of view and short-focal-length lenses have wide angles of view.

You can do superb photography of scenes and people without knowing the technical definition of focal length and about the lens nodes. Most of the time, you don't care what the focal length is. You are interested in angle of view because that affects the appearance of the photo.

Traditionally, lenses are known by their focal lengths rather than their angles of view. As you use lenses, you will gradually learn to translate focal length into its practical effect—angle

of view. You will know that a 200mm lens has a narrower angle of view than a 35mm lens and, more important, you will know the pictorial effect of various focal lengths.

Standard Lens—The *standard* lens sold with most 35mm SLR cameras is a 50mm lens or a zoom lens that includes 50mm as one of its focal lengths. People say that a 50mm lens gives a "natural" image because the angle of view is about the same as that seen by the human eye. That means one eye. If you close one eye, what you see clearly with the other is about what a 50mm lens sees.

A more practical reason to sell a camera with a 50mm lens is that the focal length is useful for many photographic situations and, therefore, a good choice for your first lens.

Notice that I have made a distinction between normal and standard lenses.

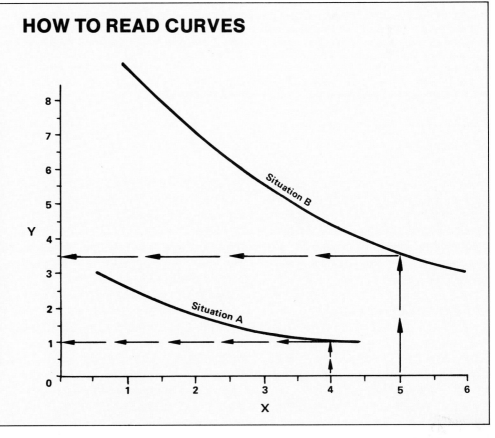

HOW TO READ CURVES

If you are accustomed to "reading" graphs, you can skip this discussion.

A curve or graph provides a way to find one number of a pair when you know the other number. Call one number X and the other Y.

Using the curve labeled Situation A, find the value of Y when X is 4. Make a vertical line from 4 on the X scale, as shown. Where the vertical line intersects the Situation A curve, project a horizontal line over to the Y scale. As you can see, the value of Y is 1. It also works the other way. If you know that Y is 1, you can read the curve to find that X is 4.

Another set of circumstances is shown by the curve labeled Situation B. When Situation B applies, and X is 5, the value of Y is about 3.5.

A telephoto lens foreshortens perspective in a photo that is viewed at a normal viewing distance. This photo was made with a 500mm lens. The road appears much shorter in the picture than it does to the eye. You can use this effect to produce images with dramatic impact. However, if such a photo is viewed from a long distance, the perspective will appear normal again. Look at this picture from about six or eight feet away and you'll see what I mean. Photo by Thomas Ives.

A wide-angle lens exaggerates perspective in a photo viewed from a normal distance. This Indian woman is harvesting the fruit of the saguaro cactus. The plant seems to tower over the woman, making for a dramatic image. If you could view such a photo from a very close distance—about four inches—the perspective would return to near normal. Photo by T. A. Wiewandt.

Normal indicates that a lens is of a design that is neither telephoto nor wide-angle. Its focal length is usually about 50mm. A lens sold with a camera, as standard equipment, is generally called a *standard* lens— usually also about 50mm.

SELECTING THE RIGHT FOCAL LENGTH

The best way to have the right focal length lens when you need it is to own a lot of lenses and carry them with you at all times. That provides good physical exercise and builds strong muscles. Many photographers attempt to lighten the load by anticipating what will be photographed and taking along only suitable lenses.

There's a simple way of determining approximately what focal length you need for a specific shot without even looking through the camera viewfinder. All you need is an empty 35mm-slide mount.

Close one eye and view the scene through the slide mount. Move the mount back and forth until the scene is framed as you want it. Estimate the distance of the mount from your eye. That gives you approximately the focal length you should use.

For example, if the scene is framed as desired with the mount about four inches from your eye, you'll need a focal length of about four inches and should, therefore, select a 100mm lens.

APERTURE

Physically, a lens aperture is an approximately circular opening formed by metal blades. The blades pivot to change the diameter of the opening. As I've explained earlier, aperture size is specified by an *f*-number. The *f*-number is the lens focal length divided by aperture diameter:

f = Focal Length/Aperture Diameter

The *f*-number is called *relative* aperture. It is an indication of the amount of light that will reach the film. If one lens set at *f*-4 will give correct exposure, then another lens of different focal length that is also set at *f*-4 will also give correct exposure.

In print, *f*-numbers are written in a variety of ways such as *f* /4, F4 and *f*-4. This book uses *f*-4.

If a 100mm lens has an aperture diameter of 50mm, it is an *f*-2 lens. If the aperture is made smaller, it transmits less light. If the aperture is 25mm, it is an *f*-4 lens. Larger *f*-numbers mean that the lens transmits less light to the film.

If a 100mm lens has an aperture diameter of 25mm, the *f*-number is 100/25, which is *f*-4. By the same reasoning, a 200mm lens with an aperture of *f*-4 has a diameter of 50mm. Longer focal lengths require larger aperture diameters to preserve the same *f*-number. A larger aperture diameter requires larger lens elements and a larger lens barrel.

To avoid making really huge and expensive lenses, manufacturers often sacrifice maximum aperture size at longer focal lengths. For example, the maximum aperture of a 200mm lens may be *f*-4. The maximum aperture of an 800mm lens may be *f*-5.6 or *f*-8.

Aperture Ring—Aperture size is controlled manually by turning the aperture ring on the lens. Engraved on the ring is a scale of *f*-numbers so you can read the setting. These numbers are the standard *f*-number series, such as 1.4, 2, 2.8, 4, and so forth. There are detents at each *f*-number and sometimes in between.

The smallest *f*-number represents the largest aperture size of the lens— usually referred to as its maximum aperture. Sometimes, the maximum aperture of a lens is not a standard *f*-number in the series. If so, the actual maximum aperture is shown. Standard *f*-numbers are used for all smaller apertures.

For example, if the maximum aperture of a lens is *f*-1.2, the aperture scale will read 1.2, 2, 2.8, 4, and so forth until the minimum aperture is reached.

Telephoto lenses are useful when you want a large image of a subject you can't get close to, such as wildlife. Photo by C. Allan Morgan.

A wide-angle lens is useful when you are working in a confined space but want to include a wide area in a picture. To make this photo, the photographer could not move farther back. With a standard lens, he could have included only a fraction of the scene. Photo by Jack Dykinga.

A lens aperture is formed by metal blades that pivot toward or away from the center of the lens to form a smaller or larger opening.

NAME OF ABERRATION	EFFECT	USER CORRECTION
SPHERICAL ABERRATION	Image not sharp with any film or subject.	Shoot at smaller than maximum aperture.
CHROMATIC ABERRATION	Image not sharp with any film. Color fringes visible on color film.	Same as above
ASTIGMATISM	Out-of-focus effect at edges of picture. Changes when you operate focus control but you can never get all parts of image in good focus.	Same as above
COMA	Off-axis points on subject have tails like comets when viewed under high magnification. To unaided eye, edges of picture are fuzzy.	Same as above
CURVATURE OF FIELD	When photographing flat surfaces such as stamp or newspaper, center is sharp, but edges are out of focus.	Same as above
DISTORTION	Straight lines in scene appear curved.	None

LENS ABERRATIONS

Defects of various types exist in every lens, but the effect is normally minimal in lenses from reputable manufacturers. Optical defects in a lens are called *aberrations*. The accompanying table lists some image problems and what you can do about them.

You can reduce most aberrations by using smaller than maximum aperture. Here are two aberrations you should know about.

Spherical Aberration—This is caused by lens surfaces that are spherical—and that includes most lenses. Correction is possible by including in the lens design one or more elements that are not spherical. Such elements are called *aspheric*. Lenses with aspheric elements are designed to produce a sharper image.

Chromatic Aberration—The most visible effect of this aberration is color fringes around bright lights or objects in the picture. It happens because light of different colors is not brought to focus at the same location.

Lens elements made of *fluorite*—a man-made crystal—are effective in reducing this aberration. Another correction is use of special low-dispersion glass in lens elements.

FLARE AND GHOST IMAGES

These are caused by stray light entering the lens—usually from the side—and reflecting off internal glass and metal surfaces. Flare is an overall haze or a diffused spot of light. Sometimes one or more images of the aperture are formed, especially if you shoot into the sun. These are called *ghost images*.

The best prevention is to use a lens hood or otherwise shade the lens so light from sources outside the field of view doesn't strike the lens.

FLATNESS OF FIELD

When you photograph a flat surface, such as a drawing or a postage stamp, all parts of the subject should be in focus on the film. If they are not, the lens has poor flatness of field. You can improve it by using a smaller aperture.

DIFFRACTION

When light rays pass close to an opaque edge, such as the edge of the aperture blades, their direction is changed. This is called *diffraction*. The result is an overall lack of sharpness in the image because the diffracted rays don't land on the film in the right places.

The effect of diffraction is greatest at small lens apertures, when a large proportion of the light passing through is near the aperture blades. You can't eliminate its effect, but you can reduce it by using a larger aperture. A larger aperture allows a greater proportion of the light to pass through the center of the opening, where it can't cause diffraction.

OPTIMUM APERTURE

Aberrations are reduced by smaller aperture. Diffraction is reduced by larger aperture. The optimum aperture is neither very large nor very small.

A long telephoto lens like this should be used on a sturdy tripod. Even at a fast shutter speed, such as 1/500 second, the risk of camera shake with a handheld camera would be high.

Most lenses make the sharpest image when set about midway between the largest and smallest aperture size.

LENS COATING

A very thin, transparent coating on the front surface of a lens reduces reflections from that surface and admits more of the light into the lens. Coating the interior glass surfaces reduces internal reflections and thereby reduces flare and ghost images.

A single-layer coating reduces reflections from one color of light. Multiple layers of different thicknesses reduce reflections of several colors, which is better.

Virtually all modern lenses are coated. If multiple coating is used, the lens manufacturer usually says so in advertising and may use a special name for the coating. It is usually not possible to find out if all glass surfaces are coated, but you can rely on the reputation of the manufacturer. Makers of high-quality lenses do enough coating to produce a very good image.

Lens Types

The two main specifications of a lens are the focal length in millimeters and its maximum aperture size stated as an f-number. Manufacturers' lens tables include additional information, such as minimum aperture, angle of view, lens size and weight, the diameter of the filter-mounting threads at the front and the distance range of the focus control.

In lens tables provided by manufacturers, lenses are usually placed in categories determined by their focal lengths.

WIDE-ANGLE LENS

These lenses have focal lengths of 35mm and shorter, with larger angles of view at shorter focal lengths. They are useful to photograph interiors where you want to get a lot of a room in a single photo. They are useful when you can't stand far enough back to use a longer lens.

They make pleasing outdoor and scenic shots when you want to include a vast expanse of landscape, or something like a small flower with surrounding vegetation.

A special type of very-short-focal-length lens is the fish-eye, described later.

STANDARD LENS

Standard lenses for 35mm cameras have focal lengths in the range of 40mm to 55mm. They are good general-purpose lenses and give a perspective that is about the same as we see. Some camera manufacturers offer a zoom lens as standard, with a range of focal lengths that includes 50mm.

MEDIUM TELEPHOTO

With focal lengths in the range of 70mm to 200mm, these lenses are useful when you can't get close enough to the subject to fill the frame with a standard lens. They are popular for sports, travel and nature photography. Because they have narrow angles of view, they are used to isolate and photograph an interesting part of a wider view, leaving out the uninteresting parts.

LONG TELEPHOTO

These are specialist's lenses with focal lengths from 300mm to 2000mm. I once attempted to photograph a wind-surfing competition using a 600mm lens. My images weren't large enough. Professional magazine photographers nearby were using 1000mm and 2000mm lenses.

Long telephoto lenses require a tripod or other steady mount to avoid image blur due to camera movement.

As the lens focal length is made longer, the aperture must be physically larger to preserve the same f-number. Therefore, the lens diameter is larger. This makes long telephoto lenses large and heavy.

Most long lenses sacrifice large maximum apertures to reduce size, weight and cost. Maximum apertures of f-5.6 and smaller are common, often making the use of fast films a necessity.

MACRO LENS

An ordinary 50mm lens, used as close as possible to the subject, pro-

LENSES AND TYPICAL SUBJECTS

A wide-angle lens is sometimes necessary when you must include all of an object in the frame but can't move back far enough to use a 50mm lens. Wide-angle lenses are also useful in scenic views covering a large area.

A 50mm lens is probably the most useful for general photography. Shoot with a focal length of around 50mm unless you have a good reason to use a different lens. Color photo by Thomas Ives.

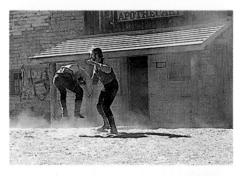

A medium telephoto, such as 135mm, is sometimes necessary when you can't get close enough to fill the frame with a 50mm lens. When making this photo, I was part of the audience at an amusement park.

Long focal lengths, such as 300mm, are sometimes used to "reach out" and fill the frame with a distant object. This great blue heron, with its wings spread, is a fine example. Color photo by C. Allan Morgan.

duces an image on film that is about 10% as tall as the subject. There are special *macro* lenses that focus much closer to the subject, to produce much larger images. Using macro lenses is discussed in Chapter 8.

ZOOM LENS

Zoom lenses have a control that changes the focal length while the lens remains focused on the subject. The subject grows larger or smaller in the frame as you zoom. These lenses have become very popular, and deservedly so. A single zoom lens can provide the focal lengths of several non-zoom lenses, and all focal lengths in between.

A zoom is useful in composing a photo because it gives very precise control of what appears within the frame. This is especially useful when you can't easily change the camera location.

Zoom lenses are handy, and sometimes essential, when shooting action and sports. In these cases you don't always have time to change lenses to get a different focal length.

There are two types of zoom lenses.

One has a separate focusing ring and zoom ring. The other has both functions combined in a single ring. To focus, turn the ring. To zoom, slide the ring forward or backward along the lens body.

Some people form a preference for one type or the other. If you buy more than one zoom lens, it's a good idea to have them all the same type. It is awkward to switch back and forth.

Zoom Lens Aperture—Zoom lenses typically have smaller maximum apertures than fixed-focus lenses.

Some zoom lenses change aperture size when zoomed. For example, the maximum aperture may change from *f*-3.5 to *f*-4 as the lens is zoomed from its shortest to longest focal length. Other aperture settings will change proportionally.

If you are setting exposure manually, zoom first, then set exposure. If the camera is setting exposure automatically, don't worry about the aperture change. The camera will compensate for it automatically.

Zoom Lens with "Macro" Setting— Some zoom lenses have a special control or setting to allow close focusing

distances and thereby a somewhat larger image. The largest possible image is typically about 25% as large as the subject.

At the "macro" setting, flatness of field may not be good enough to photograph flat subjects such as a postage

These photos were made with a 35—70mm zoom lens from the same camera position. The upper photo was made at the 35mm setting and the lower photo at the 70mm setting. The lower image is approximately twice as large as the upper one.

Essential lens data are usually engraved on the front. XR RIKENON is the brand name of this lens. Maximum aperture is indicated as 1:2.8. This means it's an *f*-2.8 lens. Focal length is 135mm. Ricoh is the manufacturer. There is a threaded ring, 55mm in diameter, on the front of the lens that can be used to attach filters and other accessories such as a lens cap or hood.

This 28—85mm *f*-4 zoom has three controls. The focusing ring is at the front. Just behind it is the zoom ring. At the back is the aperture ring.

This is a 15mm fish-eye lens that fills the rectangular image frame. It has a diagonal angle of view of 180°. The lens hood is cut away at the corners to prevent vignetting.

Both photos were made with a 15mm rectangular fish-eye lens. The red pond is polluted by industrial waste. I used fish-eye distortion to make the place look as desolate and grotesque as possible. In the other scene, visible distortion is minimized by placing the horizon at the center of the image. The result is a pleasing wide-angle view.

stamp. There may also be some visible distortion of straight lines. Such defects are normally not noticeable if you use the lens to photograph objects in nature, such as rocks and flowers, and the resulting photos are usually acceptable.

FISH-EYE LENS

A special lens design, called *fish-eye*, has a very wide angle of view—typically 180°. The lens creates fish-eye distortion—any straight line that does not pass through the center of the picture is bowed away from center. The focal lengths of fish-eye lenses range from about 6mm to 17mm.

Circular Fish-Eye Lens—This lens type makes a circular image within the film frame. The remainder of the frame is unexposed. A lens hood cannot be used because it would obstruct part of the scene.

Rectangular Fish-Eye Lens— This lens makes a rectangular image that fills the frame. The film frame fits just inside the circular image made by the lens. The lens may have a built-on hood that shades the image area outside the film frame.

Filters with Fish-Eyes—Fish-eye lenses don't use front-mounted filters because the filter frame would obscure part of the image. Most have several built-in filters on a turret inside the lens. A control rotates the desired filter into the optical path.

36

MIRROR LENS

Mirror lenses—also called *reflex* or *catadioptric* lenses—use two mirrors to fold the light path inside the lens, as shown in the accompanying drawing. Curved front-surfaced mirrors can bring light rays to focus, just like a lens. In addition, there are conventional lens elements.

This design is used mainly for long focal lengths, such as 250mm and longer.

A mirror lens can be physically much shorter and lighter than a conventional lens of the same focal length. Using mirrors also reduces several of the lens aberrations.

Mirror lenses don't have adjustable apertures. Exposure controls are just shutter speed and film speed. To avoid overexposure, you can use a neutral-density light-reducing filter in front of the lens.

When bright points of light in a scene are recorded out of focus, they appear as tiny rings of light in the image. Sometimes these doughnut-shaped highlights can be attractive. They always call attention to the fact that a mirror lens was used.

TELE-EXTENDERS

Accessories called *tele-extenders* or *tele-converters* fit between the lens and the camera body. They multiply the lens focal length by a factor such as 1.4, 2 or 3. The factor is written with an X to signify multiplication, such as 2X.

This is a handy way to get additional focal lengths. For example, if you use a 50mm lens with a 2X tele-converter, the focal length of the combination becomes 100mm.

Another advantage is that the minimum focusing distance of the lens is not changed. That allows making larger images with a 50mm lens and 2X tele-converter than you can with a 100mm lens because it won't focus as close.

Disadvantages—There are two. One is that the tele-extender also multiplies the *f*-number of the lens by the same factor. A 200mm lens set at *f*-4 and used with a 2X extender acts like a 400mm lens set at *f*-8. The light loss is sometimes troublesome.

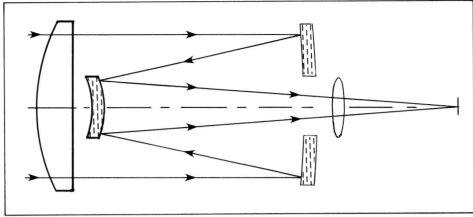

Reflex lenses use mirrors to "fold" the optical path, making the lens physically shorter. The mirror surfaces are curved and participate in focusing the image. Glass lens elements are also used. The ring-shaped opening in the front mirror forms the aperture of the lens, which is not adjustable in size.

This 500mm *f*-8 Yashica mirror lens is physically very small and lightweight compared to conventional lenses of the same focal length. The lens hood at right is packaged with the lens.

The design of mirror lenses causes out-of-focus bright spots to record as distinct doughnut shapes, as show here. When you see these bright rings, you can be sure a mirror lens was used. Photo by Kent Knudson.

This Tamron 1.4X teleconverter is designed to work with Tamron long-focal-length lenses. By a mechanical linkage, the scale on the teleconverter shows the effect on aperture. For example, if the lens is set at *f*-4, the scale on the teleconverter will indicate *f*-5.6.

The other disadvantage is a possible loss in image quality. With an inexpensive tele-extender, image quality may become unacceptable. With good quality tele-extenders, made by the same manufacturer as the lens, it may be difficult to detect any quality loss.

Some lens makers produce tele-extenders for specific lenses, or a specific range of lenses. Image quality is usually excellent.

WHEN CAMERA LOCATION CHANGES, PERSPECTIVE CHANGES

50mm

100mm

200mm

Perspective is governed by the relative sizes of objects in a photo, as seen by a viewer. In these photos, the model remained at the same location. With longer focal lengths, the camera was moved back to keep the model about the same height in the viewfinder. The background seems to move closer to the model.

Depth of Field

Photos of scenes with great depth, such as landscapes with foreground detail, are not always in sharp focus over their entire distance range. The zone of acceptable focus is called *depth of field*. For example, depth of field may extend from an object 20 feet away to infinity.

In normal photography, depth of field extends about twice as far behind the point of best focus as in front of it. In close-up and macro photography, it extends about an equal distance on each side of best focus.

In photographs made for technical purposes, it is usually best to have everything is sharp focus. In artistic photography, it is often desirable to use depth of field selectively. For example, a portrait against a cluttered background usually looks better if the background is out of focus.

Some lenses are packaged with depth-of-field tables. Or, the manufacturer may provide a table on request.

BASIC RULES

Depth of field is controlled by the lens aperture setting. Large apertures give less depth of field. Depth of field is also affected by image size. A fuzzy point will appear sharper if it is smaller and less sharp if it is larger. Those two considerations lead to the following rules.

To Increase Depth of Field:
● Use a smaller aperture.
● Use a shorter focal length to get a smaller image.
● Use a greater subject distance to get a smaller image.

To Decrease Depth of Field:
● Use a larger aperture.
● Use a longer focal length to get a larger image.
● Use a shorter subject distance to get a larger image.

The reason focal length and subject distance affect depth of field is that they affect image size.

In the top photo, a large aperture was used to limit sharpness to the nearest part of the bridge. For the center photo, I used a medium aperture, with the lens focused near the middle of the bridge. The bottom photo was made at a small aperture, to improve sharpness at both ends of the bridge.

VIEWING DEPTH OF FIELD

Normally, you view the scene in the camera at open aperture, so you see minimum depth of field. If the lens stops down to take the picture, there will be more depth of field than you saw.

If your camera has a *stop-down* button or lever—sometimes called a *depth-of-field preview button* or *lever*—you can use it to stop down the lens to the set aperture value. The viewfinder image will become darker but you can usually see the depth of field that will be recorded on film. Remember, however, that if the image is later enlarged, depth of field will be reduced accordingly.

Focusing Screen—Focusing screens with a matte surface show the condition of the image at that surface. Objects sharply focused appear sharp. Those out of focus appear blurred.

Clear focusing screens are used for special purposes, such as astronomy and high-magnification photography. With a clear screen, you can see the focused image, but you can't judge depth of field.

DEPTH-OF-FIELD SCALE

Most lenses have a depth-of-field scale. For each focused distance, it shows depth of field for a range of aperture sizes. The accompanying photo shows how to read it.

HYPERFOCAL DISTANCE

When focused at the hyperfocal distance, depth of field extends from half the hyperfocal distance all the way to infinity. If you use a smaller lens aperture, the hyperfocal distance gets nearer to the camera lens. By setting the lens to a small aperture and at the hyperfocal distance, you can be sure of an extended depth of field for quick "grab shots," when you don't have time to focus.

How to Find the Hyperfocal Distance—When focused at infinity, the hyperfocal distance is the near limit of depth of field as shown by the depth-of-field scale on the lens.

First, focus the lens at infinity. Read the depth-of-field scale to find the near limit. Then change focus to that distance. Read the depth-of-field scale again and you will see that depth of field extends from one-half the hyperfocal distance all the way to infinity.

Choosing Lenses

It is helpful to have a plan when you buy lenses. There are two main considerations. You want a variety of focal lengths ranging from wide-angle to telephoto. You want some focal lengths with large maximum apertures for use in dim light. In addition, large apertures allow dramatic depth-of-field effects, especially with longer focal lengths.

A rule of thumb is that each longer focal length should be approximately double the next shorter focal length. That gives a series of focal lengths such as 24mm, 50mm, 100mm, 200mm and 400mm. Another possible series is 17mm, 35mm, 70mm, 150mm, 300mm.

You can obtain some focal lengths by using a tele-extender. If you have a 300mm or 400mm lens, you can use a tele-extender to convert it to a 600mm or 800mm lens. However, if you need such a long lens frequently, I recommend that you buy one.

You can obtain a wide range of focal lengths with just two zoom lenses, such as a 30-70mm and a 100-200mm.

You can also get one zoom lens to cover a very wide range, such as 28-200mm. It will probably have variable aperture with a large change in maximum aperture, such as *f*-3.5 at the shortest focal length to *f*-5.6 at the longest. At *f*-5.6 the viewfinder will be very dark and focusing will be difficult. The focusing aid may black out somewhere between *f*-4 and *f*-5.6. Therefore, a single wide-range zoom may be an unsatisfactory compromise.

To overcome the problem of a relatively small maximum aperture with a zoom lens, buy a large-aperture fixed-focal-length lens near the center of the zoom range. For example, if you have a 100mm-200mm zoom, you might also buy a large aperture 150mm

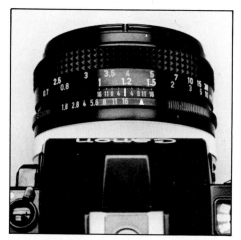

The small scale between the aperture ring and focusing ring is the depth-of-field scale. It has the number 16 at each end. If the lens aperture is set to *f*-16, as shown, then each 16 on the depth of field scale acts as a "pointer" to a distance on the focused-distance scale. The two pointers indicate the depth of field—in this case, about 1 meter to 1.5 meters. If the aperture is changed, for example to *f*-11, then each 11 on the depth-of-field scale acts as a pointer to show depth of field.

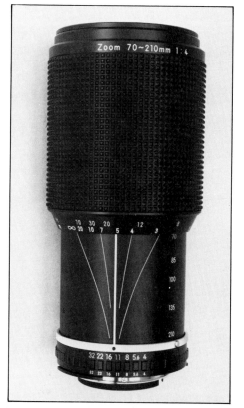

This is a 70—210mm zoom lens with a single control to focus and zoom. Turn the ring to focus, slide it to zoom. The lens is set at a focal length of 70mm. Sliding the zoom ring toward the camera increases focal length. The curved lines are the depth-of-field scale, read where they touch the focused distance scale on the back of the zoom ring. The lines are color-coded to match colored *f*-numbers on the aperture scale. Notice that there is much more depth of field at 70mm than at 210mm.

lens. Then, when you can't use the zoom—because of dim light—you can use the 150mm lens and get approximately the same composition.

If you intend to buy a 50mm or 100mm lens, consider buying a macro lens with that focal length instead of an ordinary lens. Macro lenses have smaller maximum apertures, such as f-3.5 or f-4, but the macro capability is often worth the sacrifice in aperture size.

CHECK LENS CONTROLS

Check the direction of rotation of the lens control rings, especially the focusing ring. All should focus closer by turning the ring in the same direction. Lenses of one manufacturer usually all focus the same way, but it's worth checking.

If you buy more than one zoom lens, it's convenient to have the controls the same on each lens—either separate zoom and focus rings or the two functions combined in one ring.

Most lenses have a threaded ring at the front in which you mount filters and special-effect accessories. This is usually called a *filter ring*. Polarizing filters and some special-effect filters depend on orientation. Check to see if the filter ring rotates when the lens is focused or zoomed. If so, you will have to rotate the filter back to the desired orientation each time you adjust the lens.

HOW TO HOLD THE CAMERA

If the camera moves while you are taking a picture, the image may be blurred. Camera shake or jiggle is the most common cause of fuzzy pictures.

The accompanying photos show good ways to handhold the camera. Even your breathing can cause the camera to move. Take a full breath, let part of it out, and then don't breathe while you click the shutter. Learn to *squeeze* the shutter button without moving the camera—don't jab it. Hold the camera firmly against your face. Hold one elbow firmly against your body.

In addition to holding the camera correctly, look for ways to give your body maximum stability. The world is well equipped with objects and supports to help you hold the camera steady. Lean against a wall or tree. Press the side of the camera firmly against a telephone pole or the corner of a building. Rest your elbows on a railing or the back of a chair.

Some photographers carry a "bean bag." They place the bag on a solid support and then cradle the camera in the bag.

Rule of Thumb—Lenses with longer focal lengths increase image blur due to camera movement. Faster shutter speeds reduce image blur because less of the movement occurs while the shutter is open.

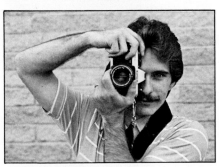

Here is a rule of thumb that suggests shutter speeds for handholding with various lenses. The slowest shutter-speed for any lens is the reciprocal of the focal length. That means, 1 divided by the focal length. For example, with a 200mm lens, the slowest shutter speed should be 1/200 second. Use the next faster speed of your shutter—1/250 second.

With a 50mm lens, the fastest speed should be 1/60 second. The shutter-speed dial on most cameras shows speeds of 1/30 and slower in a different color as a warning that such slow speeds may produce a blurred photo if you handhold the camera. Obviously, this assumes that you are using a 50mm lens.

Most photographers occasionally handhold at slower shutter speeds than the rule suggests. Some are better at handholding than others. If you have no choice, try to get the shot. And, learn at how slow a speed you can hold the camera steady.

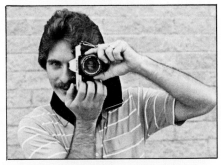

Use a Tripod—Nearly every photo will be improved if you put the camera on a tripod. Tripods are inconvenient to carry around. So are skis and fishing tackle, but all are essential to the intended activity. Suggestions on choosing a tripod are in Chapter 9.

Top photo: For horizontal-format shot, cradle lens in left hand. Grasp camera with right hand and press it firmly against face or forehead. Operate lens controls with left hand. Tuck in elbows. "Squeeze" shutter button gently. **Second photo:** For vertical-format shot using right eye, rotate camera as shown. **Third photo:** Left-eyed people may find this more convenient way to hold camera for vertical-format pictures. Operate shutter button with thumb. **Bottom photo:** Take advantage of supports to steady camera. For example, prop elbows on fence or wall.

3
Films

This image was shot on color slide film, suitable for projection. It could also have been made on color-negative film, for production of a color print. B&W film could also have been used, to make a negative and, ultimately, a b&w enlargement. Some color-slide films are balanced for use with daylight, others for tungsten illumination. Films differ in speed, grain structure and contrast. The modern SLR photographer has a wide selection of films to choose from.

The b&w negative, at left, has reversed brightnesses compared to a print from that negative, at right. Photo by Joshua James Young.

In this chapter, I'll discuss color and b&w films, how an image is formed, exposure considerations such as film speed and exposure latitude, and film storage. Films made by different manufacturers are essentially similar and the information in this chapter applies generally to all films.

FILM TYPES

You can use several types of films in a 35mm SLR. Common film types, each available in a range of speeds, are discussed here.

B&W Negative Film—This produces a negative black-and-white image of the scene. In a negative, brightnesses are reversed. White records as black, and black as white.

To make a positive image, called a *print,* the negative image is exposed onto photographic printing paper. When that image is developed, the brightnesses have been reversed again as they were originally. In the printing process, the 35mm image is normally also enlarged.

Color Negative Film—This film makes a negative image in color. Brightnesses are reversed, as they are in a b&w negative film. The colors are "reversed," too.

To make a positive color image, the reversed brightnesses and colors of the negative are exposed onto color-print paper and a normal-looking image results. The image is generally also enlarged during printing.

Color negative film is usually labeled *color print film* on the carton because color prints are the end result.

Color Slide Film—During processing, the image formed on a color slide film is converted to a positive image in color. This means the negative image on the film is reversed back to a positive image, resembling the original scene in tone and color. For this reason, these films are also known as *color reversal films.*

The color slides returned to you from a lab are the same film that you originally exposed in the camera. No separate printing process is involved.

However, it is possible to make color prints from color slides. One procedure involves making an intermediate color negative, sometimes called an *internegative* or *interneg.* The print is then made from that negative. That procedure produces the best color print. Another, less expensive, procedure makes prints directly from the slide, using special *reversal* printing paper.

Special-Purpose Films—There are a lot of special-purpose films. Some that may interest you are b&w infrared film, color infrared film, chromogenic b&w film and "instant" slide film. These are discussed briefly later in this chapter.

Using B&W Film

B&W negative film has a clear base on which is coated a light-sensitive *emulsion.* The emulsion is made up of small particles of a silver compound called *silver halide,* dispersed in a layer of gelatin.

Film is exposed by allowing light to

reach the emulsion surface. Where light strikes the emulsion, silver halide particles are activated. Brighter light activates more of the particles. An invisible image, also called *latent image,* is formed.

After exposure, the film is processed chemically to *develop* the image. This changes the activated particles of silver halide into metallic silver particles, which are black and opaque to light.

EXPOSURE CONSIDERATIONS

Exposure is discussed in the next chapter. Some film and subject characteristics that affect exposure are discussed briefly here.

Brightness Range—Each point in a scene reflects light toward the camera. White, brightly lit objects reflect the most light and appear brightest. Black, dimly lit objects reflect the least amount of light. The scene has a range of brightnesses.

Density Range—When b&w negative film is correctly exposed to light from a scene and then the film is developed, a white area of the scene causes the negative to be black in that part of the image. Similarly, black areas in a scene record as a clear area in the negative. Intermediate brightnesses in the scene cause shades of gray on the film.

The darkness of an area on the film is called *density*. The density *range* of

a film can extend from almost completely clear to a dense black, with shades of gray in between.

Exposure Range—The goal in b&w photography is to record each part of the scene in a shade of gray that is proportional to its brightness. Therefore, each brightness of the scene should have a corresponding density on the negative.

This means that the brightness range of the scene must fit within the exposure range of the film. The exposure range is best identified in the film's characteristic curve, discussed next.

Characteristic Curve—The accompanying diagram shows how b&w film responds to exposure. It shows a range

of exposures along the bottom of the graph—caused by a scene's brightness range, together with the camera exposure given to the scene.

The resulting range of film densities is shown along the left. As you can see, along the "straight-line" section of the curve, each different value within the exposure range causes a different density on the film. This graph is called the film's *characteristic curve*.

The curve has a *toe* at the bottom, a *shoulder* at the top, and a line that is almost straight in between.

Notice that the toe of the curve flattens out and becomes horizontal. If exposure extends into the toe area, the resulting density differences are insufficient to form a satisfactory image. This causes loss of shadow detail in the print.

If exposure is excessive, it will extend into the shoulder of the curve. Here, too tones are recorded with insufficient differences and, consequently, highlight detail is lost. Bright parts of the scene tend to blend together to form an even, white area.

Fitting Scene Brightness Range onto the Curve—To make a good exposure, you must consider two things: The scene brightness range and where you place it on the characteristic curve of the film.

By using the exposure controls on the camera, you can center the scene brightness range on the straight-line section of the curve. Then, if the scene brightness range is not too wide, neither the toe nor the shoulder will be used and an acceptable exposure results. That is the situation shown by Figure 3-1.

Underexposure—If you place exposure too far to the left on the curve, you'll use the toe section and lose shadow detail. The result is underexposure. This will happen even if the subject brightness range would normally fit within the straight-line part of the curve.

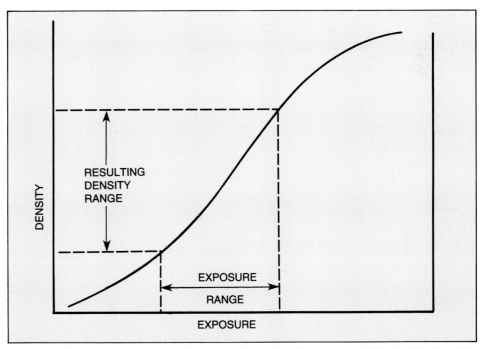

Figure 3-1/The brightness range of the scene determines the exposure latitude of the film. This curve shows how a range of exposures is converted to a range of densities in a processed film. When the exposure range falls mainly on the straight portion of the curve, the resulting densities will be a satisfactory record of the scene.

Overexposure—If you place exposure too far to the right on the curve, the exposure will run into the shoulder section. In this case you lose highlight detail. This is overexposure.

You can improve an over- or underexposed negative to some extent during printing by choosing paper of appropriate contrast and controlling exposure properly. However, shadow or highlight detail lost on the negative can not be restored.

Brightness Range too Wide—No matter how carefully you select exposure for a subject with a brightness range too wide for the film, you won't get a perfect image. You'll lose either shadow detail, highlight detail or both.

Calculating Brightness Range—The exposure range on the film is partly determined by the range of scene brightnesses. Exposure is measured in steps. Each step is double the next smaller value.

The percentage of incident light reflected by an object is called its *reflectivity*. A white object may have a reflectivity of about 96%. A very dark object may reflect about 3% of the light that falls on it. It's easy to calculate the number of exposure steps between those extremes by doubling numbers starting with 3%:

<div align="center">3 - 6 - 12 - 24 - 48 - 96</div>

The dashes between values represent exposure steps. The range is five steps.

B&W negative film intended for general use can accept about seven steps of exposure without getting too far into the toe or shoulder of the curve and losing detail. Therefore, there is plenty of room for an exposure range of 5 steps as long as it is reasonably well centered on the straight part of the curve.

Uneven Scene Illumination—If 100 "units" of light fall everywhere on the scene, then the part that reflects 3% will reflect 3 units and the part that reflects 96% will reflect 96 units. The exposure range will be 5 steps, as indicated.

If the illumination on different parts of the scene varies, however, the above won't necessarily be true. Suppose the darkest object in the scene is

This photo was shot on color slide film, which has a relatively narrow exposure range. Notice that there is ample detail in both the shadow and highlight sides of the balloons. If the contrast of the scene had been higher, it would have been advisable to expose for the highlight areas, even if the shadows lost some detail.

in shadow. It still reflects 3% of the light that falls on it, but only receives 25 light units. This means it reflects a total of 0.75 light units. The brightest object still reflects 96% of the light reaching it and actually receives 100 units of light. The total amount of light reflected is 96 units.

The total number of exposure steps is now determined by the numbers:

<div align="center">0.75 - 1.50 - 3 - 6 - 12 - 24 - 48 - 96</div>

The scene now includes 7 exposure steps. It will be a little more difficult to expose correctly on b&w film without losing shadow detail or highlights.

Primary Color	Complementary Color
Red	Cyan (Blue-Green)
Green	Magenta (Red-Blue)
Blue	Yellow (Red-Green)

One of the three primary colors is red. Its *complement* is formed by the other two primary colors, blue and green, which combine to make cyan. Similarly, magenta is the complement of green and yellow is the complement of blue.

You must now determine exposure very carefully.

From what I have just told you, it is clear that *effective* subject brightness range depends on both the reflectivity of the various subject parts and the amount of light falling on each of those parts.

When you shoot in bright sunlight, with shadows in a scene, the useful exposure range of the film may be exceeded. You can set exposure to lose shadow detail, highlight detail, or a little of each. Setting exposure is discussed in Chapter 4.

EXPOSURE LATITUDE

The useful section of the characteristic curve of b&w film is the straight part, together with a little of the toe and shoulder.

If the usable part is seven steps wide and the brightness range of the scene is also seven steps, then you have no *exposure latitude*. To record the scene best, center exposure in the usable part of the curve.

If the brightness range of the scene is only four steps, then there is some exposure latitude. You can place the exposure a little to the left or right on the curve without losing picture detail. That will make the negative a little lighter or darker than if the exposure were centered, but it won't sacrifice any image detail.

Film manufacturers sometimes refer to exposure latitude as though it were a property of film alone. For example, they may state that a film has a wide exposure latitude. However, exposure latitude depends on the number of exposure steps the film can accept *and* the brightness range of the scene.

Using Color Film

Reproduction of scenes in color on film is based on the fact that all colors in the spectrum can be reproduced by appropriate mixtures of three *primary colors:* red, green and blue.

If your eye sees a mixture of approximately equal amounts of red, green and blue light, you see white light. If the brightness of all three colors is reduced proportionally, you see a shade of gray.

In addition to the primary colors, there are three other colors you should know about. The combination of red and green produces yellow. Similarly, red and blue combine to make a purple color that we call magenta. Green and blue combine to make a color called cyan. Yellow, magenta and cyan are called *complementary colors.*

Each color has many shades. Red, for example ranges from dark red to light pink. Lighter shades are made by adding white light. Red with a lot of white added becomes pink. If no white light is present, a color is very strong and we say it is *saturated.*

If you start with white light and remove all of the red component, what is left is a saturated shade of cyan (blue-green). Suppose you put 90% of the red back. The 90% red combines with 90% of the blue and 90% of the green to make white. The remaining 10% blue and 10% green make a very diluted, light shade of cyan.

COLOR NEGATIVE FILM

The major components of color negative film are three separate layers of silver-halide emulsion, similar to the emulsion in b&w film. The film is designed so that each layer responds to only one of the three primary colors.

When color negative film has been exposed, each layer has a latent image that records a single primary color. For example, the red-sensitive layer has a "map" showing the amount of red at each point on the scene.

In processing, the latent silver-halide image in each layer is developed and then replaced with a visible color image formed by a chemical dye. The colors are complementary—"reversed" compared to the actual colors of the scene. The dye in the red-sensitive emulsion layer is cyan. The dye in the green-sensitive layer is

To see how colors are reproduced using only the three primary colors, use a magnifying glass to examine the screen of a color TV. This photo shows the *white* area of a TV test pattern, photographed at high magnification. The dots are the three primary colors—red, green and blue—with equal brightnesses. To make other colors, some of the dots must be less bright than the others.

magenta and that in the blue-sensitive area is yellow.

In the color negative, not only are the colors complementary to those in the scene, but the tones are reversed, too. Dark subject areas are light and light subject areas are dark.

To make a color print, the negative is projected onto color printing paper, using white light. The color printing paper also has three layers, similar to those of the negative. In printing, the scene brightnesses and colors are reversed back again to provide a positive image with brightnesses and colors matching the original scene.

Exposure Considerations—Most of what I said earlier about exposing b&w film applies also to color negative film. The film has a characteristic curve with a straight part, a toe and a shoulder. However, the usable exposure range of color negative film is narrower than that of b&w film. Typically, it is about five exposure steps— enough to record an average scene in fairly uniform illumination. It is not enough to record outdoor scenes with detail in both bright, sunlit and dark, shaded areas.

If you can control the lighting, such as in a studio, it is usually best to keep the lighting as uniform as possible. Outdoors, shooting on a lightly overcast day is best. If the light is fairly contrasty, you can fill the shadows with flash or the use of reflector cards.

The exposure latitude of color-negative film is widened by the fact that, as with b&w negative film, you get a second chance. To a limited extent, you can compensate for over- or underexposure at the printing stage.

COLOR SLIDE FILM

Color slide film also has three silver-halide layers, each responding to a single primary color. During processing, the three layers work together

Although most of this scene is in silhouette, the subtle blue and yellow in the sky give the photo a mood that would be lacking in a b&w shot. To be effective, a color picture need not necessarily be full of bright colors. Photo by Kent Knudson.

to reproduce the original colors and tones of the scene. The result is a positive image on the same piece of film you originally exposed in the camera.

Exposure Considerations—Slide film also has a characteristic curve with a toe and shoulder. The usable exposure range is typically about six or seven steps.

The appearance of the positive image is determined *solely* by the original exposure in the camera. If you over- or underexpose in the camera, the finished slide will be over- or underexposed. Therefore, you must expose slide film with great care.

Film Speed

Film manufacturers indicate the speed of each of their films by giving it a film-speed number —for example 25 or 400.

When you put an unexposed cartridge of film into your camera, you should set the film-speed dial on the camera to the film-speed number of that film. If the camera reads DX-coded film cartridges, it can set film speed for those films automatically.

The purpose of film-speed numbers is to tell the camera how much exposure the film needs to place the brightness range of an *average* scene at the correct location on the film's characteristic curve. Film speed is a *message* from the film manufacturer to the exposure system in your camera.

When you use the camera, the built-in exposure meter measures the amount of light coming from the scene. The camera then calculates aperture size and shutter speed to provide the amount of exposure required for the film's speed.

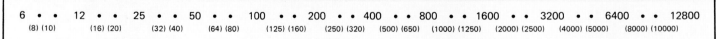

6	• •	12	• •	25	• •	50	• •	100	• •	200	• •	400	• •	800	• •	1600	• •	3200	• •	6400	• • •	12800
(8) (10)		(16) (20)		(32) (40)		(64) (80)		(125) (160)		(250) (320)		(500) (650)		(1000) (1250)		(2000) (2500)		(4000) (5000)		(8000) (10000)		

Figure 3-2/The film-speed dial on most cameras shows numbers in the standard film-speed series, such as 100 and 200. There isn't room to show intermediate values, such as 125 and 160, so they are represented by dots, as shown in the top part of this chart. The value represented by each dot is shown in parentheses below the dot. If you are using film with a speed of 125 or 160, you have to know which dot to use so you can set film speed correctly.

This reproduction is made from a color slide. For best image quality with slide film, exposure accuracy is particularly important. Be sure to set the correct film speed on your camera so that the built-in meter can set exposure correctly. Photo by C. Allan Morgan.

The camera assists you in setting the exposure controls by a display in the viewfinder that shows if a setting is correct. An automatic camera can set one or both of the exposure controls for you.

THE STANDARDS

In the United States, ASA film-speed numbers—named after the former *American Standards Association,* now called the *American National Standards Institute*—are used on the film-speed dial of virtually all SLR cameras. ASA film-speed numbers are shown in Figure 3-2.

In Germany, a different numbering system called DIN—after *Deutsche Industrie Norm*—is used.

A few years ago, the *International Standards Organization (ISO)* announced a new international way of specifying film speed, called ISO film-speed ratings. ISO ratings simply combine ASA and DIN numbers, as shown in Figure 3-3.

Film-Speed Numbers—Manufacturers of cameras continue to use the ASA part of the ISO numbers on film-speed dials. In literature, and on camera controls, they may be referred to as ISO/ASA, ASA/ISO or just ISO.

Effect on Exposure—In Figure 3-2, the standard ASA film-speed series is shown by the large numbers, such as 25, 50, 100 and 200. These numbers double as the series progresses.

Higher film-speed numbers represent faster films that require less exposure. Each *higher* number in the standard series demands an exposure that is *half* as much as that for the preceding value.

The difference in exposure between one standard film-speed number and the next is one exposure step. ASA 400 film requires one step *less* exposure than ASA 200 film.

FILM-SPEED RATING		
ASA	**DIN**	**ISO**
12	12°	12/12°
25	15°	25/15°
50	18°	50/18°
100	21°	100/21°
125	22°	125/22°
160	23°	160/23°
200	24°	200/24°
400	27°	400/27°
800	30°	800/30°
1600	33°	1600/33°
3200	36°	3200/36°

Figure 3-3/The ASA film-speed system was developed in the United States. The DIN system was developed in Germany. The ISO system conveniently combines the two. Most cameras sold in the U.S. show only ASA numbers on the film-speed dial. ASA numbers double to change film speed by one step, such as from ASA 100 to ASA 200. Intermediate values represent one-third steps, such as ASA 125 and ASA 160. The DIN system uses a degree symbol and adds 3° for a full step, such as from DIN 21° to DIN 24°. Intermediate one-third steps are written by adding 1°, such as DIN 22° and DIN 23°. Both systems have the same value at 12. From there, you can calculate the entire range.

Not all films have speeds that can be stated by numbers in the standard series. Between each pair of standard film speeds are two intermediate speeds representing one-third steps of exposure. The intermediate settings are shown by dots in the scale of Figure 3-2 because they are usually shown by dots on camera film-speed dials. The value represented by each dot is shown in parentheses below.

CHOOSING FILM

Most types of films are available in a range of film speeds. The speed is shown on the carton and also on the cartridge. At the end of this chapter, there's a list of some common films and their speeds.

There are two considerations in choosing film. One is the amount of scene illumination. If you are shooting in dim light, you may prefer a fast film, such as ISO 400/27° or even faster. Fast film, requiring relatively shorter exposure times, may allow you to handhold the camera rather than putting it on a tripod.

If you'll be shooting in bright sunlight, fast film may be a disadvantage because it forces you to use both small aperture and fast shutter speeds. To reduce depth of field, you may prefer a larger aperture. You may want to use a medium-speed or slow film.

The "sunny-day *f*-16 rule" discussed in Chapter 4 will help you choose film speed for outdoor use.

A second consideration in choosing film speed is image quality. In general, slower films produce sharper images with less visible grain.

COLOR BALANCE

If the colors in a positive color image are close enough to the original scene to appear believable, the image is said to have good *color balance.*

Films of various types may have slightly different color balance. Some may show skin tones that are *warm,* meaning slightly reddish. Others may give *cold,* bluish skin tones. Sometimes such differences are not noticeable unless one print is compared with another.

Photographic magazines often publish surveys of currently available

General-purpose films have different storage instructions than professional films. The Kodachrome 25 package at left contains professional film. The Kodachrome 64 package contains general-purpose film.

color films, with test photos. Using these and personal experience, you can judge color balance and other factors relating to image quality.

Daylight and Tungsten Films —Both color-print and color-slide films are available with color balance suitable for use either with daylight illumination or tungsten light. The film carton is marked *Daylight* or *Tungsten.* For more information on this topic, see Chapter 5.

FILM STORAGE

Professional films and *general-purpose* films are available. Professional film cartons are so labeled. The difference between the two is mainly in consistency of performance and storage requirements.

General-Purpose Films—Films for the general public are sold in camera stores, drug stores and other outlets. Normally, they are held at room temperature until sold and held by the user at room temperature until exposed and processed.

During this time, the film characteristics tend to slowly change. For example, you can expect color film to go through a slight change in color balance with aging. For general-purpose use by amateur photographers, the change is so small that it is acceptable or perhaps not even noticed.

The expiration date on each film

carton shows the approximate end of the film's useful life when the film is stored at room temperature.

If you buy general-purpose film and store it in a refrigerator, the change in characteristics will stop or slow down greatly. That preserves the color balance of the film as it was at the time you purchased it. It does not guarantee that the film was at its optimum color balance at that time.

Professional Films—Professional photographers often need more predictable and consistent color balance from roll to roll.

After manufacture, professional films are held at the factory until they have aged to the best color balance. Then, they are refrigerated to stop further changes and shipped under refrigeration to retail suppliers of professional films. At the store, they should be kept under refrigeration.

After purchase, and after exposure, they should be refrigerated until processed.

Precautions—Store films as suggested on the carton. Kodak general-purpose films are marked *Protect From Heat.* That allows storage at room temperature, although you can refrigerate them if you wish.

Kodak professional films have storage instructions such as *Store Below 55F/13C.* For best and most consistent image quality, refrigerate them. Stor-

To retain detail in highlight and shadow areas in a scene of moderately high contrast, exposure accuracy is important. Notice that this scene, which has a high subject-brightness range, has recorded with some detail in both the bright wall and the shaded side of the child's face. Photo by Thomas Ives.

age at room temperature would allow slow changes to take place.

Film is packaged to protect it from humidity. Leave it in the original packaging until just before you use it.

If you refrigerate film, keep it in the original packaging while being refrigerated and for sufficient time afterward to allow it to return to room temperature. If you open it while it is still colder than the surrounding air, moisture may condense on the emulsion. This will ruin the film.

For 35mm film cartridges in individual cartons, three hours is normally enough time for it to return to room temperature.

If you must store film for a very long time, you can freeze it. This may pro- tect its quality even beyond the expiration date on the carton. Before you use film that has been frozen, allow it to warm up for at least 24 hours at room temperature.

Effects of Age—After manufacture, film changes its characteristics slowly until it is developed. Exposure does not stop the changes, but development does. B&W films gradually lose speed and exhibit decreased image contrast. Color films also show changes in color balance.

These changes are accelerated by high storage temperature and high humidity. They are reduced by storage at low temperatures and virtually stopped by freezing. Changes are also accelerated by storage in the presence of chemical vapors such as those produced by some plastics and solvents, and by gases such as hydrogen sulfide.

Processing—After exposure, have film processed promptly.

I am reluctant to mail or ship exposed film for processing, unless that's the only way. I fear that it may encounter high temperature or excessive humidity somewhere along the way—such as being placed near a heater or furnace outlet.

In my community, I can take the film to a local lab. Or, I can drop it off at a camera shop and ask that it be sent to Kodak for processing. Such film is picked up daily by a courier and sent by air to the nearest Kodak processing facility.

RECIPROCITY FAILURE

Earlier, I showed you this equation:

$$\text{EXPOSURE} = \text{INTENSITY} \times \text{TIME}$$

The equation represents the *reciprocity law* of exposure. From it, you can conclude that doubling exposure time will double the exposure on film.

That is true over a wide range of exposure intervals. However, with very short and very long exposure times, it is not exactly true. Those deviations are referred to as failures of the reciprocity law or *reciprocity failure*.

When reciprocity failure occurs, at either long or short exposures, the film does not receive as much exposure as it should. The basic adjustment is to give more exposure.

With b&w and color films, exposures longer than about 1 second may cause low-light-level reciprocity failure. Exposures shorter than about 1/1000 second may cause short-exposure-duration reciprocity failure with b&w film.

Very short exposures are produced by electronic flash. Because you can't make the flash last longer, the correction is to use a larger lens aperture. Color films generally tolerate very short exposures without reciprocity failure so that corrections are not needed.

With long exposure times, there are two ways to give more exposure: Either use a larger aperture or give additional exposure time. Using a larger aperture is preferable because using a longer exposure time adds further to the reciprocity failure problem.

Effect on Color—Color films suffer low-light-level reciprocity failure. These films have three silver-halide emulsion layers that don't behave identically. The amount of reciprocity failure in each of the layers tends to differ. This causes changes in color balance.

For example, if the red-sensitive layer is affected most by reciprocity failure, the resulting image will be deficient in red. The image will have a slight cyan cast.

Correction for B&W Films—Increase the exposure and, ideally, modify the development time.

Correction for Color Films—Increase exposure and use a color filter to correct the change in color balance. Filters are discussed in Chapter 7.

SPECIAL-PURPOSE FILMS

Among the many special-purpose films available, here are a few that may be of interest to you:

B&W Infrared Film—This film is sensitive both to visible light and to infrared radiation. Sunlight and most other light sources produce infrared radiation as well as visible light.

This film is normally used with a dark-red filter over the lens. The filter blocks all or most of the visible light. The film then records mainly the infrared reflected by the scene. This often gives a surreal effect or makes a daylight photo appear to have been taken by moonlight.

Color Infrared Film—This is a color-slide film. The three emulsion layers record red, green and infrared. The film has medical and scientific uses. It is also used, with a variety of color filters, to produce startling color slides with colors that vary greatly from those of the original scene.

Chromogenic B&W Film—The word *chromogenic* implies color. Although this is a b&w film, the final image is not made up of silver particles but of dye.

Chromogenic b&w film forms a latent silver image on exposure. During processing, that image is replaced with a black or near-black dye image. Processing is the same as for color negative film and most film labs can do it.

The advantages are less visible grain in the image and variable film speed without the need for processing compensation.

Instant Slide Films—These are self-developing 35mm films made by Polaroid Corporation. There is a color-slide film, a continuous-tone b&w film and a high-contrast b&w film. Unlike other Polaroid films, they can be used in conventional 35mm cameras without special adapters. Processing can be done instantly after exposure by using a special film processor.

FILM INFORMATION

A wide variety of color films is manufactured by Kodak, Fuji, Agfa and the 3M Company. B&W films are readily available from Kodak and Ilford. For up-to-date information on the films available and their characteristics, write the film manufacturer or consult your photo dealer.

Shooting subjects that are dimly lit can call for relatively long exposure times. This can cause reciprocity failure, making an image darker than expected and possibly giving it a color imbalance. You can correct this problem by giving more exposure and using appropriate filtration. Fortunately, sunsets usually require a relatively short exposure time and, therefore, reciprocity failure rarely occurs. Basically, you meter the bright sky and permit foreground areas to record in silhouette. Photo by Ted DiSante.

4
Exposure

Exposure meters are designed to indicate good exposure for average subjects. When you shoot non-average scenes, such as this one, you may have to make an exposure compensation. Unless you want a snow scene to record as a dull gray, you must give more exposure than indicated by the meter. Photo by Gabor Demien, Stock Boston, Inc.

In the preceding chapter, I discussed the idea of placing the brightness range of the scene on the straight part of the film's characteristic curve. You do that by controlling the amount of exposure the film receives from the scene.

SLR cameras have a built-in exposure meter that measures scene brightness and calculates suitable apertures and shutter speeds for correct exposure.

The camera "knows" how much exposure each film type needs because the film-speed number conveys that information.

However, the camera manufacturer doesn't know anything about the scene you are photographing. Therefore, the camera is designed on the assumption that you will photograph *average* scenes.

AVERAGE SCENE

An average scene has two important characteristics. One is that the reflectances of all objects in the scene average out to 18%. This means that, of the total amount of light falling on the scene, 18% is reflected toward the camera.

Average scenes are those without large areas that are unusually light or dark. Most of the scenes that we photograph, such as landscapes, are average.

The other characteristic is that all colors in a scene average out to a shade of gray. For many scenes and subjects this is true—but not for all. If you fill the frame with the image of a large, green building, that scene will not average out to gray.

GRAY CARD

Special cards that reflect 18% of the light that strikes them are available from camera stores. They are called *18% gray cards*. The inside covers of this book are printed approximately 18% gray.

Your camera's exposure meter is designed to "think" it is always looking at an average subject—or an 18% gray card. As long as it is actually looking at one of these, it will indicate correct exposure. When the subject differs from this average, you must *interpret* what the meter tells you. This

This photo is average in the sense that there are no large areas that are unusually light or dark. The small areas of blue sky and patches of sunlight are balanced by the dark leaves and shadows. The camera will meter this scene correctly.

This scene is not average because it is dominated by the white building. The camera will meter this scene to give a dull-gray building. To get a good image, you must increase the exposure indicated by the meter.

is discussed later in this chapter.

The idea that the colors of a scene average out to gray is important in printing color negatives. High-volume color printing is done on automatic machines without human intervention. In making the print, exposure is auto-matically adjusted so the print is not too light or dark.

Also, the colors of the print are automatically adjusted, within limits, so they average out to gray. If the photo is full of green building, the color on the print may not be realistic because the

automatic color printer adjusted it toward gray.

You may have used a red filter over the lens, perhaps to make a surrealistic red landscape. An automatic color printer thinks landscapes should look like landscapes, so it may take out the overall red color.

If that happens, you can ask for another print and explain why. If you request *custom printing* of your color negatives, you can include printing instructions so your artistic effects are preserved.

The above statements do not apply to color slides because the positive image is controlled entirely by what happens in the camera.

Exposure Metering

The built-in light-measuring system in an SLR camera measures light from the scene. Based on the light measurement, an internal computer calculates exposure settings on the assumption that an average scene is being measured. The combination of light-measuring sensor and exposure computer is called an *exposure meter*.

The exposure meter is inside the camera and measures the light coming in through the lens. Such meters are called *Through-The-Lens (TTL)* exposure meters.

THE SENSOR

A light sensor is a small panel that responds electrically to the amount of light falling on it. There are three common types of light sensors.

Most modern cameras use either silicon or gallium-arsenide sensor cells to measure light. Silicon sensors are often referred to as *Silicon Photo-Diodes,* abbreviated *SPD. Gallium sensors* may be referred to as *GPD*.

Cadmium Sulfide (CdS) sensors were once common but are now rarely used. They respond more slowly than the other types. If exposed to bright light, they require a minute or so to readjust for accurate readings.

Depending on camera design, a light sensor may be placed in one of several locations.

RECOMMENDED EXPOSURE

Based on the amount of light from the scene and the film speed being used, the camera calculates suitable aperture and shutter-speed settings to provide correct exposure of an average scene.

I will refer to the calculated exposure as the *camera-recommended* exposure. When operating your camera, you can use that amount of exposure or a different amount.

Visible in the viewfinder is an information display that shows you the camera-recommended exposure. Typical exposure displays are shown later in this chapter.

If you are setting exposure man-

If you use the camera-recommended exposure, a small subject against a light background will appear in silhouette.

EXPOSURE CORRECTION FOR NON-AVERAGE SCENES

BACKGROUND	CORRECTION
White	2 steps more
Light	1 step more
Average	no change
Dark	1 step less
Black	2 steps less

These corrections are approximate. They are based on the assumption that you want correct exposure of a small subject against a large background that is visible to the meter.

ually, you can use the recommended exposure shown in the viewfinder or you can use different settings. If the camera is set to give automatic exposure control, it will use the recommended value unless *you* cause the camera to use a different exposure. There are several ways to do that, as discussed later.

NON-AVERAGE SCENE

The main reason to use an exposure different from the camera-recommended value is to photograph scenes that are not average.

If you photograph an 18% gray card, exposure should be perfect because the camera expects everything out there to have a reflectance of 18%. If you photograph an average scene that has 18% reflectivity, exposure should also be perfect.

When you use negative film, incorrect exposure can be corrected to some degree when a print is made. When you use color slide film, camera exposure totally determines the appearance of the final image. Therefore, correct exposure is particularly important when you shoot color slides.

Light Background—A common non-average feature of scenes is the background. For example, if you photograph an object against a large white background, the average reflectance of that scene will not be 18%. The white background reflects much more light than 18%. Therefore, the overall scene will reflect more than 18% of the light falling on it.

However, because the camera "thinks" that *every* scene is average it also thinks that a large, white area is average. The camera will provide an exposure to reproduce the scene as 18% gray. If you shoot at that exposure, you are likely to get a silhouetted subject against a gray background.

To correct the exposure, you must *increase* it. The accompanying table shows suggested values.

Dark Background—A relatively small subject against a large dark background will also "fool" the camera's exposure meter. The camera will assume that the overall scene—including the large, dark background—is 18% gray and will record it accordingly.

The result will be too much exposure and an image that's too light. The correction is to give *less* exposure.

Translating Light Reading into Exposure Setting—If you used the camera-recommended exposure, any uniform tone would be recorded as 18% gray. Snow, sand, a black cat and a gray card would all record as the same tone of gray. You *know* something the meter doesn't know: that snow is white, sand is very bright and a black cat is very dark. You must interpret the meter reading accordingly.

For example, to get snow to record as nearly white, with just a little tone and texture, you must increase the meter's recommended exposure by about two exposure steps.

If most of the subject occupies the image, so that little of the background is seen, you won't need to make an exposure compensation. For example, if you're shooting a head-and-shoulders portrait in front of a snow scene and the scene occupies only about 10% of the image area, little or no correction will be required.

Knowing precisely how much compensation is needed with different background tones and areas is a matter of experience and judgment. A reliable

alternative is to take a close-up reading of the main subject or bracket exposures, as explained later.

SKIN TONES

The reflectance of light skin is about 36%, a difference of one exposure step from 18% gray. If the meter reading is dominated by light skin, and you shoot at the recommended exposure, the skin tone will record near 18% gray in the image.

Theoretically, that is too dark, and correct exposure should require one more exposure step. In practice, this correction is rarely needed because most portraits are taken against darker rather than lighter backgrounds. The dark background causes the camera to give increased exposure.

METERING PATTERNS

Some exposure meters have greater sensitivity in one part of the image frame than in other parts. A "map" showing the area of increased sensitivity is called a *metering pattern*.

Full-Frame Averaging—The simplest metering pattern is no pattern at all. The light meter is equally sensitive at all parts of the image area and averages the result it reads.

When the camera was pointed at this scene, the meter "saw" a large dark area. Giving the exposure determined by the meter would have given an image in which the two faces in the foreground were too light. For correct exposure of the main subjects, exposure had to be decreased. Photo by Jack Dykinga.

The averaged amount of light from the entire scene is used to calculate exposure. A bright spot in the corner of the scene will have as much effect on the exposure meter as a bright spot in the middle of the frame.

Center-Weighted—Users of full-frame averaging meters may get unsatisfactory exposures under some common conditions. Typical conditions of this kind include bright and dark background, bright foreground—as on a sandy beach—and bright sky in a landscape.

To minimize this problem, a center-weighted metering pattern was developed. It is more sensitive to light in the center of the frame. In calculating exposure, more emphasis is given to the center of the frame.

Bottom-Weighted—A metering pattern that is bottom-weighted is similar to a center-weighted pattern, except that it is more sensitive to the foreground. The assumption is that sky background is the common problem and foregrounds are usually medium-toned anyway.

The meter is bottom-weighted only when you hold the camera with the long dimension of the frame horizontal. That's because it is assumed that most landscape photographs—with bright sky— will be shot horizontally.

If you turn the camera for a vertical-format picture, the pattern becomes left-weighted or right-weighted, depending on which way you turn the camera.

Spot Metering—Some cameras meter only a small spot at the center of the frame. The spot is sometimes the same diameter as the circular focusing aid, which gives you an indication of which part of the scene is being measured.

Multi-Pattern Metering—Some cameras offer a choice of patterns, such as center-weighted or spot, selectable by a switch.

Meter Interpretation—Even with center- and bottom-weighted metering patterns, you may still need to make exposure corrections for non-average scenes. It depends on how much background appears in the metering area, compared to the size of the subject. It also depends on whether you are holding the camera horizontally or vertically and how much bright sky is in the picture area.

Full-frame metering responds uniformly to light anywhere in the frame.

Center-weighted metering has maximum sensitivity in the center of the frame. Light farther away from the center has proportionately less effect on the meter reading.

Bottom-weighted metering responds predominantly to the middle and lower portion of the frame.

Spot metering is sensitive only to light in a small area at the center of the frame. The area is usually the same as the outer circle containing the focusing aids. Light outside that area does not affect the exposure meter.

Because the metering area is not precisely defined or marked in the viewfinder, you have to guess a little. Once familiar with their cameras, most people use these patterns effectively and without difficulty.

With spot metering, you generally don't have to worry about the background because it isn't included in the measurement. You simply measure the small area at which the spot is aimed.

Exposure Modes

This section describes exposure modes, including manual exposure control and several types of automatic exposure. In manufacturer's literature, AE is often used to mean *automatic exposure.*

A multi-mode camera has several exposure modes. You select one by a control on the camera. In each mode, the camera presents an exposure display in the viewfinder to guide you in setting controls or to show you the exposure settings made automatically by the camera.

The essential information that is always displayed is whether or not the film will be correctly exposed. Some cameras specifically warn of over- or underexposure. Useful information that is sometimes displayed includes aperture and shutter-speed settings and the exposure mode in use.

When electronic flash is used, most cameras display information about the flash such as when it is ready to fire and if the flash provided correct exposure after firing.

Types of Displays—Viewfinder information displays are usually electronic. One type is a light-emitting diode (LED), which glows when turned on. LEDs can be made to glow in one of a variety of colors.

LEDs are usually used as indicators. If an LED glows beside a printed shutter speed in the viewfinder, it is indicating that speed. Numbers and characters of the alphabet are not usually formed by LEDs.

Another display type is a liquid crystal diode (LCD), commonly used in digital wristwatches. These are used to form numbers, characters and symbols in a viewfinder display. LCDs do not glow. They must be illuminated by an external source to become visible.

Some cameras have an auxiliary information display on top of the camera body. These are LCD displays. They may show the film-speed setting of the camera, number of frames exposed, the operating mode, shutter speed, and other information.

MANUAL EXPOSURE CONTROL

The simplest and least expensive SLR cameras offer only manual exposure control. You set both aperture and shutter speed using the aperture ring on the lens and the shutter-speed dial on the camera. The exposure display shows if the controls are set to produce correct exposure.

To help you find correct exposure, there is an indication of one or two steps more exposure than the camera-recommended value, and one or two steps less. If the display shows too much exposure, use a smaller aperture or faster shutter speed. If it shows too

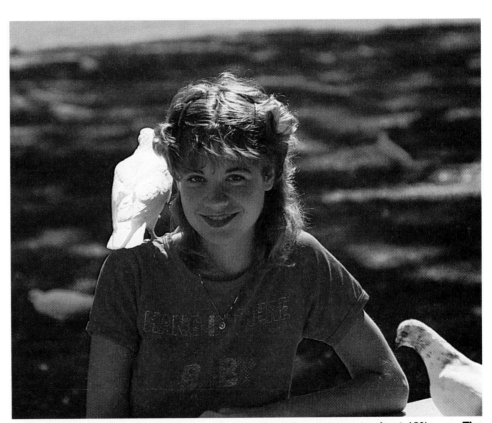

This Chinon CP6 camera allows you to choose a center-weighted metering pattern—labeled AVG—or spot metering. If the control is set between those two positions, the meter averages the center-weighted reading and the spot reading.

Although this is a high-contrast scene, its overall tonality averages to about 18% gray. The meter-indicated exposure was given. To check whether a contrasty scene is within the exposure range of the film, it's advisable to make close-up readings from the lightest and darkest parts that you want to record with detail.

little exposure, use a larger aperture or a slower shutter speed. This indicator is also helpful when you must correct exposure for non-average scenes.

Aperture or Shutter Priority— When using manual exposure control, you may wish to use a specific aperture setting so you control depth of field. If so, set the desired aperture first. Then turn the shutter-speed dial until correct exposure is indicated. That is called *aperture priority* because you choose aperture and then use whatever shutter speed is needed for correct exposure.

If you are photographing a moving object, you may wish to use a specific shutter speed, either to stop motion or to blur it deliberately. Set the shutter speed and then use whatever aperture size is needed for correct exposure. That is called *shutter priority*.

APERTURE-PRIORITY AUTOMATIC

To use a camera in the aperture-priority automatic mode, you set aperture manually. The camera then sets shutter speed *automatically* for correct exposure of an average scene. If you change aperture, the camera automatically changes shutter speed.

Exposure Display—The camera usually displays the camera-selected shutter speed. If you don't want to use that speed, change the aperture until the speed you want is displayed. Some models also display the selected aperture size.

A typical viewfinder display has a row of LED lamps along a scale of standard shutter speeds. One LED glows opposite the camera-selected shutter speed. If two adjacent LEDs glow, the shutter speed will be an intermediate value between the two indicated speeds.

There may be no available shutter speed to make a correct exposure using the aperture you selected. For example, if you chose a large aperture to shoot a scene in bright sunlight, the camera may not have a shutter speed that is fast enough. In that case, an overexposure indication appears in the viewfinder—usually above the fastest shutter speed.

Underexposure is shown by a symbol below the slowest shutter speed.

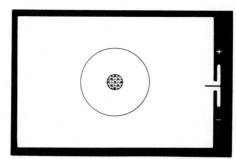

This is a *needle-centering* exposure display. It is used with manual exposure control. When you change either aperture or shutter speed, the needle moves to show the effect. When the needle is centered, exposure is correct for an average scene. It the needle is above center, overexposure is indicated. Below center means underexposure.

Advantages—For any scene, there is only one camera-recommended amount of exposure. If you set the controls manually according to the viewfinder display, or let the camera do it automatically, the exposure will be the same. The advantages of automation are speed and convenience.

SHUTTER-PRIORITY AUTOMATIC

You set shutter speed manually and the camera automatically sets aperture for correct exposure of an average scene. This is normally done by a mechanical connection between the camera body and the lens. If you

The Pentax A3000 camera offers aperture-priority automatic or a programmed automatic mode, discussed later in this chapter. The flash symbol at the top is used with electronic flash. The P symbol indicates that programmed auto has been selected. If the P does not glow, the camera is on aperture-priority automatic. You set aperture. The camera-selected shutter speed glows on the scale at left. Overexposure is indicated by a blinking 1000 numeral and by an audible beep. Exposures slower than 1/30 second are indicated by a blinking 30 numeral. Aperture is not displayed.

This manual-exposure camera shows the set aperture in a window above the frame. The set shutter speed is shown by a dial at right. One of the LEDs glows. The green dot means exposure is OK for an average scene. An adjacent red dot glows if exposure is a half-step over or under. The outside dots indicate over- or underexposure of a full step or more.

change shutter speed, the camera automatically changes aperture size.

Exposure Display—The viewfinder display shows the camera-selected aperture size. If you don't want to use that aperture, change the shutter speed until the aperture you want is displayed. Some models also display the selected shutter speed.

If there is no available aperture size to make a correct exposure at the selected shutter speed, an under- or overexposure signal appears. This is often done by blinking the displayed aperture value. If the *f*-number of the smallest aperture blinks, overexposure is indicated. Underexposure is shown

The Konica FT-1 offers shutter-priority automatic, plus manual. When set to manual, the M symbol blinks. On shutter-priority auto, you set shutter speed. One of the red LEDs glows to indicate the camera-selected aperture. Underexposure is indicated by blinking the unlabeled LED below the M symbol. Overexposure is indicated by blinking the 22 numeral. On manual, you set shutter speed. The viewfinder display shows the camera-recommended aperture. You set the aperture manually.

These photos were made with a camera on automatic exposure, using center-weighted metering. The sand on the beach was almost black. At left, the center-weighted meter "saw" mainly black sand. It increased exposure in an attempt to make the sand a medium tone. Everything in the photo is too light. When the foaming wave swept up on the beach, I shot again, allowing the camera to set exposure. The white water caused the camera to reduce exposure to make the *average* tone in the metering area middle gray. As a result, the scene recorded too dark in the right photo.

by blinking the *f*-number of the largest aperture.

Shift System—Some shutter-priority cameras are designed to get the picture if possible, even if it can't be done at the shutter speed you selected. If overexposure will result even after the camera has selected the smallest possible aperture, the camera will automatically "shift" to a faster shutter speed.

Overexposure will be indicated only if correct exposure cannot be made with the smallest aperture and the fastest shutter speed. In dim light, the camera will shift to slower shutter speeds, if that is necessary to get the picture.

In my opinion, this is a worthwhile feature. I use automatic modes mainly for speed in setting exposure. If I make

a control setting that won't work, it's helpful to have the camera set the nearest setting that will work.

PROGRAMMED AUTOMATIC

Some cameras set both aperture and shutter speed automatically, using a program built into the camera electronics. Figure 4-1 shows a typical program.

The typical viewfinder display shows both aperture and shutter speed. Over- and underexposure are indicated by blinking the display or by special symbols.

Disadvantage—Programmed exposure makes SLR cameras simpler to use, but it has some limitations. With programmed automatic, you must use whatever aperture size and shutter speed the program calls for. There-

fore, you have little control of depth of field or image blur.

Multiple Programs—To reduce the limitations just indicated, some program cameras have more than one program. Three programs are common, as shown in Figure 4-2. One is a "standard" program, similar to that shown in Figure 4-1. Another is intended to minimize image blur by using faster shutter speeds and larger apertures than the standard program. The third is intended to increase depth of field by using smaller apertures and slower shutter speeds than the standard program.

All exposure programs are compromises. If you want maximum control of depth of field or image blur, I suggest not using programmed automatic.

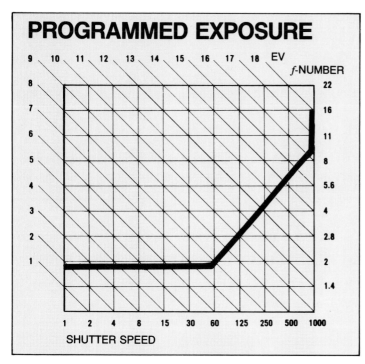

PROGRAMMED EXPOSURE

Figure 4-1/This is a graph of the Olympus OM-PC programmed automatic mode using an *f*-1.8 lens and ISO 100/21° film. The camera sets both aperture and shutter speed automatically. The top right end of the graph represents very bright illumination. The camera uses the fastest shutter speed and the smallest lens aperture. As the light becomes less bright, aperture is gradually opened, but shutter speed remains at 1/1000 second. When aperture has opened to about *f*-10, the program begins to gradually change both aperture and shutter speed in response to reduced scene brightness. At maximum aperture of *f*-1.8, shutter speed is 1/60 second. If the scene becomes still darker, the lens remains at maximum aperture but shutter speed becomes slower. Notice that this program exhibits no "preference" between shutter speed and aperture. It yields one step in aperture for each step in shutter speed.

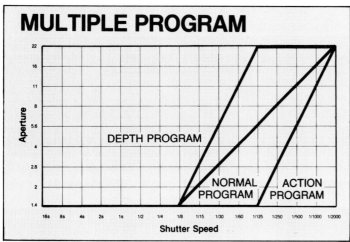

MULTIPLE PROGRAM

Figure 4-2/Some cameras offer more than one program to allow more control of image blur or depth of field. This graph shows the three programs available in the Ricoh XR-P. The Normal Program changes aperture one step for each step of shutter speed. The Depth Program favors depth of field. As the scene becomes darker, it remains at *f*-22 until shutter speed drops to 1/125 second. Then, it yields two steps of aperture for each step in shutter speed. The Action Program tends to reduce image blur of moving subjects by using faster shutter speeds than the Normal or Depth programs.

FLASH AUTOMATION

In addition to the modes just discussed, most cameras have automatic features when used with companion flash units. These are discussed in Chapter 6.

Light Sensor Location and Operation

In this section, I discuss the location in the camera of exposure-meters sensors and how they do their job. A wide, and sometimes confusing, array of camera designs and capabilities is available. After you have read this section, you should be able to figure out

how your camera's metering system works. If you are buying a camera, this section will help you select one with features that you want.

SENSOR IN VIEWFINDER

One location for the light sensor is in the viewfinder housing, above the focusing screen. The sensor looks down at the image on the focusing screen and measures image brightness, using one of the metering patterns discussed earlier.

The sensor measures light *after* it has passed through the focusing screen. If the camera uses interchange-

able focusing screens, they must all transmit the same amount of light to the sensor. Otherwise, exposure of the same scene would be different with different screens. This limits the range of focusing-screen designs that can be used.

It's possible to use focusing screens that transmit different amounts of light and correct the exposure, depending on the screen used. However, this is inconvenient.

Another disadvantage of placing the light sensor in the viewfinder is that metering must be done before the actual exposure. The camera "remembers"

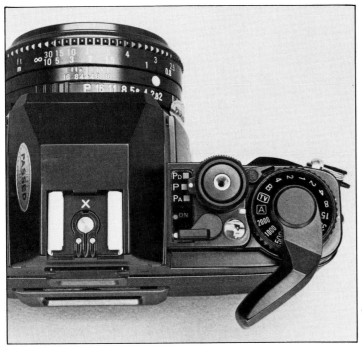

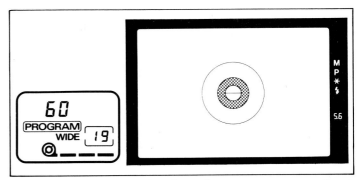

Some cameras with several modes and programs use conventional displays in the viewfinder, such as a row of LCDs. There is a trend to simplify the viewfinder display and provide additional information in a separate display. The Canon T70 has an LCD display on top of the camera, shown at left. It shows shutter speed, the fact that a program for wide-angle lenses is in use—favoring depth of field. There is film in the camera and the next frame is number 19. The simplified viewfinder display, right, shows M on manual and P on programmed automatic. The asterisk relates to the metering mode and the lightning symbol indicates flash. On programmed automatic, the aperture value is displayed.

This Ricoh XR-P has several modes and programs. To set the lens so aperture can be controlled automatically by the camera, turn the aperture ring to P. That sets the lens at minimum aperture, which allows the camera to use the full range of aperture values. To prepare the camera to set exposure automatically, turn the shutter-speed dial to A.

Programmed Automatic—Set the lens to P and the shutter-speed dial to A. Choose one of the three programs by rotating the program-selector ring surrounding the shutter button. The camera sets both aperture and shutter speed according to the selected program.

Shutter-Bias Programmed Auto—In any of the program modes, you can set a lower limit to shutter speed. Change the shutter-speed dial to a numbered speed, rather than A. The program will normally use that or a faster speed. If a slower speed is necessary, the camera will use it and blink a warning in the viewfinder.

Aperture-Priority Automatic—Set the shutter-speed dial to A. Set the desired aperture on the lens. The camera sets shutter speed automatically.

Manual—Set aperture to the desired value. Set shutter-speed to a numbered value. The viewfinder display shows both the set shutter speed and the camera-recommended shutter speed for that aperture.

TV Mode—To photograph TV or computer screens with automatic exposure control, set the lens to P. Set the shutter-speed dial to TV. Shutter speed depends on the setting of the program-selector. At PD it is 1/25 second, for European TV. At P, it is 1/30 second, for USA and Japan. At PA it is 1/4 second, for computer screens.

the exposure setting. When the mirror moves up, light to the viewfinder is blocked and the exposure meter can no longer operate.

SENSOR IN CAMERA BODY

Another location for the light sensor is below the mirror. The sensor looks toward the film. It measures light reflected from the emulsion surface of the film *during* exposure. The metering pattern is provided by a small lens in front of the sensor. Any metering pattern may be used.

This is a convenient way to control exposure automatically. When the light sensor has measured enough light for correct exposure, the camera closes the shutter.

A major advantage of this method is to control exposure automatically with electronic flash. When sufficient exposure has been measured, the camera turns off the flash. The sensor mea-

sures both light from the flash and ambient or continuous light on the scene. Control of flash exposure using a light sensor in the camera is called *Through The Lens (TTL) Auto Flash.*

Another advantage of measuring the light falling on the film during exposure is that automatic compensation for light variations during exposure is made.

Dual Sensors—With a conventional one-piece mirror, a light sensor in the camera body cannot meter when the mirror is down because the light coming through the lens is reflected up into the viewfinder.

To know how to set the exposure controls manually or what settings the camera will use automatically, you must meter before exposure.

One way to provide metering before *and* during exposure is to use two sensors. One is in the viewfinder for use before the shutter opens. The other is in the camera body to control exposure after the shutter opens.

Some cameras use a viewfinder sensor to set exposure with continuous light and a camera-body sensor to control exposure with flash only.

Some cameras use a viewfinder sensor to give a "preview" exposure indication with continuous light. Actual exposure is controlled by a sensor in the camera body—and it may be slightly different. The camera-body

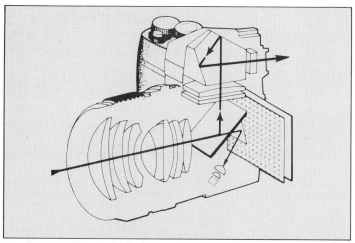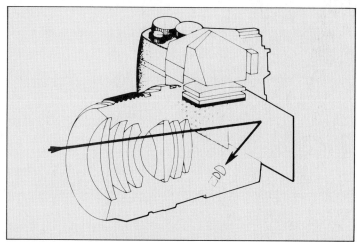

The Pentax LX has a single sensor in the bottom of the camera to measure light both before and during exposure. In the drawing at left, the main mirror is down and an auxiliary mirror is in position behind it. About 15% of the light passes through a semitransparent area at the center of the main mirror and is reflected to the sensor by the auxiliary mirror. When the main mirror moves up, the auxiliary mirror folds up also. In an automatic-exposure mode, light reflected from the film surface is measured by the light sensor. When sufficient light has been measured, the shutter closes. The light sensor is also used to control exposure with flash.

sensor will also control electronic flash.

Auxiliary Mirror—Some cameras with a light sensor in the camera body avoid the need for another sensor in the viewfinder by using a special mirror arrangement.

The main mirror has a semi-transparent section in the center. When this mirror is down for viewing, a small amount of light passes through the central area. A secondary, or auxiliary, mirror is behind the main mirror. It reflects light downward into a sensor at the bottom of the camera body. That's the only sensor in the camera.

Before exposure, the sensor measures light passing through the center of the main mirror. When the mirrors move up, the auxiliary mirror folds up against the bottom of the main mirror. Then, the shutter opens and the light sensor measures light reflected from the film emulsion.

The light sensor provides *preview metering* before exposure and then *controls exposure,* with continuous light or flash. The center of the image seen through the viewfinder may appear slightly darker than the rest of the image because of the light lost to the exposure meter.

Patterned Shutter Curtain— When a sensor in the camera body is used to control exposure with *continuous* light, the front of the first shutter curtain is given a reflective pattern having about the same reflectivity as the emulsion surface of film.

The exposure interval begins and the meter is turned on when the first curtain starts to move. Therefore, the sensor measures light reflected by the front of the first curtain while it is opening.

If the sensor is used only to control flash exposure, a patterned curtain is not necessary because the flash doesn't fire until the first curtain is fully open.

FILMS YOU CAN USE

With a light sensor in the viewfinder, you can use any film. Measuring exposure with a sensor in the camera body also works with *most* films because the emulsion surfaces of most general-purpose films have about the same reflectivity.

However, some special-purpose films have a different reflectivity. In such cases, exposure correction may be necessary. Polaroid instant slide films are one example. To find out what the required adjustment is, you may need to make some test shots.

OPEN-APERTURE METERING

No matter what metering system the

camera uses, metering before exposure is normally done at the maximum aperture of the lens. The reason is to provide the brightest possible image on the focusing screen.

The camera calculates exposure settings based on the aperture that will be used to make the picture and displays these settings. It also uses those settings for automatic exposure unless control is handed over to a sensor in the camera body.

The exposure calculator must "know" what aperture will actually be used to make the exposure—the "shooting" aperture—so it can adjust the light measurement made at open aperture.

If you set aperture manually, a lever on the back of the lens tells the camera what aperture has been set. If the camera sets aperture automatically, then it already knows what aperture will be used.

STOP-DOWN METERING

A few special lenses require metering at the shooting aperture. This is called *stop-down* metering. Some equipment used for high magnification requires metering stopped down, as discussed in Chapter 8.

Some cameras have special control settings for stop-down metering. Some

do it automatically when needed. The camera instruction manual should show how to meter stopped down.

METERING RANGE

Exposure meters have a range over which they measure accurately. If the light is too dim or too bright, the measurement and subsequent exposure recommendations may not be correct. A few cameras have viewfinder warnings to tell you if the light is outside the meter's brightness range.

If a camera sets exposure automatically, then the metering range is also the range over which the automatic-exposure system can operate.

For some cameras, the metering range is indicated only in the printed camera specifications. It is stated by Exposure Value (EV) numbers, described next.

EV NUMBERS

The same exposure can result from several combinations of aperture and shutter speed. For example, 1/125 second at f-4 is the same exposure as 1/250 second at f-2.8, which is one step larger aperture and one step faster shutter speed.

Each exposure step has an EV number. All pairs of shutter-speed and aperture settings that produce the same amount of exposure have the same EV number.

In the accompanying EV table, EV numbers are at the left, shutter speeds at the top, and f-numbers in the body of the table. Read horizontally across the table from any EV number, such as EV 3. The f-numbers with the shutter speeds directly above all provide the same exposure. EV 0 is equivalent to 1 second at f-1.

Using EV Numbers to Measure Light—When EV numbers are used to express the range of an exposure meter, the intent is to specify the scene brightness range over which the meter is accurate. That requires some assumptions.

The assumptions are that light from the scene correctly exposes ISO 100/21° film through an f-1.4 lens that is wide open.

With those assumptions, an EV scale becomes a brightness scale. A typical exposure-meter range is EV 1 to EV 18. EV 1 is dark and EV 18 is bright. A very wide range is EV -6 to EV 20.

To see how dark EV 1 is, set your camera film-speed dial to 100 and use an f-1.4 lens, wide open. Find lighting that's dark enough to make the camera exposure display show correct expo-

EV NUMBERS & EQUIVALENT EXPOSURE SETTINGS																				
EV	4 min.	2 min.	1 min.	30 sec.	15	8	4	2	1	1/2	1/4	1/8	1/15	1/30	1/60	1/125	1/250	1/500	1/1000	1/2000
-8	f-1																			
-7	1.4	f-1																		
-6	2	1.4	f-1																	
-5	2.8	2	1.4	f-1																
-4	4	2.8	2	1.4	f-1															
-3	5.6	4	2.8	2	1.4	f-1														
-2	8	5.6	4	2.8	2	1.4	f-1													
-1	11	8	5.6	4	2.8	2	1.4	f-1												
0	16	11	8	5.6	4	2.8	2	1.4	f-1											
1	22	16	11	8	5.6	4	2.8	2	1.4	f-1										
2	32	22	16	11	8	5.6	4	2.8	2	1.4	f-1									
3	45	32	22	16	11	8	5.6	4	2.8	2	1.4	f-1								
4	64	45	32	22	16	11	8	5.6	4	2.8	2	1.4	f-1							
5		64	45	32	22	16	11	8	5.6	4	2.8	2	1.4	f-1						
6			64	45	32	22	16	11	8	5.6	4	2.8	2	1.4	f-1					
7				64	45	32	22	16	11	8	5.6	4	2.8	2	1.4	f-1				
8					64	45	32	22	16	11	8	5.6	4	2.8	2	1.4	f-1			
9						64	45	32	22	16	11	8	5.6	4	2.8	2	1.4	f-1		
10							64	45	32	22	16	11	8	5.6	4	2.8	2	1.4	f-1	
11								64	45	32	22	16	11	8	5.6	4	2.8	2	1.4	f-1
12									64	45	32	22	16	11	8	5.6	4	2.8	2	1.4
13										64	45	32	22	16	11	8	5.6	4	2.8	2
14											64	45	32	22	16	11	8	5.6	4	2.8
15												64	45	32	22	16	11	8	5.6	4
16													64	45	32	22	16	11	8	5.6
17														64	45	32	22	16	11	8
18															64	45	32	22	16	11
19																64	45	32	22	16
20																	64	45	32	22
21																		64	45	32

sure at 1 second at *f*-1.4. That is an EV 1 light level.

Automatic Operating Range—Because an automatic camera can't work when the exposure meter is inaccurate, EV numbers are also used to state the operating range of the camera. Camera makers show a graph in the instruction booklet, called *meter coupling range* or some similar name.

The graph tends to be confusing. The problem is that not all lenses are *f*-1.4 and not all films are ISO 100/21°. The graph attempts to show camera operating ranges with various lenses and film speeds. Don't worry too much about the graphs. the basic fact is that an automatic camera will operate within a certain range and not beyond.

Overexposure or Out of Range?—If you get a warning signal in the viewfinder, it may mean that the exposure setting is incorrect or that the light level is beyond the camera's metering range. If you see an exposure warning, you should change one or both of the exposure controls to find settings that will not indicate overexposure. If that works, the problem did not lie with the exposure meter's range.

If no exposure-control settings stop the warning signal, the combination of film-speed setting and light from the scene is out of the metering range of the camera.

Exposure Correction

You may wish to correct exposure for a non-average scene or to compensate for reciprocity failure. Or, you may wish to give more or less exposure to a scene for artistic effect.

ON MANUAL

The viewfinder exposure display is just a guide. If the scene is average, the camera-recommended exposure is probably correct. However, you can use any settings you want to achieve the desired effect.

To compensate for a non-average scene, use more or less exposure. If you want two steps more, set the controls to agree with the camera-recommended exposure and then open the aperture two steps. Or, use a two-step slower shutter speed.

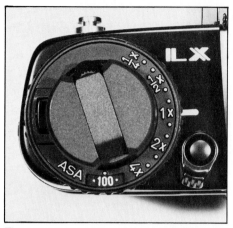

The exposure-compensation control is used to give more or less exposure than an automatic-exposure camera would normally use.

ON AUTOMATIC

In any automatic mode, the camera will use the metered exposure as displayed in the viewfinder. If you want more or less exposure, there are several methods for achieving this.

Change Film-Speed Setting—If you are using 200-speed film but set the film-speed dial to 100, that tells the camera to give the film one step more exposure. Don't forget to restore the correct film-speed setting afterward!

Exposure-Compensation Dial—Most automatic cameras have an exposure-compensation dial that you can use to temporarily get more or less exposure than the meter requests. This control is linked mechanically with the film-speed dial. What it does is change the film-speed setting inside the camera, without actually changing the film-speed dial.

RULES FOR SUBSTITUTE METERING	
Meter on an 18% reflectance surface	Follow exposure meter recommendation
Meter on a *brighter* surface	Use *more* exposure.
Meter on a *darker* surface	Use *less* exposure
Meter on white	Use 5 times as much exposure
Meter on black	Divide recommended exposure by 5
Meter on light skin	One step more exposure

The control has a scale, normally with a range of plus or minus two exposure steps. The plus direction gives more exposure. The scale may be labeled in exposure steps, like this:

−2 • • −1 • • 0 • • +1 • • +2

The dots on that scale are intermediate settings. Because the intermediate film-speed settings are one-third steps, the intermediate settings on the exposure-compensation scale are usually also one-third steps. On some cameras, however, they are half steps. Other cameras use ratios on the scale, like this:

1/4 • • 1/2 • • 1 • • 2 • • 4

The 1/4 symbol means 1/4 as much exposure as requested by the meter—or two steps less.

When you no longer need exposure compensation, return the control to its normal setting at the center of the scale. Some cameras have a reminder symbol that appears in the viewfinder when you are using exposure compensation.

Exposure-Compensation Button—Some cameras have a button that gives 1-1/2 or 2 steps more exposure to correct for bright backgrounds. It is sometimes called a *backlight button*.

Some cameras have both an exposure-compensation dial with a range of +2 to −2 steps and a button.

AUTOMATIC BACKGROUND COMPENSATION

To make photography easier for people who don't want to think about it, some cameras have metering systems designed to compensate automatically for non-average scenes.

Such systems divide the frame into several areas and measure the brightness of each area. The brightnesses are analyzed electronically in the camera. The camera decides how much exposure correction is required and automatically applies that correction.

Photographers who prefer to remain in control of exposure can turn off the automatic background correction system.

SUBSTITUTE METERING

This is a very handy way to set exposure for virtually any scene, average or

The upper-left photo was made with an automatic camera, using the metered exposure. For the upper-right picture, the exposure-compensation dial was set for one step more exposure. At left, the dial was set for two steps more exposure.

not. If a scene has an area with 18% reflectance and you meter on that area, exposure will be correct. If the scene doesn't have such an area, put an 18% gray card in the scene so it receives the same illumination as the scene. Arrange it so surface reflections from the card don't enter the lens. Meter the card.

On manual, set the exposure controls for correct exposure. If you take that picture, the gray card will be correctly placed on the film characteristic curve. Most lighter and darker tones will also be placed correctly. You'll get a good exposure, unless the brightness range of the scene exceeds the capability of the film.

Remember to remove the card from the picture area before you actually make the exposure.

If the scene is distant and you can't get close to it, simply hold the gray card in the same light that illuminates the scene. Meter the card and shoot at that exposure. You are using the gray card as a *substitute* for a similar, medium tone in the scene.

The substitute metering surface can be in the scene or out of it, as long as it is in the same light as the scene. If you don't have a gray card, nature provides many medium-toned surfaces that are about as good. Grass, green vegetation, brown weeds and dirt, old gray asphalt paving and many other surfaces have about 18% reflectance.

The reverse side of the 18% gray cards available from photo stores is usually white, with a reflectance of about 90%. That's five times as much as 18%. White paper has about the same reflectance. If you take a meter reading from white, give five times as much exposure as indicated—an increase of about 2-1/3 steps.

Exposure Lock Button—You can do substitute metering with the camera on automatic. However, when you move the camera away from the substitute surface to frame and compose the scene, the exposure will change if the scene is not average.

There are two ways to prevent the exposure from changing. Most automatic cameras have a button that locks in an exposure measurement. It is called an *Exposure Lock Button* or *AE Lock Button*. Meter on the substitute surface and press the lock button. Hold the lock button depressed while you compose the scene and press the shutter button. The exposure setting for the scene will be the same as for the substitute surface.

If the camera doesn't have an exposure lock button, notice the exposure display while you are metering the substitute surface. Then compose and meter the scene. If the exposure is not the same, change the exposure-compensation control or the film-speed dial to make the exposure the same as for the substitute surface. Make the shot. Don't forget to reset the exposure-compensation control or film-speed dial when you've finished.

SUNNY-DAY *f*-16 RULE

For an average scene in direct sun-

I made this photo using substitute metering. I metered exposure from the sunlit foreground area and locked the setting using the exposure-lock button. Then, I composed the scene through the ramada and shot at the locked-in exposure.

light, good exposure will be produced by an aperture of *f*-16 and a shutter speed that is the reciprocal of ASA/ISO film speed. That is, if film speed is 500, shutter speed should be 1/500. Of course, that amount of exposure with different control settings will also be OK, such as 1/1000 second at *f*-11.

Selecting Film Speed—When shooting outdoors, where you don't have much control over the light, that rule can help you choose film speed. Film for ordinary use is made in a wide range of speeds—from 25 up to 1000 and faster. Fast films are intended to be used in dim light.

If you have film with a speed-rating of 1000 in your camera, and step outdoors on a sunny day, *f*-16 at 1/1000 second should produce a good exposure. Some lenses have a minimum aperture of *f*-16. On many cameras, the fastest shutter speed is 1/1000 second. If your camera has that combination, you can set exposure only that one way. Because you have to use *f*-16, your picture will have great depth of field.

A film speed of 100, 200 or 400 is a better choice for use outdoors. It gives you the flexibility to use a range of aperture sizes to control depth of field and a range of shutter speeds to control image blur.

As faster film speeds became available, lenses were produced with smaller minimum apertures, such as *f*-22 instead of *f*-16. New cameras were offered with faster shutter speeds, such as 1/2000 second or 1/4000 second.

EXPOSING FOR SHADOW OR HIGHLIGHT DETAIL

If a scene is partly sunlit and partly in shadow, the brightness range may be too wide for the film. With negative films, it's generally more important to preserve detail in the shadow areas. Take your meter reading from a medium tone in such an area.

With color slide film, correct exposure in the highlight areas is generally more important. Therefore, you should take your meter reading from a medium tone in a bright area.

AVERAGING READINGS

If a scene has light and dark tones, but no medium tones, you can often get a good exposure by averaging readings. Meter the lightest tone and the darkest tone. Count the exposure steps and shoot halfway in between.

Some cameras have a mode that averages meter readings automatically. For example, two or more spot readings are averaged and exposure made at that setting.

	APPROXIMATE EXPOSURE FOR NIGHT SCENES (BRACKETING RECOMMENDED)					
SUBJECT	**ASA FILM SPEED**					
	25-32	**50-64**	**100-125**	**160-200**	**320-500**	**800-1200**
Interiors with enough light to read by	EV 5	EV 6	EV 7	EV 8	EV 9	EV 10
Faces in candlelight	EV 2	EV 3	EV 4	EV 5	EV 6	EV 7
Group around campfire	EV 5	EV 6	EV 7	EV 8	EV 9	EV 10
Night sports events	EV 6	EV 7	EV 8	EV 9	EV 10	EV 11
Subject in arc-type spotlight	EV 8	EV 9	EV 10	EV 11	EV 12	EV 13
Stage shows	EV 7	EV 8	EV 9	EV 10	EV 11	EV 12
Brightly lit streets	EV 6	EV 7	EV 8	EV 9	EV 10	EV 11
Floodlit buildings	EV 3	EV 4	EV 5	EV 6	EV 7	EV 8
Electric signs	EV 8	EV 9	EV 10	EV 11	EV 12	EV 13
Christmas lights	EV 3	EV 4	EV 5	EV 6	EV 7	EV 8
Full moon, clear sky	EV 13	EV 14	EV 15	EV 16	EV 17	EV 18
3/4 moon, clear sky	EV 12	EV 13	EV 14	EV 15	EV 16	EV 17
1/4 moon, clear sky	EV 11	EV 12	EV 13	EV 14	EV 15	EV 16
Crescent moon, clear sky	EV 10	EV 11	EV 12	EV 13	EV 14	EV 15
Moon in total eclipse	EV 0	EV 1	EV 2	EV 3	EV 4	EV 5
Subject illuminated by full moon high in clear sky	EV -6	EV -5	EV -4	EV -3	EV -2	EV -1
Sky at sunset	EV 11	EV 12	EV 13	EV 14	EV 15	EV 16
Sky immediately after sunset	EV 8	EV 9	EV 10	EV 11	EV 12	EV 13
Aurora Borealis	EV -7	EV -6	EV -5	EV -4	EV -3	EV -2

Bracketing sometimes results in more than one acceptable exposure, each with a different mood or feeling, as this pair of photos shows.

BRACKETING

A good way to improve the odds of getting a good shot is to shoot at several exposure settings, centered on the exposure you think is correct. That is called *bracketing*. Virtually all good photographers bracket and then throw away the bad exposures. It may sound wasteful, but if it ensures good pictures it's well worth it.

With negative film, bracketing is usually done in full exposure steps above and below the central value. With color slide film, bracketing in half steps is recommended.

On manual, you can change aperture in half steps or shutter speed in full steps. On automatic, use the exposure-compensation dial, if the camera has one. Otherwise, change film speed. Both of these controls usually have increments of 1/3 step.

Double and Multiple Exposures

You can use cameras with a manual film-advance lever to make more than one exposure on the same frame, as explained a little later. Cameras with a built-in motor to advance the film, and no manual lever, may not have that capability.

Non-overlapping Subjects—If you photograph a subject against a *dark* background with normal exposure, the film frame can be considered as two distinct areas. The area of the subject is normally exposed while the dark background is virtually unexposed.

You can then shoot a second subject on the same frame, against the same dark background. Its exposure can be normal, too, *provided* the areas on the film occupied by the two subjects do not overlap.

Now the film frame can be considered as three areas. One for each subject and some still unexposed or underexposed background. Obviously, you could place a third subject in the unused dark background area and give normal exposure to the third subject.

The rule for multiple exposures against a *dark* background where the subjects *do not overlap* is to give normal exposure to each shot. However, the background must be dark enough to be able to stand two or more exposures without recording on the film.

Overlapping Subjects—When subjects overlap, the situation is different. Normal exposure of two subjects occupying the *same* area on film amounts to twice as much exposure as that area needs—one step too much. Three overlapping exposures give three times as much total exposure as the film needs, and so forth.

With overlapping subjects, the rule is to give the correct *total* amount of exposure to the film, allowing each individual shot to contribute only a part of the total. If there are two overlapping images, each should receive one-half the normal exposure. Three overlapping images should each receive one-third the normal exposure, and so forth.

This procedure tends to give normal exposure to the *combined* images on the film. However, parts of each image that do not overlap another will be less bright. The more exposures are added together, the less bright the non-overlapping parts will be. If you make more than three exposures, each individual image will be pretty dim, but the result is often very effective. Even though the background is dark, it will get lighter and lighter with successive exposures.

RULES FOR MULTIPLE EXPOSURES

Here are basic rules for making effective multiple exposures:
- Dark, uncluttered backgrounds are preferable.
- The background gets lighter with each exposure.
- If there is no image overlap, give normal exposure to each shot.
- If there is image overlap, divide the normal exposure for each shot by the total number of shots to be made.

70

This is the result of a simple, but effective, double exposure. I made one shot of the lens and another of the box it came in—which was *not* transparent!

Photography at night often involves unusual lighting, where exposure is difficult to measure or estimate. If you bracket liberally, you can get some dramatic shots, such as the one of this floodlit oil-drilling rig.

- A handy way to adjust exposure is to multiply film speed by the planned number of shots and set the nearest available speed on the camera dial. Then use the camera normally for each shot. Don't forget to reset film speed when you've finished.
- You can also adjust exposure by changing shutter speed or aperture.

CAMERA OPERATION FOR MULTIPLE EXPOSURES

Cameras prevent accidental double exposures by a mechanical interlock. It forces you to advance the film before each shutter operation.

The procedure for deliberately making double or multiple exposures varies among cameras. Some have a special control for that purpose. If you are shopping for a camera and are particularly interested in making multiple exposures, buy one with a multiple-exposure control.

The Easy Way—If your camera has a control—usually a lever—that allows multiple exposures to be made, the job is an easy one. Operate the control each time and shoot as many times as you want on the same frame. The control allows you to operate the film-advance lever to prepare the camera for the next shot *without advancing the film.*

Three-Finger Method—This method can be used on most cameras that don't have a control for making multiple exposures:

Tension the film by turning the rewind knob clockwise until *very slight* resistance if felt. Grip the camera so you have a finger free to hold the rewind knob in this position. Don't let it move until you have completed the procedure.

Press the film-rewind button with another finger and hold it in the rewind position. Operate the film-advance lever as though you were advancing the next frame. Because the film-rewind button is held, the film does not actually move in the camera—at least not very much. Your next shot will be on the same frame. Practice this procedure a couple of times without film in the camera because, at first, you may run short of fingers.

How to Check Film Registration—With the three-finger method just described, the film may move just a little bit. You can check your technique in this way: Remove the lens. Set the shutter-speed dial on B. Depress the shutter button and hold it to keep the shutter open. Use a pencil to mark a rectangle on the film. Close the shutter. Do the double-exposure trick with your fingers. Open the shutter again. Look for the rectangle you marked with pencil. You'll see if it moved.

Blank-Frame Insurance—Because the film may move during multiple exposures made by the three-finger method, multiple exposures may overlap the preceding frame or the one following. If you plan the multiple exposure in advance, shoot a blank frame before and after. If you do it on impulse, at least shoot a blank frame after.

Some cameras surprise you by not advancing the film when you operate the fim-advance lever after completing the multiple exposure. The rewind button remains depressed until *after* you operate the film-advance lever, forcing you to make one more exposure even though you don't want to. Make it with the lens cap on and no harm is done.

Cameras with a special multiple-exposure control normally make multiple exposures without film slippage, so blank frames before and after are not necessary.

FRAME COUNTER AND MULTIPLE EXPOSURES

If your camera is equipped with a special multiple-exposure control, it may be built so the frame counter does not advance when making multiple exposures. You can make several shots on frame 7 and the counter will not change to 8 until you actually advance the film.

Cameras using the multiple-exposure procedure involving the rewind button usually count strokes of the film-advance lever rather than actual movement of the film. If you make three shots on frame 7, the frame counter will count 7, 8, 9, and then move to frame 10 when frame 8 is ready to be exposed. This is not a major inconvenience when you know about it. Watch the frame counter while making a double exposure and you will see what it does.

End of the Roll—If the camera disengages the frame counter during multiple exposures, it maintains the correct frame count all the way to the end of the roll.

If it counts film-advance-lever strokes, the frame count will be wrong after the first multiple exposure on the roll. If you make several mutiple exposures, it may take 40 or more strokes of the film-advance lever to expose a 36-exposure roll of film.

The frame counter usually has a slip clutch. It will count to 36 or a little higher and then stop counting. You can still advance film until you reach the end of the roll and feel resistance at the film-advance lever. Then rewind.

You can take dramatic lightning pictures at night. When there's a storm, set your camera up on a tripod and aim the camera at that part of the sky where lightning seems to be most frequent. If you use a film of ISO 64/19° speed, with the lens aperture set to *f*-8 or *f*-11, you can leave the camera shutter open for four or five minutes, provided you're in a really dark area. During that time, you may be lucky enough to capture several lightning bolts on the one film frame. A word of warning: For the safety of both you and your camera, shoot from a safe location, under cover. Photo by Thomas Ives.

When you're photographing action, it's often most effective to show some of that action as a blur. To capture this dramatic shot of a vital moment in a relay race, the photographer used a 1/60 second shutter speed and panned the camera with the runners. The blurred background and the "moving" feet help to make a dramatic action picture. Incidentally, if you look at the shadows on the ground, you'll see that both runners were in midair the moment the picture was made! Photo by Jack Dykinga.

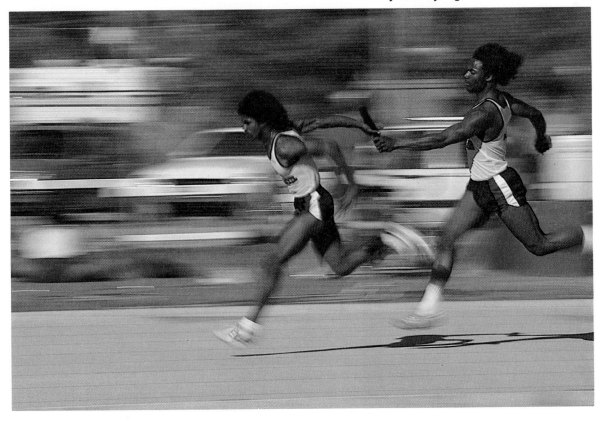

5
Light and Color

White light contains all the colors of the spectrum. When white light passes through a prism, component colors are separated, as shown here. Different light sources contain different amounts of individual colors. For example, average daylight contains more blue than tungsten light. These differences are important in color-film and filter selection. Photo by Ted DiSante.

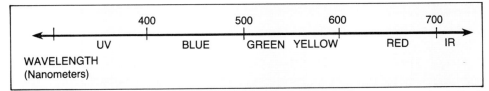

Different colors of light have different wavelengths, measured in *nanometers (nm)*. Each nanometer is one-billionth of a meter. The visible spectrum extends from about 400nm (blue) to about 700nm (red).

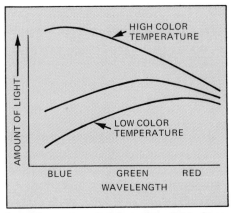

Incandescent materials radiate light. At relatively low temperatures, the light is predominately red. At high temperatures, it is predominately blue.

Because photography is a graphic medium that is dependent on light, it has been called *painting with light*. In this chapter, I'll discuss light, its colors and its control.

We can think of light as traveling in *rays* or *waves*. Lenses are easier to understand by using the concept of light *rays*, which normally travel in straight lines. Colors are easier to understand if light is considered as a *wave* motion similar to waves on water. Each of these representations is valid for its own purposes.

THE SPECTRUM

The range of colors visible to the human eye is called the *spectrum*. Different wavelengths of light produce different color sensations, as shown in the accompanying chart. Light wavelengths are very short. They are measured in *nanometers (nm)*, each of which is equal to one billionth of a meter.

Visible wavelengths range from about 700nm for red light to about 400nm for blue light. Wavelengths longer than about 700nm are called *infrared (IR)* and are not visible. They can be felt as heat. Special infrared-sensitive films respond to these wavelengths.

Wavelengths shorter than about 400nm are called *ultraviolet (UV)* and are not visible. All commonly available films are inherently sensitive to UV.

Sunlight—Sunlight is composed of all colors of the visible spectrum—plus IR and UV. It is called *white light*. A rainbow separates and displays the visible colors that compose sunlight. If you look at a brilliant rainbow, you see the color spectrum.

COLOR TEMPERATURE

When some materials are heated beyond a certain temperature, they become *incandescent*, which means that they radiate light. When heated just to incandescence, such objects radiate mainly red light. The burners on an electric stove are an example. If the temperature is increased, additional shorter wavelengths are produced. If the temperature is the same as the sun, all colors in the spectrum are produced and the light appears white—just like sunlight.

We use the temperature of a radiant object to specify the color of light that it radiates. When so used, it is called *color temperature* and is stated using the *absolute* temperature scale—*degrees Kelvin (K)*.

The color temperature of the sun is about 5000K. Lower color temperatures contain relatively more red. For example, candlelight has a color temperature of about 1800K. Higher color temperatures are more bluish. The color temperature of light from a clear blue sky can be 12,000K and higher. Of course, that doesn't mean that the sky is *hot*. It simply means that light from blue sky has the same color as an object heated to 12,000K.

A table of color temperatures of a variety of light sources is in Chapter 7.

Photographic Daylight—On a clear day, objects illuminated by sunlight also receive light from the sky. The combined illumination is more blue than sunlight alone. Standard photographic daylight—a combination of direct sunlight and skylight—is defined as having a color temperature of 5500K.

Tungsten Light—Household incandescent lamps, usually called light bulbs, have tungsten filaments that glow when heated. Light from any lamp with a glowing tungsten filament is called *tungsten light*.

The temperature of a tungsten filament is lower than that of the sun and the light is more reddish. The color temperature of household tungsten lamps ranges from 2500K to 3000K, depending on the wattage rating of the lamp.

There are two standard tungsten color temperatures for photographic lamps: 3200K and 3400K. Photo lamps and tungsten studio lights are designed to have one or the other of those temperatures.

CONTINUOUS SPECTRUM

All incandescent light sources radiate a *continuous spectrum*. This means that light of all colors is present, although one may be dominant. The accompanying graphs show that light of low color temperature is predominantly reddish but has some of all colors of the spectrum. Light of high color temperature is predominantly bluish but also has some of all other visible colors.

All general-purpose color films are designed to work best with light that has a continuous spectrum.

Illumination of public places often includes fluorescent lamps and high-intensity mercury and sodium lamps. These light sources do not have a full color spectrum. Although their light may appear acceptable to the eye, it usually causes a color imbalance on film. The green imbalance shown here can be reduced or removed with filters. For more details, see chapter 7.

This photo was made in daylight on a color slide film balanced for tungsten light. That's why the image is excessively blue. The cure is to use a daylight-balanced film or use a warming correction filter.

Light from some non-incandescent sources doesn't have a continuous spectrum. Fluorescent lamps and electronic flash units, for example, emit light strongly at several colors across the spectrum with little or no light at other wavelengths.

One type of fluorescent lamp is labeled as having *daylight* characteristics. It simulates daylight to human *vision,* but not to *film.* The color quality of non-incandescent light sources, with their "missing" colors, is often a problem in color photography.

FILM COLOR BALANCE

One type of color film is specifically designed for *daylight* use. It is manufactured to photograph scenes in standard photographic daylight having a color temperature of 5500K. If so used, it will record colors remarkably realistically. We say that the film is *daylight balanced.*

There are two types of color film that are balanced for tungsten lighting. *Type A* is balanced for use with 3400K light. *Type B* is designed for 3200K light and is also suitable for use with household tungsten illumination. Usually, the film carton or the leaflet inside will say what color temperature the film is balanced for. If the carton just says *tungsten,* it is probably Type B.

Matching Light and Film— Normally, you should use daylight-balanced film in daylight and tungsten-balanced film in tungsten light. If you use daylight film in tungsten light, subjects will record excessively reddish because the illumination contained more red than the film "expected." With certain subjects, that effect can be pleasing, even though the color balance is "inaccurate." If you use tungsten film in daylight, the photo will be too blue. This effect is rarely pleasing.

You can use tungsten film in daylight and daylight film with tungsten light with the aid of corrective color filters. Colors in the photo will then look correct.

Usually, daylight is not exactly 5500K and tungsten light is not exactly 3200K or 3400K. For such fine color adjustments, you should use filters that make small changes to "fine tune" the

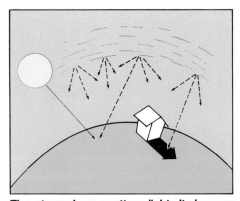

The atmosphere scatters light. It does so predominantly with blue light. That's why a clear sky looks blue. At sunrise and sunset, when the sun is low, its light travels through a thicker layer of atmosphere. More blue from the sun's light is scattered. As a result, morning and evening sunlight has a distinct reddish glow.

A clear sky appears blue because blue light is scattered most by the atmosphere. Photo by T.A. Wiewandt.

color of the light. Filters are discussed in Chapter 7.

ATMOSPHERIC EFFECTS

Light from the sun passes through a layer of atmosphere to reach the earth. That causes changes in the light and color that are important to photographers.

Atmospheric Scattering—Sunlight is *scattered* by particles in the air, such as moisture, smoke and dust. Clean air in the upper atmosphere scatters short, blue wavelengths more than longer wavelengths. Blue light is *extracted* from sunlight and scattered throughout the atmosphere. That's why the sky looks blue.

If an object is in the shade of a tree or building, it is not reached by direct light from the sun. It is illuminated by light from the sky, which we call *skylight*. This illumination contains more blue than direct sunlight.

When the sun is near the horizon, sunlight passes through more of the atmosphere to reach the spot where you are than it does at noon. More of the blue light is extracted by scattering. That's why light from the sun is more reddish at sunrise and sunset than at other times.

Light from Distant Scenes— Light is also scattered between you and distant scenes you're looking at or photographing. When you see a blue haze in a photograph, it usually suggests distance.

Dust and industrial pollution in the air scatter light of other wavelengths. The result can be a haze of one of several colors.

With a clear sky, shadows of a nearby object are dark and distinct. Shadows of distant objects appear less dark and distinct because of scattering by the intervening air. Therefore, distance often decreases subject contrast.

On an overcast day, clouds in the sky intercept and diffuse all of the light from the sun. The entire sky becomes a uniform source of light. Shadows are minimal and contrast is low.

Another factor affecting photography at long distances, especially with long-focal-length lenses, is air turbulence. Air in contact with the earth is heated and rises to form "heat waves" that can distort and diffuse a distant image.

SUBJECT COLORS

The color of an object is the color of the light that comes to your eye from that object. If an object reflects red light, it looks red.

Colored objects don't reflect all colors of the spectrum uniformly. If illuminated by white light, a red object absorbs wavelengths that are not red and reflects those that are red. This is called *selective reflection*.

A *red* object that is illuminated only by *blue* light will not reflect any light and will appear black.

Transparent objects, such as colored glass, hold back some colors and allow other wavelengths to pass through.

What we see is determined both by the color of the object and the color of the light used to view it. Things look different in the *warm* red glow of sunset than they do in the *cold* blue light of skylight.

Late-evening sunlight is reddish because it travels through more atmosphere, causing more blue light to be extracted by scattering. The paint on the Kitt Peak solar telescope in Arizona, shown here, is actually white, not pink.

The scattering of blue light by the atmosphere has another effect: It puts a bluish veil over distant scenes, like the mountains in this photo.

VIEWING COLOR

When viewed by average daylight, reflected from a white card, a color slide may look perfect. Viewing against a blue sky will make the image appear excessively blue. Viewed by tungsten light, the image may appear unacceptably reddish.

Our minds adapt easily to the color of the surrounding, ambient light. A color photo may look OK in daylight and tungsten light—until you switch quickly from one to the other. Then, you'll see in which light it really looks best.

To ensure color consistency in their photographs, professionals use special, standard viewing lights. They have a color temperature of about 5000K. If a photo looks too red or too blue in that light, it is regarded as having a color imbalance.

Light Control

To make a good picture, you may need to control the direction and quality of the light on the subject. You may also need to control color with filters, discussed in Chapter 7. In the remainder of this chapter, I discuss lighting without regard to its color.

SHADOWS

When light from more than one source illuminates a subject, the source that produces dominant shadows is called the *main* light. Outdoors, in daylight, the main light is nearly always the sun. Placement of the main light in relationship to the subject determines subject *modeling*. That's the relationship between highlights and shadow areas.

Both indoors and outdoors, we are accustomed to light coming from above or to the side. Shadows from a light source below a subject look unnatural and usually unflattering. Light that is directly above, however, also causes unflattering shadows and should generally be avoided.

Light control is essentially the same thing as shadow control. You must control the *position, darkness* and *distinctness* of shadows.

Point Source—A single, small source of light is sometimes called a *point source*. The sun in a clear sky, or a

The sunlight struck the young man from his right side, creating distinct facial shadows. This kind of lighting is often suitable for men, to emphasize their rugged features. The young woman's face is in shade and, therefore, in soft lighting. This kind of light is often best for the female face. By carefully positioning your subjects, you can often achieve both kinds of light in one photo, as shown here.

single bare light bulb in a room, appear small at subject position. Point sources create shadows that are dark and have a distinct outline.

Large Source—A light source that is physically large, compared to the subject, produces diffused shadows that are less dark and less distinct. On an lightly overcast day, when some direct sunlight penetrates the cloud layer, you'll see faint, soft shadows. When there is a heavy overcast, the entire sky is a large and diffused source of light. Light comes to the subject from all directions and there are virtually no shadows.

When the sky is clear, but the subject is in shade, direct sunlight does not reach the subject. Only light from the sky illuminates the subject. Because the sky is a large and diffused source, shadows are minimal.

Generally, outdoor portraits made on an overcast day, or in the shade on a clear day, are more flattering to the subject than portraits in strong sunlight, with deep shadows. You may need to use a warming filter to correct for the bluish color imbalance caused by skylight.

FILL LIGHT

Shadows can be lightened by directing another source of light into the shaded areas. This is called "filling" the shadows with light or using *fill light*.

In sunlight, shadows can be filled by a reflector panel as shown in the accompanying photo. Another good way is to use flash, as discussed in the next chapter.

MAIN AND FILL LIGHT

To make fine photographs, you must *control* the lighting. The main light determines the modeling of the subject, or where the shadows fall. The fill light lightens the shadows. the fill light should be soft and not strong enough to create shadows of its own.

In the accompanying drawings of studio lighting setups, the main light is to the right of the camera. The fill light is near the camera position.

The main light is positioned to establish the basic lighting pattern. Its location determines the angle at which shadows fall. Exposure is generally based on the main light.

With the main light positioned, locate the fill light to lighten shadows to the required extent. The film should record some detail in shadow areas.

The left photo was made in direct sunlight. There is little detail in the shaded side of the face. For the right photo, I used a simple card reflector, visible on the left side of the picture. It directed some sunlight into the shadows, giving a more pleasing, detailed image.

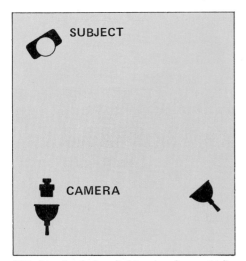

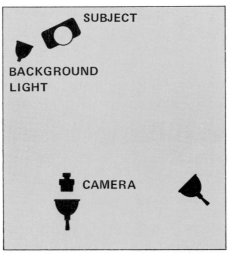

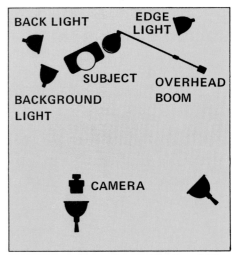

This is a basic two-light setup for portraits. The main light, on the right, causes shadows, establishing the modeling in the subject. The fill light is at the camera location. It is less bright and serves to lighten the shadows caused by the main light.

A background light has been added. By changing the size, brightness and direction of this light, you can achieve a wide variety of background effects. Be sure to keep this light out of the camera's view.

Portraits are often enhanced by the addition of some back light. It can add sparkle to hair and rim lighting to face and body. The overhead boom enables a light to be suspended over a subject without the intrusion of a light stand into the picture. Drawings courtesy of Smith-Victor Corporation.

STUDIO LIGHTING

Lighting problems in a studio are basically similar to those outdoors, but they are easier to control.

Studio lighting includes the main light and the fill light. It may also include a light for the background. A spotlight, or some other source whose angle can be controlled, is useful to rim light a subject's hair and shoulders.

Most of the b&w photos in this book of cameras and other equipment were made with a single, large light source—a bank of special fluorescent lights.

INVERSE SQUARE LAW

There are several ways to control the amount of light reaching a subject from a studio lamp. In b&w photography, where color temperature is not important, you can control brightness by using bulbs of different wattage ratings. You can also change the voltage setting or use a light-absorbing filter in front of the lamp.

A simple method that's useful with almost any lamp involves changing the distance between lamp and subject. When distance is increased between source and subject, the brightness of the light on the subject is decreased

I constructed this alcove for the photography of objects—mainly cameras and photographic equipment. To maintain detail in shadows and give some sparkle to objects that are often predominantly dark, I need a large, soft light source. Two light banks are suspended from the ceiling. Each contains four fluorescent tubes. The walls are white. Seamless background paper is on rolls at the back.

RULES FOR POSITIONING LIGHT SOURCES	
To Decrease Illumination By:	**Multiply Light-Source Distance By:**
1 exposure step	1.4
2 exposure steps	2
3 exposure steps	2.8
4 exposure steps	4
5 exposure steps	5.6
To Increase Illumination By:	**Divide Light-Source Distance By:**
1 exposure step	1.4
2 exposure steps	2
3 exposure steps	2.8
4 exposure steps	4
5 exposure steps	5.6

Notice that the distance factors in this table are the same as the series of f-numbers. Multiply distance by 1.4 to reduce light by one step, 2 to reduce by two steps, 2.8 to reduce by three steps, and so forth.

THE INVERSE SQUARE LAW

A small light source produces an expanding beam of light. When such a beam travels twice as far, it illuminates a surface that is twice as tall and twice as wide. That's four times as much area. When the same light covers four times the area, its brightness on the surface is reduced to one-quarter. When a beam travels three times as far, brightness is reduced to one-ninth, and so forth. The light always falls off as the square of the distance. That's the *Inverse Square Law.*

accordingly. That is true only for a small light source that produces an expanding beam of light, as shown in the accompanying drawing. The law does not apply to large banks of soft light or to the focused narrow-beam light from a spotlight.

The *inverse square law* states that the brightness of the light on the subject falls off as the square of its distance from the subject. For example, if the light-to-subject distance is doubled, brightness at the subject is reduced to one-fourth its original value. If distance is tripled, brightness becomes one-ninth, and so forth.

Stated mathematically:

$$B_2 = B_1 (D_1 / D_2)^2$$

B_1 is brightness on subject before light was moved.

B_2 is brightness on subject after light was moved.

D_1 is original lamp-to-subject distance.

D_2 is final lamp-to-subject distance.

The accompanying table gives you the required information in convenient form.

LIGHTING RATIO AND BRIGHTNESS RATIO

When a subject is illuminated by two light sources at different locations, there may be three values of light on the subject. One is the area illuminated only by the main light. Another is the area illuminated only by the fill light—in the shadows cast by the main light. The third is the area illuminated by both lights, where they overlap.

Suppose the main light casts two units of light on the subject and the fill light casts one unit of light on the subject. The brightest area receives three units of light. The darkest area receives only one unit.

Lighting Ratio—The ratio of main-light to fill-light brightness is called the *lighting ratio.* In the example just given, the lighting ratio is *two to one* (or 2:1) because the main light is twice as bright as the fill light.

Brightness Ratio—The ratio of actual brightnesses of the subject, as seen by the camera, is called the *brightness ratio.* In the example, the brightness ratio is three to one (3:1) because the brightest area receives three times as much light as the darkest area.

You *use* a certain lighting ratio to *cause* a specific subject-brightness ratio.

Because the brightness ratio must record on film, you will usually want to keep it within the usable exposure range of the film.

Establishing the Ratios—The easiest way to establish the lighting ratio is to use lights of the same wattage and measure or estimate the distances between lights and subject. See the accompanying table.

You can measure the lighting ratio with an exposure meter. Turn on only the main light and measure on a gray card at the subject. Then turn on only the fill light and measure again. Find the difference between those exposures in exposure steps. The lighting ratio is that number of exposure steps squared.

For example, if the two exposure measurements are 1/60 second at f-11 and 1/60 second at f-5.6, the difference is two exposure steps. The lighting ratio is 4:1 and the brightness ratio is 5:1. To find brightness ratio, add one to the numerator of the lighting ratio.

SETTING EXPOSURE

Usually, you will want *correct* exposure of the part of the subject lit by the main light. You can find correct exposure by measuring the reflected light from a gray card at subject position, using the camera's built-in meter.

Or, you can take an *incident-light* meter reading from subject position. For the latter, you need an accessory

incident-light meter. It is designed to read the light *reaching* the subject instead of the light *reflected from* the subject. You make the reading by holding the meter close to the subject and pointing it toward the light source.

TYPES OF PHOTO LAMPS

Tungsten photo lamps are available with color-temperature ratings of 3200K or 3400K. Because 3200K lamps operate at a lower filament temperature, their life expectancy is longer than similar lamps operating at 3400K.

Tungsten lamps age and eventually burn out because tungsten evaporates from the heated filament until the filament becomes so thin that it breaks. Evaporated tungsten forms a gray coating on the inside of the glass envelope. This gradually lowers both the light output and the color temperature during the life of the lamp.

Tungsten-Halide Lamps—The *tungsten-halide* or *tungsten-halogen* lamp is a great improvement over regular tungsten lamps. By use of a halogen gas inside a specially designed bulb, the tungsten that evaporates from the filament is continuously removed from the inside surface of the glass envelope and replaced on the filament. This ensures uniformity of light output and color temperature along with a longer lamp life.

SUGGESTED RATIOS		
Film Type	Lighting Ratio	Brightness Ratio
B&W	4:1	5:1
Color Slide	3:1	4:1
Color Negative	2:1	3:1

The above are suggested ratios. Practical ratios depend on the subject, the reflectivity of objects in the composition, and the desired photographic effect.

LIGHTING RATIO AND BRIGHTNESS RATIO		
For a Lighting Ratio of:	Use Fill-Light Distance Equal to Main-Light Distance Times:	Brightness Ratio is:
1:1	1	2:1
2:1	1.4	3:1
3:1	1.7	4:1
4:1	2	5:1
5:1	2.2	6:1

This table is based on the assumption that lights of equal output are being used.

Bright colors alone will rarely ensure a striking photograph. If you combine color with a strong graphic design, you are on the right track. This photo would have been effective in b&w. Color gives it added impact.

6
Electronic Flash

Electronic flash is a wonderful light source. It offers powerful illumination in a small package. Its short duration enables you to freeze all but the fastest movement. These ocelots were photographed at the Arizona-Sonora Desert Museum in Tucson, Arizona. Photo by T.A. Wiewandt.

Owning an electronic flash unit is like having the sun in a box. Flash can literally turn night into day.

There are two main differences between the sun and electronic flash. One is that the bright light from a flash lasts for only a brief time, such as 1/20,000 second.

The other difference is the relationship between subject distance and light brightness on the subject. Flash obeys the inverse square law, discussed earlier. For example, if source-to-subject distance is doubled, subject brightness drops to one-fourth its original value. This corresponds to a reduction of two exposure steps.

Suppose there are subjects at distances of 5, 10 and 20 feet. If the subject at 10 feet is correctly exposed by the flash, the subject at 5 feet will be two steps overexposed. The subject at 20 feet will be two steps underexposed.

The sun is so far away that its illumination of a subject on earth is not affected by the sun's distance from that subject.

In summary, the two important factors that separate electronic flash and sunlight are *duration* and *distance*. Flash has a very brief duration while daylight is continuous. The effect of flash on a subject is determined by the flash-to-subject distance. The brightness of sunlight on a subject is independent of distance.

BASIC PRINCIPLES

The simplest electronic flash units don't do anything automatically. You control exposure manually. To explain the basics of electronic flash, I'll discuss manually operated flash. Please refer to the accompanying diagram.

Power Source—Flash is usually powered by batteries, which supply a relatively low voltage, such as 3 or 6 volts. To fire the flash, a much higher voltage, such as 400 volts, is needed.

Voltage Converter—This is an electronic device that raises the low voltage from the batteries to the 400 volts or so needed.

Storage Capacitor—The electrical energy from the voltage converter is received and stored in a capacitor. The electrical energy in the capacitor is

On-camera electronic flash is handy for photographing domestic scenes like this one. To get uniform illumination on each subject, be sure everyone is about the same distance from the camera. If you want detail in the background, keep it close to the subjects. Photo by Steve Hansen, Stock Boston, Inc.

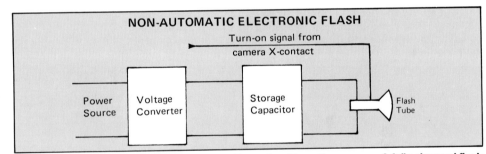

A non-automatic electronic flash is triggered by a signal from the camera. A fully charged flash gives the same amount of light each time it is fired.

built up slowly but discharged instantaneously. That rapid discharge fires the flash tube.

Flash Tube—This is a glass envelope filled with xenon gas. The electrical energy from the storage capacitor causes the flash tube to emit a pulse of very bright light. In a non-automatic flash unit, when the storage capacitor runs out of energy, the light stops. I discuss automatic flash later.

The flash is turned on by a signal from the camera shutter. Before the flash can be fired again, the capacitor must be recharged. The recharging

time is called the *recycle time*.

FLASH SYNCHRONIZATION

The short duration of electronic flash must be timed to occur when the SLR's shutter is fully open. That timing is called *synchronizing* the flash with the shutter— abbreviated *sync* or *synch*.

The sync signal from the camera is produced by a pair of electrical contacts associated with the focal-plane shutter. Synchronization with electronic flash—as opposed to flash bulbs—is called *X-sync*.

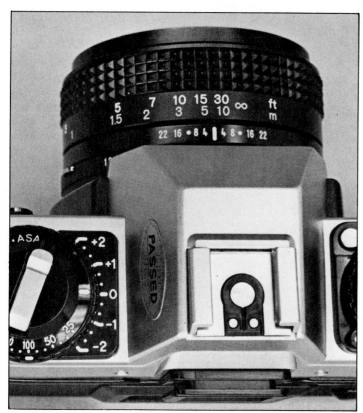

The hot shoe, on top of the viewfinder housing, has electrical contacts that mate with contacts in the mounting foot of small electronic flash units. The large center contact delivers the X-sync signal to fire the flash. One or more smaller contacts are used to provide special operating features.

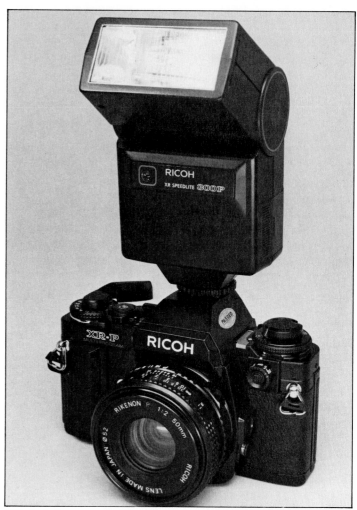

This hot-shoe-mounted flash has a tilting flash head. You can direct the beam upward, for bounce flash, as well as directly at the subject.

FLASH CONNECTION

Small flash units mount in a *hot shoe* on top of the camera. The word *hot* implies electrical contacts.

A hot shoe has a central electrical contact that delivers the X-sync signal to a mating contact in the flash-mounting foot. It is called the *X-contact*. Flash units with special features require more complex electrical connections. These are provided by additional auxiliary contacts surrounding the X-contact.

Most cameras also have a flash connector on the camera body that can receive an electrical cord—called *flash cord* or *sync cord*—from the flash unit.

It allows using the flash detached from the hot shoe. If only the X-sync signal is delivered by that connector, a single-conductor *PC-cord* is used between camera and flash. The end fittings on PC cords simply press into the mating connectors.

To provide for special features of flash and camera, a special multi-conductor sync cord is used. The connectors on camera and flash have multiple pins. The cord usually screws into the camera connector.

Large flash units with handles are usually furnished with a bracket to which both flash and camera are attached. These are called *handle-mount* or *bracket-mount* flash units. Electrical connections are made with a flash cord between flash and camera. The cord may attach to a connector on the camera body or it may have a special fitting on the end that plugs into the hot shoe.

FLASH WITH FOCAL-PLANE SHUTTER

A focal-plane shutter places an upper limit on shutter speeds that can be used with electronic flash. The flash must fire when the film frame is fully open to light. This means that neither of the shutter curtains should be covering any part of the frame.

1/125

1/250

1/500

1/1000

1/60

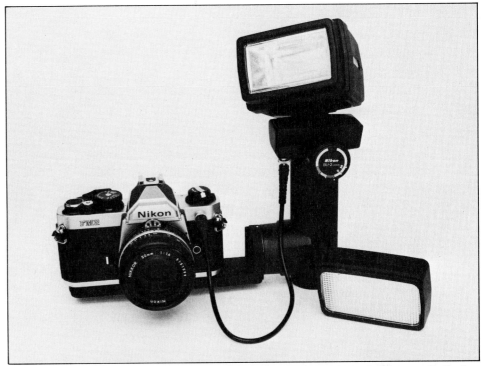

A handle-mount flash is larger and more powerful than flash units intended to mount in the hot shoe. It is connected to the camera by a sync cord. By attaching both flash and camera to a bracket, you can handle them as one unit. Without the bracket, you can hold and aim the flash independent of the camera. The attachment at lower right fits over the flash window to widen the beam of light, for use with wide-angle lenses.

The X-sync signal to fire the flash occurs when the first shutter curtain is fully open. When the flash fires, the second curtain must not yet have started to cover the image area.

The *fastest* shutter speed with which electronic flash can be used is called the *X-sync shutter speed*. Any *slower* shutter speed can also be used.

Different SLR camera models have X-sync speeds such as 1/60, 1/80, 1/125 or 1/250 second. The X-sync speed is usually shown on the camera shutter-speed dial in a special color or identified by a flash symbol. The customary symbol for flash is a lightning bolt.

If you attempt to use a shutter speed faster than the X-sync speed, most cameras will not fire the flash. If the camera does fire the flash at such shutter speeds, part of the image frame will be covered by the second shutter curtain. An example is shown in the accompanying photos.

ADVANTAGE OF FAST X-SYNC SHUTTER SPEED

When you use electronic flash, there may also be some continuous light, such as daylight or room lighting, on the scene. The film will be exposed to flash and the continuous, *ambient* light.

If the subject is moving, you may get a sharp image due to the short-duration flash, overlaid by a blurred image formed by continuous light. The second image is called a *ghost image*.

The faster the X-sync shutter speed,

The X-sync shutter speed of this camera is 1/60 second. At that speed, the entire image frame is exposed at the moment the flash fires. At 1/125 second, part of the image area is obstructed by the second curtain at the time the flash fires. The result is an incomplete image. As shutter speed is increased, less of the image area is exposed to the flash.

CONVERSION GRAPH — FEET TO METERS or METERS TO FEET

This graph converts meters to feet and vice-versa. In the example shown by the arrows, 50 meters converts to 164 feet or 164 feet converts to 50 meters.

the less ambient light will affect the film. This reduces the possibility of ghost images. At the X-sync shutter speed or slower, shutter speed has no effect on the exposure caused by the flash. The film receives the entire flash at *any* of those speeds.

If you deliberately want to expose a scene partially by ambient light, you can use a shutter speed slower than the X-sync speed.

Because light from flash diminishes rapidly with increased distance, scenes with distant backgrounds, exposed mainly by flash, tend to have dark backgrounds. If there is sufficient ambient light on the background, you can make it lighter in a photo by using a shutter speed slower than the X-sync speed.

GUIDE NUMBER

All flash units have a special number that "guides" you to a correct manual exposure setting. This is called the *guide number (GN)*. It is part of the flash specifications.

Exposure by electronic flash depends on the light output of the flash, the flash-to-subject distance, the reflectivity of the subject and the film speed. Shutter speed is not a factor because all permissible speeds hold the shutter open for the full flash duration.

Guide numbers are stated for a specified film speed, such as 25 or 100. If you use a different film speed, you must convert the guide number so it applies to that film speed. A guide number tells you what *f*-number to use for a subject at a specified distance from the flash.

Guide numbers are based on average scenes with a reflectivity of about 18%. They are based on the assumption that the flash is used indoors, where the subject is illuminated both by direct light from the flash and reflected light from the flash that bounces off walls and ceiling. Guide numbers do not take into account exposure due to ambient light.

Measure or estimate flash-to-subject distance, using the same units (feet or meters) as the guide number. Divide that value into the guide number. The result is the *f*-number setting of the lens. Here's the formula:

f-no. = GN/Flash-to-subject distance

If flash and camera are at the same location, then flash-to-subject distance and camera-to-subject distance are the same. After focusing, you can read the distance scale on the lens. Otherwise, you must estimate or measure the flash-to-subject distance.

A guide number is specified for unit of distance—feet or meters. If a flash guide number is 28 (feet) and flash-to-subject distance is 10 feet, then the lens aperture setting should be *f*-2.8. If the guide number is 28 (meters), then *f*-2.8 is used with a distance of 10 meters. Distance *must* be expressed in the same unit as the guide-number specification.

Converting Distance Units—You can convert the guide number for distance in feet to that for meters, or vice versa:

To get GN in feet, multiply GN in meters by 3.3.

To get GN in meters, divide GN in feet by 3.3.

GUIDE NUMBER CONVERSION FACTORS TO CHANGE ASA BASIS OF GUIDE NUMBER

NEW ASA FILM SPEED

PUBLISHED ASA FILM SPEED	25	32	40	50	64	80	100	125	160	200	250	320	400
25	1.0	1.1	1.3	1.4	1.6	1.8	2.0	2.3	2.5	2.8	3.2	3.6	4.0
32	0.88	1.0	1.1	1.3	1.4	1.6	1.8	2.0	2.3	2.5	2.8	3.2	3.6
40	0.8	0.88	1.0	1.1	1.3	1.4	1.6	1.8	2.0	2.3	2.5	2.8	3.2
50	0.71	0.8	0.88	1.0	1.1	1.3	1.4	1.6	1.8	2.0	2.3	2.5	2.8
64	0.63	0.71	0.8	0.88	1.0	1.1	1.3	1.4	1.6	1.8	2.0	2.3	2.5
80	0.56	0.63	0.71	0.8	0.88	1.0	1.1	1.3	1.4	1.6	1.8	2.0	2.3
100	0.5	0.56	0.63	0.71	0.8	0.88	1.0	1.1	1.3	1.4	1.6	1.8	2.0
125	0.44	0.5	0.56	0.63	0.71	0.8	0.88	1.0	1.1	1.3	1.4	1.6	1.8
160	0.4	0.44	0.5	0.56	0.63	0.71	0.8	0.88	1.0	1.1	1.3	1.4	1.6
200	0.35	0.4	0.44	0.5	0.56	0.63	0.71	0.8	0.88	1.0	1.1	1.3	1.4
250	0.31	0.35	0.4	0.44	0.5	0.56	0.63	0.71	0.8	0.88	1.0	1.1	1.3
320	0.28	0.31	0.35	0.4	0.44	0.5	0.56	0.63	0.71	0.8	0.88	1.0	1.1
400	0.25	0.28	0.31	0.35	0.4	0.44	0.5	0.56	0.63	0.71	0.8	0.88	1.0
500	0.22	0.25	0.28	0.31	0.35	0.4	0.44	0.5	0.56	0.63	0.71	0.8	0.88
640	0.2	0.22	0.25	0.28	0.31	0.35	0.4	0.44	0.5	0.56	0.63	0.71	0.8
800	0.18	0.2	0.22	0.25	0.28	0.31	0.35	0.4	0.44	0.5	0.56	0.63	0.71
1000	0.16	0.18	0.2	0.22	0.25	0.28	0.31	0.35	0.4	0.44	0.5	0.56	0.63
1250	0.14	0.16	0.18	0.2	0.22	0.25	0.28	0.31	0.35	0.4	0.44	0.5	0.56
1600	0.13	0.14	0.16	0.18	0.2	0.22	0.25	0.28	0.31	0.35	0.4	0.44	0.5
2000	0.11	0.13	0.14	0.16	0.18	0.2	0.22	0.25	0.28	0.31	0.35	0.4	0.44
2500	0.1	0.11	0.13	0.14	0.16	0.18	0.2	0.22	0.25	0.28	0.31	0.35	0.4
3200	0.09	0.1	0.11	0.13	0.14	0.16	0.18	0.2	0.22	0.25	0.28	0.31	0.35
4000	0.08	0.09	0.1	0.11	0.13	0.14	0.16	0.18	0.2	0.22	0.25	0.28	0.31
5000	0.07	0.08	0.09	0.1	0.11	0.13	0.14	0.16	0.18	0.2	0.22	0.25	0.28
6400	0.06	0.07	0.08	0.09	0.1	0.11	0.13	0.14	0.16	0.18	0.2	0.22	0.25

NEW ASA FILM SPEED

PUBLISHED ASA FILM SPEED	500	640	800	1000	1250	1600	2000	2500	3200	4000	5000	6400
25	4.5	5.0	5.6	6.3	7.1	8.0	8.9	10.0	11.3	12.7	14.1	16.0
32	4.0	4.5	5.0	5.6	6.3	7.1	8.0	8.9	10.0	11.3	12.7	14.1
40	3.6	4.0	4.5	5.0	5.6	6.3	7.1	8.0	8.9	10.0	11.3	12.7
50	3.2	3.6	4.0	4.5	5.0	5.6	6.3	7.1	8.0	8.9	10.0	11.3
64	2.8	3.2	3.6	4.0	4.5	5.0	5.6	6.3	7.1	8.0	8.9	10.0
80	2.5	2.8	3.2	3.6	4.0	4.5	5.0	5.6	6.3	7.1	8.0	8.9
100	2.3	2.5	2.8	3.2	3.6	4.0	4.5	5.0	5.6	6.3	7.1	8.0
125	2.0	2.3	2.5	2.8	3.2	3.6	4.0	4.5	5.0	5.6	6.3	7.1
160	1.8	2.0	2.3	2.5	2.8	3.2	3.6	4.0	4.5	5.0	5.6	6.3
200	1.6	1.8	2.0	2.3	2.5	2.8	3.2	3.6	4.0	4.5	5.0	5.6
250	1.4	1.6	1.8	2.0	2.3	2.5	2.8	3.2	3.6	4.0	4.5	5.0
320	1.3	1.4	1.6	1.8	2.0	2.3	2.5	2.8	3.2	3.6	4.0	4.5
400	1.1	1.3	1.4	1.6	1.8	2.0	2.3	2.5	2.8	3.2	3.6	4.0
500	1.0	1.1	1.3	1.4	1.6	1.8	2.0	2.3	2.5	2.8	3.2	3.6
640	0.88	1.0	1.1	1.3	1.4	1.6	1.8	2.0	2.3	2.5	2.8	3.2
800	0.8	0.88	1.0	1.1	1.3	1.4	1.6	1.8	2.0	2.3	2.5	2.8
1000	0.71	0.8	0.88	1.0	1.1	1.3	1.4	1.6	1.8	2.0	2.3	2.5
1250	0.63	0.71	0.8	0.88	1.0	1.1	1.3	1.4	1.6	1.8	2.0	2.3
1600	0.56	0.63	0.71	0.8	0.88	1.0	1.1	1.3	1.4	1.6	1.8	2.0
2000	0.5	0.56	0.63	0.71	0.8	0.88	1.0	1.1	1.3	1.4	1.6	1.8
2500	0.44	0.5	0.56	0.63	0.71	0.8	0.88	1.0	1.1	1.3	1.4	1.6
3200	0.4	0.44	0.5	0.56	0.63	0.71	0.8	0.88	1.0	1.1	1.3	1.4
4000	0.35	0.4	0.44	0.5	0.56	0.63	0.71	0.8	0.88	1.0	1.1	1.3
5000	0.31	0.35	0.4	0.44	0.5	0.56	0.63	0.71	0.8	0.88	1.0	1.1
6400	0.28	0.31	0.35	0.4	0.44	0.5	0.56	0.63	0.71	0.8	0.88	1.0

Converting to Different Film Speed—Each guide number relates to a specific film speed. If you are using a different film speed, you must convert the GN so it applies to the new film speed. Here's the formula:

$$GN_2 = GN_1 \times \sqrt{\frac{New\ Film\ Speed}{Published\ Film\ Speed}}$$

GN_1 is the published guide number.
GN_2 is the new guide number.

Suppose the published GN is 20 (feet) with a film speed of 25. You are using film with a speed of 400. To convert the guide number:

$$New\ GN = 20 \times \sqrt{400/25}$$
$$= 20 \times \sqrt{16}$$
$$= 20 \times 4$$
$$= 80\ (feet)$$

The accompanying table provides conversion factors that make the job easier. Multiply the published guide number at the published film speed by the conversion factor for the new film speed to get the new guide number.

Suppose your flash has a published guide number of 33 (feet) for a film speed of 100. The film you are using has a speed of 160. What guide number should you use? Referring to the table, to convert from a speed of 100 to a speed of 160 the factor is 1.3. Multiply the published guide number by 1.3.

$$33 \times 1.3 = 43$$

The new guide number, for the 160-speed film, is 43 (feet).

FLASH CALCULATOR DIAL

You can determine flash exposure without arithmetic by referring to the calculator dials or scales on the backs of most flash units. The accompanying photo shows a simple calculator scale.

To use a flash calculator, dial in the speed of the film you're using. No film-speed conversion is necessary.

Flash-to-subject distances and *f*-numbers appear in pairs, opposite each other. Find the appropriate distance and use the adjacent *f*-number. Distances are shown in both feet and meters. No unit conversion is necessary.

BOUNCE FLASH

Flash that's aimed at the subject from camera position produces flat lighting, with few shadows. If a wall is close behind the subject, a narrow but distinct shadow will appear on the wall.

To avoid direct frontal lighting, you must remove the flash from the camera and fire it from another angle. To do this, you must attach the flash to the camera with a long sync cord and hold the flash in your hand.

Bounce flash is another alternative. You bounce the flash off the ceiling or a wall. The resulting light on the subject is diffused by the bounce and also arrives at an angle that gives some modeling to facial features.

When using color film, avoid colored bounce surfaces. They would influence the color of the image.

Exposure Adjustment—Bounced light reaching the subject is less bright than direct light. That's because the light travels farther and some of it is absorbed and scattered by the bounce surface. With manual, non-automatic, flash, you must make an exposure adjustment. Use as flash-to-subject distance the total distance from flash to bounce surface to subject. Increase the *f*-stop this gives by one to two stops. Bracket exposures, to be sure of a good picture.

The flash calculator dial does some arithmetic for you. Set film speed in the ASA/ISO window opposite the large triangle. If you are using a beam-widening panel over the flash window, use the triangle labeled W instead. The calculator has three concentric scales. The outer scale has *f*-numbers. The next scale is distance in meters. The inner scale is distance in feet. With manual flash, use the aperture that is directly opposite the set flash-to-subject distance on the distance scale. This flash has a guide number of 110 (feet). Dividing the guide number by the distance gives the required aperture setting. Notice that for a subject distance of 5 feet, aperture is *f*-22. For a distance of 10 feet, aperture is *f*-11.

When the camera-mounted flash is pointed directly at the subject, top photo, there is little modeling in the face. Shadows are small but hard. The flash causes a distracting, dark shadow on the nearby background. When the flash is bounced off the ceiling, lower photo, the light is diffused and strikes the subject from a higher angle. This gives better modeling, softer lighting, and less obvious shadows.

This flash has a main head that tilts and swivels for bounce flash off ceiling or walls. An auxiliary flash, in the body of the unit, always points straight ahead. When bouncing the flash from the tilting head, you can also use the auxiliary flash to provide a smaller amount of direct lighting. One of the clip-on attachments widens the beam of the main head for use with wide-angle lenses. The other narrows the beam for use with telephoto lenses.

STUDIO LIGHTING

You can use flash for studio lighting just as you can tungsten light. One important difference is that you can't see the effect of flash lighting until you have a picture. That's because flash is not a continuous light source.

Modeling Lights—Professional flash equipment usually has *modeling lights*. These are relatively weak tungsten lights built into the flash heads. They enable you to build up your lighting effects visually.

When flash equipment doesn't have modeling lights, you can simulate them. Place tungsten lights, or even flashlights, in the right positions and then replace them with flashes to make the picture. However, this is a cumbersome procedure. The alternative is to rely on guesswork and experience. The more you know about basic lighting technique, the better off you'll be.

Multiple Lighting—Many manufacturers make flash units that can be interconnected by cords so they fire simultaneously. Another way to synchronize several flash units is with optical *slaves*. The light from the main flash activates the others through photoelectric cells attached to the slave flash units. No interconnecting cords are needed.

Fill Flash—The best main-light position is usually above and to the side of the camera. It provides the modeling, or the dominant shadows. The fill flash, for lightening shadows, should be soft, near the camera position and less bright on the subject than the main light.

The exact brightness of the fill light depends on how much you want to lighten the shadows. Normally, the fill light should be one to three exposure steps weaker on the subject than the main light.

Electronic flash without modeling light doesn't get hot. With it, you can reduce light output by covering the flash window with a white handkerchief or facial tissue. One thickness of handkerchief reduces the light about one step.

FILL FLASH WITH SUNLIGHT

In outdoor portraiture, direct sunlight causes dark facial shadows. You

Direct sunlight as the only light source can lead to dark shadows.

The shadows were lightened with fill flash, using the method discussed in the text.

can use flash to fill the shadows. Here are the simple steps:

● Pose the subject so the modeling provided by the sun is flattering to the subject.

● Using a shutter speed suitable for electronic flash, meter the subject and set aperture for full exposure by sunlight.

● Using the flash guide number and the *f*-number set on the lens, determine the flash-to-subject distance for full exposure by flash.

● Place camera and flash at the distance calculated for full exposure by the flash. Because there are no nearby reflecting surfaces outdoors, the flash will be a little less bright than the guide number suggests. Therefore, flash exposure will be less than daylight exposure. This is important. If the flash were too bright, it would destroy the shadows altogether.

● Close the lens aperture by about one-half stop. This compensates for the light of the flash, which reaches both shadows and areas lit by direct sunlight.

You can reduce the effect of the flash further by covering the flash window with a handkerchief or by moving the flash farther from the subject. If the flash is on the camera, you'll need to move the camera farther from the subject. To retain your original composition, you'll then need to change to a lens with longer focal length.

Film Speed—With electronic flash, you must shoot at X-sync shutter speed or slower. In bright sunlight, that will demand a small lens aperture. If you use a fast film, the lens may not have an aperture small enough. Therefore, when you use flash with sunlight, I suggest you use a film with a speed of 200 or less.

Automatic Electronic Flash

Most modern flash units have the manual mode plus one or more automatic modes. On manual, the flash always provides the same amount of light. Its effect is controlled by film speed, subject distance and aperture size.

On automatic, exposure is measured while the film is actually being exposed. Automatic exposure uses a light sensor that measures light reflected from the subject and turns off the flash when sufficient light for correct exposure of an average scene has been measured. What is controlled is flash *duration*.

In the manual mode, a flash always makes light for as long as it can—until the storage capacitor has discharged. For correct exposure at a certain distance, you must set aperture size precisely.

On automatic, aperture size determines not *the* subject distance, but *maximum* subject distance for correct exposure using the full flash output. Because flash duration is variable, a subject that is closer can also be correctly exposed without you having to change any control settings on flash or camera. At the selected aperture, there is a *range* of distances within which the subject will receive correct exposure. However, correct exposure in any one picture will occur at just one distance. Objects nearer or farther away will not be correctly exposed.

ENERGY-SAVING AUTO FLASH

For a relatively distant subject, an automatic flash may use all or most of the energy in the storage capacitor. For a nearby subject, the flash is turned off sooner, without using all of the electrical energy in the capacitor.

There are two ways to turn off the flash tube. One wastes the unused energy by discharging the storage capacitor. For the next flash, the capacitor must be recharged from zero. This lengthens the recycle time and uses battery power to replace energy in the capacitor that was never used to make a flash.

There's a better way that saves the unused energy in the capacitor for use during the next flash. This shortens

93

recycle time and provides more flashes from a set of batteries. This type of flash is called an *energy-saving, series-circuit* or *thyristor* flash.

AUTOMATIC EXPOSURE-CONTROL SENSOR

There are two methods of automatic exposure control, depending on the location of the light sensor. One uses a sensor in the flash unit, pointing toward the scene. This was the first type to be developed. It is sometimes called *normal* auto flash.

A better, more recently developed, control method uses a light sensor in the camera body, measuring the light that actually exposes the film. This type is called *Through-The-Lens (TTL)* automatic flash.

Some auto flash units are designed to be used both ways. They have a light sensor in the flash body and another one in the camera for TTL exposure control.

In the rest of this chapter, I discuss the operating principle of each type of auto flash and features that are unique to each type. Then, I discuss features that are common to both types.

SENSOR IN THE FLASH UNIT

In the simplest case, the flash is mounted in the hot shoe or on a bracket beside the camera. The light sensor on the flash "looks" at the scene being photographed.

When the flash is fired, the sensor measures both ambient and flash light from the scene and calculates exposure. When sufficient exposure has been measured, the sensor turns the flash off. The sensor on the flash is actually measuring light on behalf of the camera.

In the accompanying diagram you will see that an automatic light-sensing flash is different in two important ways from a non-auto flash. First, there is a *thyristor switch* to disconnect the storage capacitor from the flash tube, conserving the energy left in the capacitor. A light sensor sends a turn-off signal to the thyristor switch when correct exposure has been given.

Second, there is a *sensor sensitivity control*. It incorporates several openings of different sizes, one of which is positioned in front of the light sensor. This prepares the sensor to measure light for the camera at the aperture set on the camera lens.

To measure exposure, the flash unit must "know" film speed and aperture size. You set film speed on the flash calculator dial.

Auto flash units of this type offer a choice of aperture sizes, so you have some control over depth of field. The aperture size that you will use is selected by a switch or dial on the flash control panel. This adjusts the sensor sensitivity of the flash to agree with the aperture that will be used.

For each usable aperture, the *maximum* subject distance is shown on the flash control panel. Choose an aperture size based on subject distance and depth-of-field considerations. Set the *f*-number on the flash control panel *and* on the lens. Some auto flash units will set aperture for you. This is discussed later, under *Dedicated Features*.

You must make a total of four control settings: Film speed and aperture size must be set on the flash; aperture and X-sync or slower shutter speed must be set on the camera. Some flash units set shutter speed automatically.

Operating Range—Maximum operating distance is determined by aperture size. If there is a choice of apertures, each will have a different maximum range, shown on the flash control panel. At maximum range, all of the energy in the storage capacitor is used.

For each maximum distance, there is also a minimum distance. Sometimes it is also shown on the flash panel. If not, it is usually in the flash specifications. If it isn't, assume it is about 10% of the maximum range. The minimum distance is determined by how quickly the flash can turn itself off. A subject anywhere between the maximum and minimum distances should be correctly exposed.

Subject Placement—The light sensor on the flash measures light from the central part of the scene. For correct exposure, the main subject should be placed in that area.

The sensor's angle of view, or *acceptance angle,* is typically about 18°. That's about the same as the angle of view of a 135mm lens. If the camera lens has a shorter focal length, it has a wider angle of view. Then, the flash sensor sees only the central part of the frame. Exactly how much, depends on the focal length of the lens.

If the camera lens is longer than

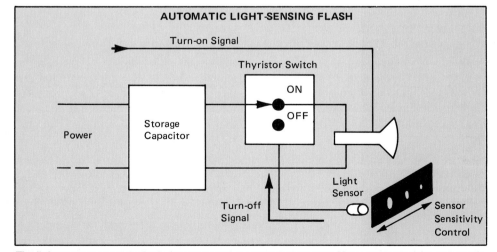

The light sensor controls flash duration to give correct exposure. You can control the automatic distance range of the flash by using different aperture settings.

135mm, its angle of view is narrower than that of the flash sensor. The sensor can then measure the light on objects that are outside the frame. Be careful that nothing bright—such as a light or reflection—is permitted to reach and influence the sensor from outside the frame.

Flash-Ready Indicator—Most flash units have a lamp on the control panel that glows when the flash is charged and ready to fire. It is called a *ready lamp, pilot lamp* or *monitor lamp.* While the flash is recycling, the lamp is off.

Sufficient-Exposure Indicator—Most auto flash units indicate if there was sufficient light for correct exposure of an average scene. That is done by a separate lamp on the control panel or sometimes by a flashing ready lamp.

This indicator shows sufficient exposure only if the flash was turned off by the light sensor. If the flash tube produced the maximum amount of light and then extinguished because the storage capacitor discharged fully, exposure was *probably* insufficient. However, it is also possible that maximum light *did* expose the scene *correctly.*

There is no warning signal for overexposure. Thus, if the subject is closer than minimum range, sufficient exposure will be indicated even though the subject will probably be overexposed.

Exposure Test Button—Some auto flash units can test in advance for sufficient exposure. After all controls are set, fire the flash manually by pressing a button —usually labeled TEST—on the flash control panel. Although the flash fires, the camera shutter does not open.

Light from the scene is measured by the flash sensor in the usual way, and the sufficient-exposure indicator works as just described.

Bounce Flash—Some hot-shoe flash units have flash heads that you can tilt up and swivel for bounce flash. The main body of the flash does not move. The sensor is in the body and continues to view the subject. This is an ideal arrangement for getting good exposure with bounce flash.

Some handle-mount flash units have a detachable sensor, or separate accessory sensor, that you can place in the camera's hot shoe. You can remove the flash from its bracket and point it in any direction. The sensor in the hot shoe continues to view the subject.

SENSOR IN THE CAMERA

In the TTL auto-flash system, a light sensor inside the camera controls flash duration. The sensor "sees" the emulsion surface of the film. This arrangement was discussed in Chapter 4. The sensor measures the light that causes

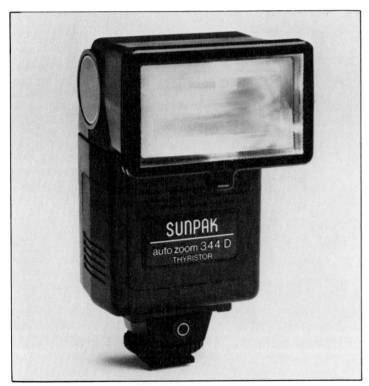

This is an automatic light-sensing flash. It measures light reflected from the subject and turns itself off when sufficient exposure has been measured. The light sensor is in the circular opening near the mounting foot. The lens in front of the flash window telescopes, or "zooms," to change the beam angle for use with wide-angle or telephoto lenses.

This automatic light-sensing flash offers manual and two automatic modes, selected by the switch at lower left. The automatic modes are color-coded. If you select the red auto mode, use the aperture indicated by the red arrow on the calculator scale—*f*-5.6. The distance range is shown by a red band adjacent to the distance scales—2 to 20 meters. If you select the green auto mode, use the aperture indicated by the green arrow—*f*-11. The distance range is 2 to 10 meters. Notice that the larger aperture setting gives the greater maximum distance. On manual, aperture is read from the calculator scales for each subject distance.

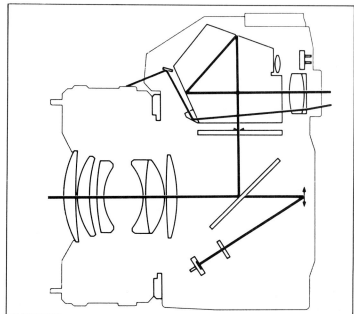

This Chinon Auto 360 flash offers manual and three light-sensing auto modes, selected by the AUTO/MANUAL switch at right on the main panel. The display shows *f*-number in the large window and distances in feet. Set film speed using the control at left. On manual, move the *distance selector* so the subject distance glows. The aperture setting for that distance appears in the large window. On automatic, two distances glow, showing the operating range. The range depends on which of the auto settings has been selected and on film speed. Aperture is shown in the large window. On automatic, the distance selector has no effect.

This drawing of a Ricoh XR-P camera shows three light paths. The light path from outside the lens enters a window in the front of the viewfinder and allows you to see the set *f*-number in the viewfinder display. When the mirror is down, light entering the lens is reflected upward into the viewfinder. Except when TTL auto flash is being used, metering is done by a light sensor in the viewfinder, measuring focusing-screen brightness. When TTL auto flash is used, the light sensor in the bottom of the camera controls flash exposure by measuring light on the film.

exposure, during the actual exposure.

It begins measuring light at the instant the flash is fired, when the first shutter curtain is fully open. It measures both ambient light and light from the flash. When sufficient exposure has been measured, the camera sends a turn-off signal to the flash and releases the second shutter curtain to close the frame.

The flash is turned on and off by the camera. Because film speed is already set on the camera, it is not necessary for the flash unit to "know" the film speed. Nor need the flash unit "know" the aperture size.

For each lens-aperture setting, there is an operating range with a maximum and minimum distance. A subject anywhere in that range should be correctly exposed.

For any aperture setting, the maximum subject distance on automatic is the same as the maximum subject distance on manual. A handy way to find maximum distance at any aperture is to

read the manual exposure calculator scales on the flash control panel. They will apply, as long as film speed has been set on the flash unit.

Because the light sensor views the scene seen through the lens, the angle of view of the sensor is always the same as that of the lens.

Exposure for bounce flash is also automatic.

Flash-Ready Indicator—There is usually a *ready lamp* or *pilot lamp* on the flash control panel. The lamp glows when the flash is charged and ready to fire.

Sufficient-Exposure Indicator— TTL auto-flash units indicate if there was sufficient light for correct exposure of an average scene. That is done by a separate lamp on the control panel or sometimes by a flashing ready lamp.

This indicator shows sufficient exposure if the flash was turned off by the light sensor. If all the light from the flash was used, exposure was probably

insufficient. However, it is possible that maximum light *did* expose the scene *correctly*.

If the flash is closer than minimum range, the subject will probably be overexposed. There is no overexposure indicator.

Exposure Test—With TTL auto flash, there is no way to test exposure in advance. If the flash unit has a test button, it is for a different mode or just to see whether the flash works.

This Ricoh 300P flash offers manual, light-sensing auto and TTL auto, with LOW and HIGH power settings. In the TTL auto mode, distance ranges are shown by the light area on the graph. For example, at *f*-16 the range is 0.5 to 2.7 meters at high power. At the low power setting, the right border of the graph moves to the left so maximum distance is reduced.

COMPARISON OF FLASH SYSTEMS

Basic features of *manual, non-TTL automatic* and *TTL-automatic* flash are reviewed here.

Manual—You must set the aperture for correct exposure. The aperture must be set for each subject distance, by reference to the flash calculator dial or a guide-number calculation. Bounce flash exposure is dependent on some guesswork and experience.

Non-TTL Auto—You must use one of the aperture sizes marked on the flash unit. For each aperture size, there is a distance range. A subject anywhere in that range will be correctly exposed. It is not necessary to reset aperture for different subject distances within that range. Bounce-flash exposure control is automatic.

Exposure can be tested in advance. The flash sensor does not necessarily have the same angle of view as the camera lens.

TTL Auto—Any aperture can be used. For each aperture size, there is a distance range over which a subject should be correctly exposed. Bounce flash is automatic. Exposure cannot be tested in advance. The flash sensor has the same angle of view as the camera lens used.

DEDICATED FLASH

Some flash units, designed for specific camera models, offer special automatic operating features. These units are called *dedicated flash*.

Dedicated flash units set camera exposure controls. What the flash does is determined by the automatic modes of the camera itself. Typical dedicated features also provide viewfinder displays related to the flash, such as flash-ready and sufficient-exposure indicators.

Shutter Speed—The flash will select the X-sync shutter speed and the viewfinder display will show that speed even though the shutter-speed dial remains at another speed.

You may wish to use a slower speed to get more exposure of the background with ambient light. To allow that, some cameras will set X-sync speed only if the camera was set to a faster speed. If set to a slower speed, the flash will use it.

Some cameras switch to X-sync shutter speed and remain at that setting when the flash is turned on. Some are switched to X-sync speed only when the flash is charged. During the recycle interval, shutter speed is governed by control settings on the camera. If the camera is on automatic, you can shoot while the flash is recycling and may get a good exposure using ambient light.

Lens Aperture—If the camera can set aperture automatically, a dedicated flash may do it also. The selected aperture size may be displayed in the viewfinder. If the auto flash requires aperture selection by a control on the flash panel, that aperture size is set automatically by the camera.

Some dedicated flash units incorporate a dark-red, almost invisible, light in the flash head. When the shutter button is pressed, a pulse of this red light is emitted and reflected from the subject. The reflected light is measured by a sensor on the flash. A suitable aperture is set automatically, the shutter opens, and the flash fires.

If an automatic camera has a programmed mode, a dedicated flash may set both X-sync shutter speed and aperture. Aperture is set for the film speed in use.

If you are shopping for a flash with dedicated features, it is important to find out which features work with your camera.

Common Features of Different Flash Systems

The remainder of this chapter applies to both non-TTL and TTL automatic flash. Much of it also applies to manual flash.

BEAM ANGLE

To avoid wasting light, flash units produce a rectangular beam with approximately the same shape as the 35mm film frame. The long axis of the flash window is the long dimension of the beam.

The angle of the beam is specified in degrees or by comparison with the angle of view of a lens. Usually, the beam angle covers the angle of view of a 35mm lens. Some cover a 28mm lens. If the flash is used with a wider lens, the frame may not be uniformly illuminated.

Beam-Angle Adapter—For some flash units, clip-on lenses that fit over the flash window to change the beam angle are available. Some widen the angle for wider lenses. Some narrow it for telephoto lenses.

Changing the beam angle changes the intensity of the light and therefore the guide number of the flash. On automatic, it changes the operating distance range. The flash instruction booklet should specify these changes.
Telescoping Beam-Angle Adapter—Some flash units have telescoping adapters to change beam width, instead of separate individual lenses.

COLOR TEMPERATURE

Light produced by an electronic flash is intended to have the same color effect on color film as average daylight. Both types of illumination have a color temperature of about 5500K. Some flash units give a light that's a little too blue. You can correct this by using a filter on the camera lens.

FILTERS

Some flash units have accessory filters that clip over the flash window to change the color of the light emitted. There are filters that balance the color

of the flash for use with tungsten-balanced color film. *Neutral-Density (ND)* filters enable you to reduce the amount of light emitted without creating a color change.

OPEN FLASH

Most flash units have an *open-flash* or *test* button on the back to fire the flash independently of the camera. With a non-TTL auto flash, it can be used to test exposure in advance.

The open-flash button also enables you to fire the flash with the camera shutter at the B setting. You can fire the flash once or several times while the shutter is open. A useful application is to light a subject from several positions with only one flash unit. This is called *painting with light*. You walk around the scene and fire the flash from the desired positions. The scene being photographed must be lit by almost no ambient light. You should fire the flash from positions where the flash unit is not visible to the camera.

POWER RANGE

Powerful flash units that produce a lot of light sometimes have a control to change the light output and therefore the guide number. Power settings

In addition to clip-on panels that change beam angle, some flash units have colored panels that can be attached to change the color of the light.

range from full down to 1/16. Operating range is reduced at the lower power settings.

On automatic, this output control allows you to limit the maximum light produced to that required by the subject distance. Variable power also allows a greater range of usable apertures and, therefore, more control over depth of field.

Repeating Flash—Units with variable power typically have a low setting, such as 1/16, for use with a motor drive. With reduced power for each flash, recycle time is fast, and the flash can keep up with the motor drive.

The flash heats up internally in this mode, which may limit its use to a specified number of flashes, such as 10 or 20. Some units have an internal circuit breaker to turn off the flash before it gets too hot.

BATTERIES

The number of flashes from a set of batteries and the recycle time are determined by the type of batteries used. Ordinary *carbon-zinc* batteries provide the least number of flashes. *Alkaline* batteries provide the greatest number of flashes. *Nickel-Cadmium (NiCad)* batteries are rechargeable. They provide more flashes than carbon zinc, but less than alkaline batteries. NiCad batteries provide faster recycle times because they can supply more current.

NiCad batteries may damage a flash that is not designed to use them.

Battery Discharge—As the batteries discharge, recycle time becomes longer. When recycle time gets intolerably long, or when the flash unit does not recharge at all, replace the batteries. All batteries in one flash unit should be of the same brand and type. All should be replaced together.

Light Output—Nearly all flash units are designed so that the ready light turns on when the storage capacitor is about 70% charged. If fired then, the flash will produce about one step less exposure than if the flash were fully charged.

Full charge takes about twice as long. If the ready light turns on in two seconds, full charge requires waiting another two seconds. For uniformity of flash output, try to *always* fire either when the ready light first turns on or at full charge.

AC Power Supply—Accessories that enable you to use household AC power are available. In function, they just replace the batteries.

On-camera electronic flash is invaluable for capturing candid, indoor family portraits like this. To get more modeling in your subjects, try shooting by window light plus fill flash or with a multiple-flash setup. Photo by Peter Menzel, Stock Boston, Inc.

7
Filters

Two special-effect filters were used to make this dramatic image of the Arc de Triomphe in Paris. A Cokin star filter provided the starburst from the sun. A Cokin orange filter added the warm sunset color. Photo courtesy of Minolta Corporation.

There are four general filter types:
Color Filters change the color of light that passes through them.
Polarizing Filters are useful for controlling reflections. They can also make colors appear more vivid and saturated. These filters are also useful for darkening a blue sky. They can do all this without *changing* the color of the light.
Neutral-Density (ND) Filters are designed to reduce the amount of light reaching the film without changing its color.
Special-Effect Filters have a wide variety of purposes. Among other things, they can produce star effects, create multiple images, or change the color of part of an image.

Filters are available in a variety of materials and with several lens-attachment methods. In the first part of this chapter, I discuss filters and their applications without concern for how they are attached to the lens. Later, filter materials and mounting methods are discussed.

Color Filters for Color Film

There are several types of color filters for use with color film. The designations discussed here are used by Eastman Kodak and most other filter manufacturers.

COLOR-CONVERSION FILTERS

These filters *convert* the color temperature of the light on the scene to match the type of color film in the camera. For example, if you are using tungsten film but need to take a photo in daylight, you can place a color-conversion filter in front of the lens to get good color balance. In effect, the filter makes daylight look like tungsten light to the film.

Because tungsten film is balanced for light that is less blue than daylight, the filter must remove blue. The correct filter, when viewed against white light, will appear amber or orange.

Color-conversion filters are shown in Figure 7-1. The table shows stand-ard light sources with their color temperatures, film types with the color temperatures for which they are balanced, and conversion filters to correct "mismatched" light and film.

Daylight is not always 5500K. Depending on atmospheric and weather conditions, and time of day, it may be more reddish or more bluish. For this reason, there's more than one conversion filter—there is a series of different strengths.

To get a specific correction, you can sometimes stack two filters on top of each other.

Series-80 color-conversion filters are bluish and intended to remove excessive red from the illumination. Series-85 color-conversion filters are amber. They are designed to remove excess blue from the illumination.

LIGHT-BALANCING FILTERS

These filters are similar to color-conversion filters but weaker. They are not designed to change color temperature from one source to that of

COLOR CONVERSION OF LIGHT SOURCES		
LIGHT SOURCE	**COLOR FILM USED**	**USE FILTER NO.**
Daylight (5500K) or Electronic Flash	Tungsten Type A (3400K)	85
	Tungsten Type B (3200K)	85B
Tungsten (3400K)	Daylight (5500K)	80B
	Tungsten Type B (3200K)	81A
Tungsten 3200K or household	Daylight (5500K)	80A
	Tungsten Type A (3400K)	82A

Figure 7-1

another common source. Their purpose is to *fine tune* color balance.

For example, on an overcast day, the light is bluish. If you were to shoot without correction, colors in a photo would be too bluish. This imbalance is especially noticeable and undesirable in skin tones. You need an amber light-balancing filter to remove the unwanted blue.

A couple of hours after sunrise or before sunset, the light is usually reddish. To correct this, you need to use a light-balancing filter that's bluish.

Of course, if you shoot a sunset, you'll most likely want to record its characteristic orange glow. If you were to "correct" it with a bluish filter, you would end up with a photo that looks as if it were taken at midday. What filter you use depends largely on what effect you want to achieve.

Series-82 light-balancing filters are bluish and remove excess red. Series-81 light-balancing filters are amber and remove excess blue. Figure 7-2 lists these filters and their strengths.

THE MIRED SYSTEM

There is a precise method of selecting color-conversion and light-balancing filters. To use it, you need to know the color temperature of the existing light and the color temperature for which the film is balanced. It also requires converting the Kelvin values of color temperature to *mired* values.

Color temperatures of common light sources are shown in Figure 7-3. Color temperature can also be measured with a *color-temperature meter*. Estimating color temperature is not easy. If you don't have a meter, I recommend that you use a good reference table.

The word *mired* is an acronym for *micro reciprocal degrees*. A mired number is another way of expressing color temperature. To calculate

mireds, divide one million by the color temperature in degrees Kelvin.

For example, a color temperature of 5500K is 1,000,000/5500 mireds, or 182 mireds. A color temperature of

3200K is 1,000,000/3200 mireds, or 313 mireds.

To select a filter to change one color temperature to another, express both color temperatures in mireds (M).

LIGHT-BALANCING FILTERS

FILTER COLOR	EFFECT ON PHOTO	FILTER NO.
DARKER YELLOW		81D
↑		81C
	REMOVE BLUE	81B
↓		81A
LIGHTER YELLOW		81
LIGHTER BLUE		82
↑		82A
	REMOVE RED	82B
↓		82C
DARKER BLUE		

Figure 7-2

COMMONLY USED COLOR FILTERS

FILM TYPE	LIGHT	EFFECT OF FILTER	COMMON NOMENCLATURE	VISUAL COLOR	FILTER FACTOR
Any	Daylight	Reduce UV exposure	UV or Haze	Clear	1X
	Any	Reduce light 2 steps	ND 4X or ND 0.6	Gray	4X
	Any	Reduce light 3 steps	ND 8X or ND 0.9	Gray	8X
B&W	Daylight	Normal sky	8 or K2	Yellow	1.5X
	Daylight	Darker sky	15 or G	Yellow	2X
	Daylight	Very dark sky	25 or A	Red	8X
	Daylight	Normal tones	8 or K2	Yellow	1.5X
	Tungsten	Normal tones	11 or X1	Yel-Grn	4X
Daylight	Daylight	Reduce blue skylight	1A or Skylight	Lt. Pink	1X
	Daylight	Warmer image	81C	Orange	1.5X
	Daylight	Less red with low sun	82C	Lt. Blue	1.5X
	3400K	Normal colors	80B	Blue	3X
	3200K	Normal colors	80A	Drk. Blue	4X
	Fluoresc.	Normal colors	FLD	Purple	IX
Tungsten	Daylight	Normal colors at morn or late aft	85C	Amber	1.5X
	Tungsten	Normal colors with household lamps	82C	Lt. Blue	1.5X
	Fluoresc.	Normal colors	FLB	Orange	1X
3400K	Day	Normal colors	85	Amber	2X
3200K	Day	Normal colors	85B	Amber	2X

The photo at left was made with tungsten-balanced film in daylight. The image is too blue. The photo at right was made on the same film, but with an 85B color-conversion filter. Satisfactory color balance resulted.

Then find the *mired change* needed:

Change = Desired M – Existing M

For example, to use film balanced for 3200K (313 mireds) with illumination of 5500K (182 mireds):

Required Change = 313 – 182 mireds
= 131 mireds

Now, all you have to do is find a filter with a mired shift of 131 mireds. You can look that up in Figure 7-4. It's an 85B filter.

Making a light source more *reddish* demands a *positive* mired shift, as above. This involves using an *amber* filter. Making light more *bluish* demands a *negative* mired shift and use of a *bluish* filter. For example, to use film balanced for 5500K (182 mireds) with 3200K (313 mired) illumination would require a mired shift of −131

and, therefore, a bluish 80A filter.

One great value of mireds is that they tell you what a filter will do at *any* color temperature. For example, a + 63 mired shift changes 3400K to 2800K or 8400K to 5500K.

Figure 7-5 makes conversion easy. An example is shown by the arrows. From the light-source color temperature, travel across the graph to intersect the curve for the film you are using. Drop down to the scale below. The numbers adjacent to the scale are the color changes in mired shifts.

If a mired shift represents a standard filter, its number is also shown. If not, refer to the Figure 7-4 and find the closest filter.

For convenience, mireds are sometimes converted into smaller units called *decamireds*. One decamired

equals 10 mireds. Color-temperature meters are usually graduated in decamireds. Several filter manufacturers number conversion and balancing filters in decamired values.

With decamired filters, you can make any color change just by stacking filters and adding up the decamired values. To convert mireds to decamireds, simply divide by 10.

COLOR-COMPENSATING FILTERS

So far, I've discussed filters that change the color temperature of a light source. They make light "warmer" or "cooler," to suit a specific film.

Color-Compensating (CC) filters change colors within the spectrum more selectively. CC filters affect single colors rather than color tem-

APPROXIMATE COLOR TEMPERATURES

SOURCE	COLOR TEMPERATURE (K)
Setting sun	1500 to 2000
Candle light	1800
Household tungsten lamp	
40-Watt	2600
75-Watt	2800
100-Watt	2900
200-Watt	3000
3200K photo lamp	3200
3400K photo lamp	3400
Clear flash bulb	
Aluminum filled	3800
Zirconium filled	4200
Blue photoflood lamp	4800
Direct noon sunlight	5000
Theatrical arc lamp	5000
Standard daylight	5500
Blue flash bulb	5500
Electronic flash	5500 to 6000
Sky	
Heavy overcast	6500
Light overcast	7500
Hazy blue	9000
Clear blue	12,000 to 20,000

Figure 7-3

MIRED NUMBERS FOR WRATTEN FILTER DESIGNATIONS

MIRED SHIFT	WRATTEN NUMBER	COLOR CHANGE
+242	86	
+131	85B	
+112	85	
+81	85C	
+67	86B	
+52	81EF	
+42	81D	TOWARD RED
+35	81C	
+27	81B	
+24	86C	
+18	81A	
+9	81	
−10	82	
−21	82A	
−24	78C	
−32	82B	
−45	82C	
−56	80D	
−67	78B	TOWARD BLUE
−81	80C	
−112	80B	
−131	80A	
−196	78AA	
−242	78	

Figure 7-4

If a sunset isn't colorful enough, you can help it along with an orange filter. You can even simulate a sunset earlier in the day in this way. For this photo, an 85B color conversion filter was used. Exposure was based on the ocean surface. As a result, the figure recorded almost in silhouette. Photo by Josh Young.

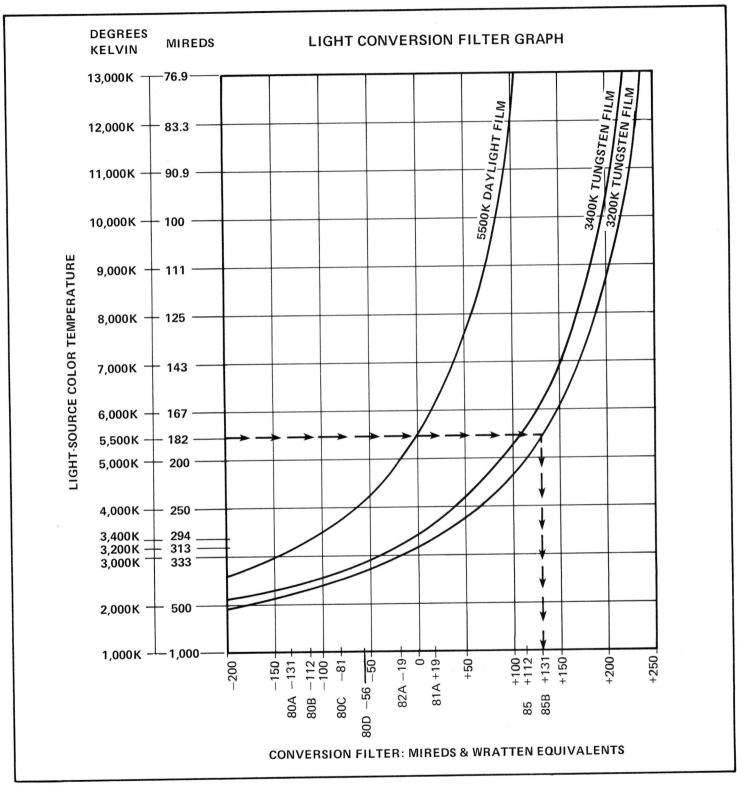

Figure 7-5

105

This is a CC20Y filter and a CC50Y filter. Where they overlap, the total density is equivalent to a CC70Y filter.

perature. The mired system cannot be used with them.

CC filters are made to control the three primary colors and the three complementary colors—red, green, blue, cyan, yellow and magenta. CC filters have a special nomenclature that tells you the type of filter, its color and how "strong" that color is.

An example is a CC20R filter. The CC tells you that it's a color compensating filter. The R tells you that it's red. The 20 indicates the darkness, or density of the filter.

The density of a filter is indicated for the colors not transmitted—the complementary colors. Densities normally range from a maximum of 50 to a minimum of 05 or 025. To derive

real density values form these numbers, add a decimal point in front of the first figure. For example, a CC 50 filter has a density of 0.50 and a CC 05 filter has a density of 0.05.

Color-Cast Correction—Often a color imbalance in a scene is not caused by the light source but by the subject's environment. For example, if you photograph someone under the green foliage of a tree, the portrait may have a greenish color imbalance. If you photograph someone close to an orange-colored wall, the photo may have an excessively orange appearance.

CC filters are ideal to correct such color casts. For example, for the portrait under foliage, a CC10M or CC20M filter should give a great improvement. The magenta color of the filter removes some of the complementary color, which is green.

Fluorescent Light—When daylight-balanced color film is exposed under fluorescent light, a greenish color cast usually results. This is particularly unflattering to skin tones. The best CC filtration to correct this depends on the type of fluorescent light used. The accompanying table gives some suggested *starting* filter combinations. To get ideal color rendition with fluorescent light, you may need to make some tests and select filtration accordingly.

Stacking Filters—You notice that I mentioned *filter combinations* in the

previous paragraph. You can stack two filters on top of each other to achieve a specific filter strength. The CC-filter values are additive. For example, when you use a CC30M filter together with a CC05M filter, you get an effective filter strength of CC35M.

EXPOSURE CORRECTION

Filters change the color of light by reducing the transmission of some colors. If the change is large, there will be significantly less light—sometimes two or more exposure steps less.

If you measure exposure with the camera's built-in meter, with the filter in place in front of the lens, the exposure reading will be OK. No exposure adjustment is needed.

Filter Factor—Before cameras had built-in exposure meters, photographers used separate handheld exposure meters. Many still do. The exposure suggested by a separate meter that does *not* view the scene through a filter must be corrected if a filter will be used on the camera.

That correction is called a *filter factor*. Filter manufacturers publish these numbers. You multiply the exposure reading taken *without* the filter by the filter factor to get the exposure to be used *with* the filter.

To indicate that the filter factor is a multiplier, it is normally used with an X symbol. For example, an 80A color-conversion filter has a filter factor of

FILTERS FOR USE WITH FLUORESCENT LIGHTING						
KODAK FILM TYPE	TYPE OF FLUORESCENT LAMP					
	DAYLIGHT	WHITE	WARM WHITE	WARM WHITE DELUXE	COOL WHITE	COOL WHITE DELUXE
Daylight and Type S Professional	40M + 30Y	20C + 30M	40C + 40M	60C + 30M	30M	30C + 20M
Tungsten, Type B (3200K) and Type L Professional	85B + 30M + 10Y	40M + 40Y	30M + 20Y	10Y	50M + 60Y	10M + 30Y
Type A (3400K)	85 + 30M + 10Y	40M + 30Y	30M + 10Y	NO FILTER	50M + 50Y	10M + 20Y

These corrections are approximate. For critical applications, make test exposures with the specific lights being used.

4X. This means you should increase exposure by four times, or two exposure steps.

SKYLIGHT, UV AND HAZE FILTERS

If a subject is in the shade, illuminated by skylight only, an uncorrected color photo will have a bluish color cast. Distant scenes often record with a blue haze.

In addition to the blue you see, sunlight includes ultraviolet radiation that you can't see. It also affects film, giving an image a bluish color cast.

Three types of filters are available to reduce excessive blue:

UV Filters reduce ultraviolet without much effect on visible light.

Skylight Filters, such as the Wratten lA, reduce both UV and the shortest visible blue wavelengths. These filters reduce haze and slightly warm the colors in a photo.

Haze Filters, offered by some filter manufacturers, have a slightly greater warming effect than skylight filters.

For most applications, there is very little difference between the three filter types mentioned. Held against white light, they all have a faint pinkish tint.

For general use, I recommend a skylight filter. Some photographers use one permanently on the lens to keep the front surface of the lens clean. It's like a transparent lens cap.

FILTERS FOR FLUORESCENT LIGHT

I've already mentioned the use of CC filters with fluorescent light. There are also special filters, designed to make an approximate color correction with fluorescent lighting.

Filters from different manufacturers are labeled in different ways. However, the purpose of the filter is usually clear from the labeling. For example, an FLA filter balances fluorescent light for Type A film. Similarly, an FLB filter is for Type B film and an FLD filter for daylight-balanced film.

There are many types of fluorescent lights. Each has its own color characteristics. Often, you'll find a mixture of several types used together. This makes precise correction recommendations impossible. Use the filters I have recommended. When you get the results back from the lab, you may have to shoot again, fine tuning the filtration as needed—using CC filters.

POLARIZING FILTERS

As mentioned earlier, polarizing filters can play an important part in color photography. With them, you can control reflections, increase color saturation, and darken a blue sky. Because the filters can be used with both color and b&w films, I'll discuss them after the section on filtration with b&w film.

Both photos were made under fluorescent lighting. At left, no filter was used. At right, a CFD filter was on the lens. There's a striking improvement.

Color Filters for B&W Film

B&W film records brightnesses in a scene, but not colors. All b&w film used for general photography is *panchromatic*. This means that it is sensitive to all visible colors. It is also sensitive to UV.

Objects of different colors, but about the same brightness, tend to record about the same shade of gray on panchromatic film. However, the brightness or darkness with which any color records can be controlled with color filters.

COLOR DIFFERENTIATION

In real life, we can easily distinguish between two objects that are equally bright if they have different colors. For example, a red rose and green leaves are plainly different.

When photographed on b&w film, however, they may record in the same shade of gray because they are equally bright. As you can see in the accompanying photo, it may be difficult to distinguish one from the other. A more pleasing photo results if they are not the same shade of gray.

The only way to differentiate between two colors of equal brightness on b&w film is to make one darker and the other lighter. This increases the *contrast* between them.

With b&w film, a color filter lightens its own color and darkens all other colors. A red rose, photographed through a red filter, will appear lighter. Green leaves will appear darker. If you were to use a green filter, the opposite would happen: The rose would be dark and the leaves bright.

A good way to select the filter is to look through it. Ignore colors and observe brightnesses. You can easily see the effect.

DARKENING BLUE SKY

Blue sky in a b&w photo usually

On b&w film, a red rose reproduces at about the same shade of gray as the surrounding green leaves.

A red filter lightens the rose and darkens the leaves.

A green filter lightens the leaves and darkens the rose.

A deep-yellow or orange filter holds back some blue light. In b&w photography, such a filter can be used to darken blue sky, making white clouds stand out more clearly.

looks lighter than in real life. That's because there is a lot of UV in the sky to which the film is very sensitive. If there are white clouds, they record about the same shade as the sky and are barely noticeable.

A more dramatic photo results if the sky is darkened. To darken the sky, you must prevent the UV and some of the blue from reaching the film. You can achieve this with a filter that holds back those wavelengths. White clouds will stand out clearly from a medium- or dark-gray sky, giving a more dramatic image.

A yellow filter darkens blue sky a little. An orange filter darkens it more. A red filter will have a very dramatic darkening effect.

CUTTING HAZE

Because haze contains a lot of UV

and blue, b&w films are very sensitive to it. Haze lightens distant scenes and makes them less distinct.

To hold back haze and get a clearer image of a distant scene, use a filter that absorbs blue and UV. With b&w film, you have more options than with color film because you needn't worry about color balance. You can use a yellow or orange filter. For dramatic haze penetration, you can use a deep-

red filter such as a No.25.

Polarizing Filters

Light travels along ray paths with a wave motion similar to waves on water. Water waves can move only up and down. Light waves can move or vibrate in all directions perpendicular to their path of travel.

Unpolarized light vibrates in all directions. Polarized light vibrates in

TO DARKEN SKY ON B&W FILM

EFFECT	FILTER
Preserve original appearance	8 or medium-yellow
Mild darkening	15 or dark-yellow
Strong darkening	25 or dark-red

HAZE-FILTER SELECTION
WITH B & W FILM

Increase haze	57 filter (blue) or any of the 80 series
More haze than you see	Use no filter
To preserve original appearance	8 (yellow)
Medium haze cutting	15 (deep yellow) or any of the 85 series
Strong haze cutting	25 or 29 (dark red)
Maximum haze cutting	Use IR film and special IR filter

HOW LIGHT BECOMES POLARIZED

Unpolarized light vibrates in all directions perpendicular to its path of travel.

Unpolarized light becomes polarized by reflection from most surfaces except unpainted metal. Reflected light from a horizontal surface is horizontally polarized; from a vertical surface it is vertically polarized. For maximum polarization of reflected light, angle A must be about 35°, depending on the reflecting-surface material.

When unpolarized light passes through a polarizing filter, it emerges with vibrations in only one direction.

Rotate the polarizer and the direction of polarization changes

POLARIZED BAND OF LIGHT ACROSS THE SKY

SUN

EARTH

90°

Unpolarized light from the sun is polarized by reflection (scattering) due to air molecules. The polarized band across the sky is always at a right angle to the sun, from the viewer's location.

only one direction. Much of the light that we see every day is polarized.

POLARIZATION BY REFLECTION

Light becomes polarized when it is reflected by most surfaces. An exception is unpainted metal. The extent of polarization is determined by the angle at which the light strikes the reflecting surface. Light is polarized most when the ray path makes an angle of about 35° with the reflecting surface.

For photographers, some of the important surfaces that polarize light include water, windows, picture frames and painted surfaces of all kinds.

POLARIZATION OF SKYLIGHT

On a clear day, light from a large part of the blue sky is polarized. That part of sky consists of a band running at a right angle to the direction of the sunlight reaching you. If the sun is low on the horizon, the polarized band is overhead and runs approximately from north to south. If the sun is overhead, the polarized band is near the horizon.

To find the polarized band, extend your thumb at a right angle to your forefinger and then point your thumb at the sun. When you rotate your wrist, your forefinger indicates the polarized band in the sky.

POLARIZATION BY FILTER

Special polarizing materials are made into polarizing filters. The filter transmits light vibrating in only one direction. You determine that direction by the orientation of the filter. Polarizing filters are made to rotate on the camera lens.

If unpolarized light enters a filter, polarized light emerges from the other side. The light may be polarized at any angle, such as horizontal or vertical, depending on the rotational angle of the filter.

If *polarized* light enters a filter that is rotated to *transmit* that angle of polarization, the light *goes through*. If *polarized* light reaches a filter set to block that angle of polarization, the light will not pass through.

Polarizing filters are gray and do not change the color of light transmitted.

The left photo shows more of what's outside the window than what's inside. The reflection totally obstructs the view of the interior. For the right photo, I used a polarizing filter. The reflection has been removed so that you can clearly see what's going on inside.

They reduce the amount of light equally at all visible colors.

REDUCING REFLECTION

Reflections on a window prevent you from seeing through the window. Glare on wooden furniture prevents you from seeing the wood grain.

Depending on the angle the light strikes the surface, such reflections consist of more or less polarized light. By selecting the angle at which there is maximum polarization—about 35°—and rotating the polarizing filter for maximum effect, you can totally eliminate such reflections and glare. Rotate the filter while you look through the camera viewfinder. Set the filter for the effect you want.

IMPROVING COLOR SATURATION

Surface reflections from houses, foliage, cars and many other objects cause the appearance of colors to be weakened. For example, when sunlight reflects from a green wall, you see both the green and the surface reflection of the white sunlight. The result is a desaturated, weak green.

Depending on the angle of the sun, and of your camera to the reflecting surface, the reflection will consist of more or less polarized light. You can eliminate or reduce a reflection consisting of polarized light by using a polarizing filter. Removing the reflection will enhance the green color in the wall.

Even with b&w film, the reduction of surface reflections can lead to much brighter, clearer images.

DARKENING BLUE SKY

If you compose an outdoor scene so the polarized part of the sky is in view, you can darken the sky dramatically with a polarizing filter. Look through the camera and rotate the filter for best effect. That doesn't work on overcast days because an overcast sky is not polarized.

Sometimes you must compromise between the rotation of the polarizer that gives the best sky and a different setting that gives the most color enhancement of other objects.

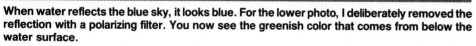

When water reflects the blue sky, it looks blue. For the lower photo, I deliberately removed the reflection with a polarizing filter. You now see the greenish color that comes from below the water surface.

If the polarized part of the sky is in view, it can be darkened with a polarizing filter.

Some polarizing filters have a handle to assist in rotating it and to indicate the angle of rotation.

USING NEUTRAL-DENSITY FILTERS TO INCREASE EXPOSURE TIME OR APERTURE		
FILTER NOMENCLATURE	MULTIPLY EXPOSURE TIME BY:	OPEN LENS APERTURE BY (f-STOPS):
ND .1	1.25	1/3
ND .2	1.6	2/3
ND .3 or 2X	2	1
ND .4	2.5	1-1/3
ND .5	3.1	1-2/3
ND .6 or 4X	4	2
ND .8	6.25	2-2/3
ND .9 or 8X	8	3
ND 1.0	10	3-1/3
ND 2.0	100	6-2/3
ND 3.0	1000	10
ND 4.0	10,000	13-1/3

A polarizing filter is particularly valuable for darkening a blue sky with color film. Using a colored filter to achieve the same effect would cause a color imbalance.

EXPOSURE ADJUSTMENT

Polarizing filters have a density that reduces light transmission by about 2.5 exposure steps. The exact density is expressed by the filter factor. Whatever it is, most camera exposure meters will automatically adjust for the light loss.

Metering Problems—Some cameras do not meter correctly when a polarizing filter is used. A camera with a semi-transparent area in the mirror, designed to transmit part of the light to a metering sensor, is a typical example. The problem is that the semi-transparent area partially polarizes the light striking it.

The light passing through the lens may not be the same as the light reaching the meter. It depends on the orientation of the filter on the lens in relationship to the orientation of the polarizing effect of the semi-transparent mirror.

Any camera with a beam splitter in the light-measuring system may measure polarized light incorrectly.

If this effect is likely to occur with your camera, the camera instruction booklet should tell you about it—although not all do. If you experience consistent overexposure at a certain rotation of your polarizing filter, it's an indication of the problem.

One solution is to meter without the polarizer on the lens. Then install and rotate the polarizer. Correct the metered exposure to compensate for the filter factor.

Another solution is to buy a *circular* polarizer. Ask your camera dealer for details.

Neutral-Density Filters

Sometimes you may want to shoot at a larger aperture or with a slower shutter speed than the lighting conditions and the speed of the film you're using will allow. For example, you may want to use f-2.8 instead of f-8, to limit depth of field. Or, you may want to shoot at 1/15 second rather than 1/60 second, to blur the water in a rushing stream. Neutral-density filters reduce the amount of light to allow using a larger aperture or slower shutter speed.

A *neutral density (ND)* filter is a gray filter. It enables you to reduce by a specified amount the light allowed to pass through the camera lens. In doing so, it causes no color changes.

The reduction of light is stated in two ways: By a filter factor, such as 2X, or by a density value such as 0.3. A filter factor of 2X represents one exposure step. A density of 0.3 also represents one exposure step. A density of 0.6 is two steps, and so forth. The accompanying table shows a series of ND-filter values and their exposure effects.

Stacking ND Filters—You can stack ND filters to get many density values with relatively few filters. The density values are additive. For example, using an ND 0.6 filter with an ND 0.3 filter is the same as using one ND 0.9 filter.

When filter density is specified by filter factor, the effect of stacked filters is the product of the factors. For example, a 2X filter stacked with a 4X filter is the equivalent of an 8X filter.

Special-Effect Filters

The variety of special-effect filters available is almost unlimited. This section lists some popular types, with brief descriptions. Manufacturers of special-effect filters invent descriptive trade names for their products, such as *Vibrant Rainbow Color*. In this discussion, I'll use generic names only.

Each special-effect filter comes with an instruction leaflet. To get the best use out of the device, read the directions carefully. Sometimes the effect produced is influenced by the focal length of the lens or the lens-aperture setting.

COLOR FILTERS

There are two basic kinds of special-effect filters. One relies on color manipulation. The other provides a wide variety of optical effects. I'll discuss color filters first.

Ordinary Color Filters—You can use ordinary color filters to obtain special effects on color film. For example, you can make people green or bananas red.

Color Filters on Flash—Using a color filter over the flash window causes the flash to emit colored light. Nearby objects, illuminated mainly by the flash, will reflect that color. Distant objects, lit by ambient light, will have normal colors.

Alternatively, by using a CC filter over the flash and the complement of that color over the lens, nearby objects will appear with normal color because the two filters cancel each other's effect. Distant objects, which don't receive much light from the flash, are colored by the filter over the lens.

Variable-Color Filters—Special filters incorporating polarizers provide variable color when rotated. The varia-

tion may be in a single color, such as dark red to light red. Or, it may be from one color to another. For example, a red-green variable-color filter is red at one extreme, green at the other, and combinations of red and green at intermediate settings.

Two-Color Filters—Half of the filter is one color and the other half is another color. Or, one half may be colored and the other half be clear. If the colors change gradually from one to the other, it is called a *graduated* filter.

A useful version for exposure control has a neutral-density filter on one half and is clear on the other. The neutral-density portion is used to darken the sky, which might otherwise record as excessively bright.

You can shoot sunsets with stronger colors by using a filter that's half orange or red and half clear. The red

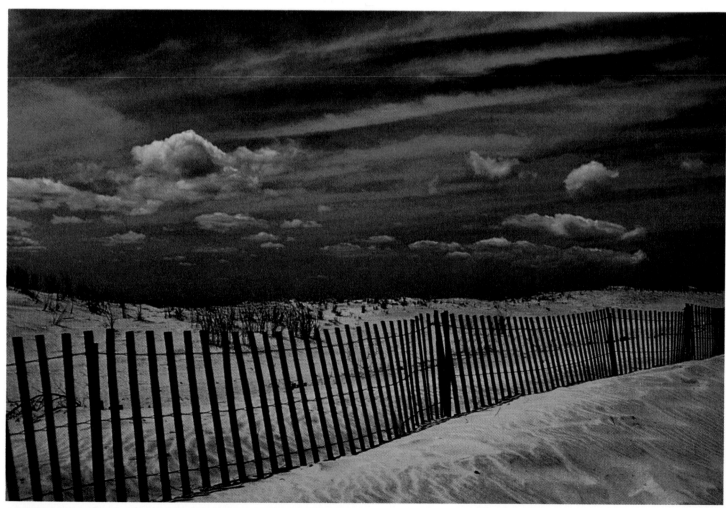

A graduated, blue Cokin filter enhanced the blue of the sky and deepened its tone without affecting the foreground color or tone. A wide selection of graduated filters is available. Photo courtesy of Minolta Corporation.

enhances the sunset without affecting the foreground area.

MASKS

Masks are black panels, held in front of the camera lens in a special holder. The masks have holes in various shapes. There are circular, heart-shaped and diamond-shaped holes. You can also get "reversed" masks, having a solid center with a clear surrounding area. There are half-masks that cover half the scene and leave the other half unobstructed.

Masks are generally used to make double exposures. Place the first mask in position and make an exposure. The film receives an image through the opening in the mask. The rest of the frame is unexposed. Then, place the reversed mask in position and make another exposure on that part of the frame which was not used for the first exposure. Meter each shot without the mask and shoot at the metered exposure. Bracket toward increased exposure.

Common tricks with masks include the placement of a face in an unusual location or including the same person twice in one image.

Spot or Clear Center—These masks have a circular spot in the center that may be colored or clear. The surrounding area is another color or "frosted" to make a diffused image. Some types are dark outside the center spot to vignette the image.

MULTIPLE-IMAGE PRISMS

These are clear "filters" with molded prisms on the front surface. Each prism produces a separate image of the subject. If the prisms are in a circular pattern, the images form a circle around a central image. If the prisms are in a row, the images will be aligned in a row.

STAR FILTER

A grid of thin, opaque lines in otherwise clear glass or plastic creates star patterns from bright points of light in a scene. Star filters are available to give stars with four, six or more points. Some star filters have one set of lines that can be rotated in respect to the other, causing asymmetrical star patterns.

This woman seems to be talking to herself. The amusing double exposure was made with a mask that covered the left side of the frame for one exposure and the right side for the other.

A prism attachment was used on the camera lens to make these multiple images in one exposure.

You can use several special-effect filters together. This photo of the Eiffel Tower in Paris was made with Cokin filters that diffused the image, made it blue and added a star effect. Photo courtesy of Minolta Corporation.

A circular diffraction filter created this colorful pattern from a setting sun.

DIFFRACTION FILTER

Diffraction occurs when light passes closely by an opaque edge. The effect is that light rays are bent and the colors are separated as in a rainbow.

Diffraction special-effect filters have many closely spaced opaque lines in otherwise clear glass or plastic. If the lines are parallel, linear rainbow patterns are formed in the image. If the lines are concentric circles, radial rainbow patterns are formed. The effect is noticeable mainly around bright points in the image.

SOFT-IMAGE FILTER

Clear filters with a rippled or frosted surface are used to diffuse the image, creating a soft-focus effect. In portraiture, this effect obscures small details, such as facial wrinkles. It can produce dreamlike images.

Some makers offer soft-focus filters in several "strengths," identified by numbers.

FOG FILTER

These filters have a slightly frosted surface that gives the effect of fog in the image. They are available in different "strengths" to produce more or less fog effect.

TRAILING BLUR

This filter forms a sharp image of the subject plus an extended blur. The effect is similar to image blur due to subject motion, but usually more exaggerated.

Filter Materials and Mounting Methods

Filters are made of a variety of materials with a variety of methods used to attach or support them in front of the lens.

It's easy to add a dreamlike mood to a photo by adding an unusual color. This beach scene was transformed by the use of a Cokin magenta-pastel filter. Photo courtesy of Minolta Corporation.

The New York skyline was reversed on itself to produce a pseudo-reflection. This was achieved with a Cokin Mirage filter. Photo courtesy of Minolta Corporation.

MATERIALS

Each filter needs a "base" to carry its color, pattern or density. A variety of bases is used. Here are the most common ones.

Gelatin Film—Eastman Kodak manufactures a large variety of inexpensive, high-quality gelatin filters. They are square, thin and flexible. They are also delicate and difficult to clean. Handle them only by the edges, preferably with soft, cotton gloves. Gelatin filters can be cut with scissors.

Gelatin is used only for color filters, not special-effect attachments designed to alter ray paths.

Acetate Film—Filters on acetate film are available in many colors. In many ways they are similar to gelatin filters. However, they are not optically homogeneous like gelatin filters and should not be used in an image-forming light path. This means they are not suitable for use on your camera lens. They are OK for use on light sources, such as flash or studio lights.

Glass—Glass filters are more durable than gelatin filters and are easier to

A step-up ring mounts a larger-diameter filter on a smaller-diameter lens. The ring shown here fits between a lens with 55mm filter threads and a filter with 62mm threads.

Some lens accessories, such as this multiple-image filter, are series threaded and attach to camera lenses by a series adapter.

clean. They are also more expensive. The filters are usually round and held in a metal ring or frame.

Good-quality glass filters have anti-reflection coatings, similar to lens coatings, on both surfaces. That increases light transmission through the filter and reduces reflections from its surfaces. Glass filters are made both for color changes and optical special effects.

Plastic—Filters made of plastic are more durable than gelatin filters but scratch more easily than glass. They cost more than gelatin but usually less than equivalent glass filters. They normally don't have anti-reflection coatings.

MOUNTING METHODS

Most lenses have a threaded ring at the front, on the inner surface of the lens barrel. It is usually called the filter ring. The diameter of the filter ring, in millimeters, is shown in filter specifications and sometimes marked on the lens with the symbol to identify it and distinguish it from lens focal length.

Filters and other lens attachments must have external screw threads with the same diameter, to fit the lens. Filter-thread diameters range from about 39mm up to about 77mm. Lenses with different focal lengths often have different filter-thread diameters.

Step-Up and Step-Down Rings—Threaded adapter rings are available to change the filter-thread diameter of a lens. The adapter screws into the lens. On the front of the adapter are threads with larger or smaller diameter than the lens.

Step-up rings provide a larger thread diameter than the lens. Step-down rings provide a smaller diameter.

Step-down rings should be used with caution. The ring itself or the attachment screwed into the ring may block light around the edge and vignette the image.

Screw-In Filters—Some glass or plastic filters are round and mounted in a threaded frame. The filter is attached to the lens by screwing it into the filter thread on the lens or into a step-up or step-down ring that fits on the lens.

Stacking Screw-In Filters— The filters have internal threads on the front of the frame that are the same diameter as those on the back. This allows stacking filters with the same thread diameter. However, stacking filters may cause image vignetting.

Lens Hoods—A lens hood usually screws into the filter threads on the lens. If a screw-in filter is used on the lens, the lens hood can be screwed into the front of the filter.

Some lenses accept bayonet-type lens hoods that attach to projections on the outer surface of the lens barrel. Filters fit inside the hood.

Choosing Filter Size—Telephoto and wide-angle lenses usually have filter-thread diameters that are larger than those of lenses in the middle range, such as 50mm.

Plan to use step-up rings rather than step-down rings. It's a good idea to buy filters to fit the largest filter-thread diameter that you own or plan to own. These can be mounted on lenses with smaller filter-thread diameters by using step-up rings. Image vignetting is then unlikely. Large filters are expensive, but less so than a set of filters for each filter-thread diameter.

Purchase lens hoods that screw into filters and that match the angles of

MILLIMETER SIZE RANGE OF SERIES-TYPE ADAPTERS	
Series Number	Approximate Millimeter Range
5	17 to 36
6	27 to 49
7	40 to 62
8	40 to 77
9	56 to 84

This holder accepts a gelatin filter in a metal frame.

view of your lenses. Check to be sure they don't vignette.

SERIES FILTERS

Although these are no longer common, you should know about them. Series filters are a way to fit filters of one diameter on a *series* of lenses with several filter-thread diameters. The filters, in circular mounts without threads, are identified by a series number that is usually stated as a Roman numeral, such as VII.

Each filter can be placed in a series adapter with the same series number. Series adapters are made with a range of thread diameters on the back to fit the lens.

There are internal threads on the front of the adapter. A retaining ring is screwed into those threads to hold the filter in place. The three parts are shown in the accompanying photo. The front threads of adapters of the same series number all have the same diameter.

You should know about series filters because some lens accessories, such as special-effect filters, are threaded to fit into the front of a series adapter with a specified series number. When you buy the filter, you should also buy series adapters to fit your lenses.

Suppose a filter has series VII threads. You need series VII adapters. If you have lenses with 55mm and 58mm filter threads, you need two series VII adapters—one with 55mm threads on the back, the other with 58mm threads.

If you also have a lens with a 72mm filter-thread diameter, the filter won't fit on it because the back threads of a series VII adapter are not available in that size. The accompanying table shows the range of back-thread sizes in millimeters for adapters of each series size.

GELATIN-FILTER HOLDERS

Gelatin filters are available in two-, three- and four-inch squares or equivalent metric dimensions. Each filter can be placed in a special metal frame. Two or more filters can be stacked together.

The metal frame is held in a slotted holder, with the open end up. There are frames and holders for each filter size. The holder screws into the filter

threads on the lens or is attached by an adapter. The adapter may be a series type. Not all holders provide threads on the front to attach a lens hood.

FILTER SYSTEMS

Several manufacturers offer filter-mounting systems that include a variety of companion filters. The purpose is to use filters of one size with lenses having more than one filter-thread diameter.

The color or special-effect filters are usually flat, plastic squares. Masks are also available, including blanks from which you can make your own cutouts.

Slotted Frame Type—One type uses a plastic holder with several slots for the square filters so they can be stacked. The holder attaches to the filter threads of the lens using special adapters. Adapters are available for various filter-thread sizes.

For filters that require rotation, such as a polarizer, the filter itself may be round and rotate in the holder, or the holder may rotate on the lens.

A lens hood fits on the front of the filter holder. One type is in sections that fit together, so you can make it

longer or shorter depending on the angle of view of the lens. Add sections until the image in the viewfinder begins to show vignetting. Then remove the last section, to eliminate the vignetting. Another type telescopes like a bellows.

Magnetic Type—Another filter system uses magnetic frames that are attached to the holder by magnetic attraction. This system also allows stacking and rotation of filters. A rubber lens hood with a magnetic base can be attached in front of the filter or filters being used.

Advantages—Filter systems offer a large variety of filters and special-effect gadgets, all with similar shape and size. The system idea is appealing because everything fits everything else. The total cost may be less and the end result easier to use than the equivalent acquired in bits and pieces from various manufacturers.

FILTER AGING

Color filters contain dyes and all dyes fade with time. To minimize this aging effect, keep filters away from light when not in use. Also avoid heat and high humidity.

Store all filters in a cool, dry, dark place, in containers that protect the surfaces from scratching.

This slotted filter holder accepts up to three filters. The filters can be rectangular or round, like polarizers and some special-effect filters. The lens hood on the front is in sections so you can adjust it to the angle of view of the lens in use.

The attachment on the lens is a magnetic ring. The mounting frames of filters used in this system are also magnetized. Several filters may be stacked, all held together by magnetic attraction. The circular filter with a tab on the side is a polarizer. Another filter, in a rectangular frame, is mounted in front of the polarizer. This system is more compact than slotted holders but makes it more difficult to rotate polarizers and special-effect filters.

A filter that transmits some colors more than others will change the color balance of a picture without removing colors totally. If you use a relatively narrow-band filter that transmits only one color, the entire picture will take on that color and all other colors will be removed. For this photo, I used a red filter. Because it transmits only red, the entire image is reddish.

This is a triple exposure of a waterfall. I made the first exposure through a red filter, the second through green and the third through blue. I moved the camera slightly between exposures. Other colors, such as yellow, were formed where the filters' effects overlapped.

8
Image Magnification

You'll enjoy exploring the world of close-up photography. It is challenging and enables you to see common things in a new, more detailed way.

Making large images of small subjects is a challenging and satisfying aspect of photography. The procedure can be as simple or elaborate as you wish. This chapter explains how to do it both ways.

For best image quality, use a bellows or extension tubes, as discussed in the following sections. For simplicity, use accessory close-up attachments, discussed at the end of this chapter.

DEFINITIONS

Magnification is the height of the image on film *divided by* the height of the subject. Of course, you can compare widths instead.

$$M = I / S$$

M is magnification; I is image size—either height or width; S is subject size, using the corresponding dimension—height or width.

If the image on film is the same size as the subject, magnification is 1, which is called *life-size* and sometimes stated as 1:1. If the image is 20mm tall and the subject is 10mm tall, magnification is 20mm/10mm, which is 2.

Photography of an object at life size or larger is called *photomacrography,* commonly referred to as *macro* photography. The practical upper limit of magnification, using your camera and normally available accessories, is about 12. For very high magnifications, it's best to shoot through a microscope.

As shown in Figure 8-1, image magnification is determined by the lens-to-subject distance and the lens-to-image distance. From now on, I'll refer to them as *subject distance (S)* and *image distance (I)*.

MAGNIFICATION BY EXTENSION

In Figure 8-1, subject and image distances are measured from the center of a simple, single-element lens. With complex lenses, having more than one element, it's a little more complicated. However, the basic principle is the same.

The rays entering the lens from the extremities of the subject are parallel to the rays leaving the lens to form an image of those extremities. The angle between these rays is the same on both sides of the lens.

If the image were farther from the lens while the subject distance remained the same, the image would be larger. By geometry, the ratio of image size to subject size is the same as the ratio of their distances from the lens. **Magnification with 50mm Lens—** With a lens focused at infinity, image distance is the same as the focal length of the lens. Using a 50mm lens, a subject at infinity gives a sharp image 50mm from the lens. As the lens is focused on nearer subjects, the lens moves *farther* from the film.

You can measure how far the lens moves because it becomes physically longer. A typical 50mm *f*-1.4 lens will travel outward about 10mm and then stop. It is then focused as near as it can be. The lens started at a distance of 50mm from the film and moved outward another 10mm. Image distance is 60mm.

When you also know subject distance, you can calculate magnification. The *focused* distance can be read on the distance scale on the lens. Focused distance is from the *film plane* to the subject. In Figure 8-1, *focused* distance is the sum of *subject* distance (S) and *image* distance (I).

Typically, the nearest focusing distance of 50mm lenses is about 18 inches, which is about 450mm. That includes *both* image distance and subject distance.

Image distance is 60mm. Therefore subject distance is 450mm minus 60mm, which is 390mm. Image magnification is 60mm/390mm, which is 0.15.

When the magnification of a lens is stated in a lens specification, it means maximum magnification at the closest focusing distance.

Why a Lens Won't Focus Closer— The closest focusing distance of a lens is limited by the *focus travel* of the lens. If you could move the lens farther

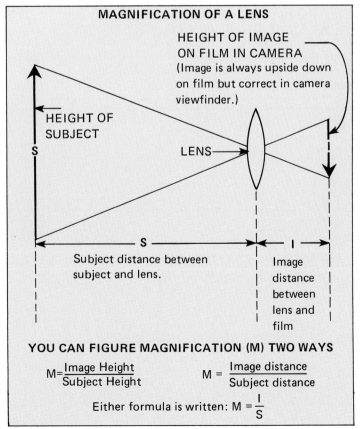

Figure 8-1

from the film, magnification would increase. Image quality would *decrease*.

Lens designers set a limit to closest focusing distance that still produces acceptable image quality. This chapter discusses ways to focus closer and get more magnification, but usually with some reduction in image quality.

Relationship Between Subject and Image Distances—With any lens, neither distance can change independently of the other. As subject distance decreases, image distance must increase, and vice versa. At magnifications higher than 1, image distance is larger than subject distance.

MACRO LENSES

One way to make larger images is to buy a lens designed for that purpose. It's called a *macro lens*. There are two main differences between a macro lens and an ordinary lens. The macro lens has a longer focus travel, so you can position it farther from the film by turning the focusing ring. Optically, macro lenses are designed to produce best image quality at a magnification of 1.

Most lens aberrations are reduced by using a smaller aperture. The maximum aperture of macro lenses is, therefore, smaller than that of ordinary lenses. Maximum aperture is usually limited to *f*-3.5 or *f*-4. Macro lenses are built with better flatness of field than ordinary lenses, so you can photograph flat objects, such as postage stamps.

Typical macro lenses are 50mm *f*-3.5 and 100mm *f*-4. Some makers also offer 200mm macro lenses.

Requirements for Life-Size Reproduction—For a magnification of 1, when image size equals subject size:
- Image distance must equal subject distance.
- Image distance will be double the

A macro lens has longer focus travel than ordinary lenses, so it provides more magnification without accessories. This is a Yashica 55mm *f*-2.8 macro lens. It provides magnifications up to 1.0 with built-in focus travel. Macro lenses typically have deeply recessed front elements.

Depth of field is always limited in close-up and macro photography. This is sometimes a problem. However, as this photo shows, it can also be an advantage. You can concentrate viewer attention on the main subject by having the rest of the image blurred. Photo by C. Allan Morgan.

focal length of the lens.

● Subject distance will be double the focal length of the lens.

Using a 50mm lens as an example, when focused at infinity, there is 50mm between lens and film. Most of that 50mm is in the camera—the thickness of the camera body.

When positioned for a magnification of 1, there must be 100mm between lens and film—double the focal length. Starting at a distance of 50mm from the film, the lens must be moved an additional 50mm outward.

50mm Macro Lens—Some 50mm macro lenses have a focus travel of 50mm. With no accessories, you can get magnifications up to 1 just by turning the focusing ring.

Another design has a built-in focus travel of only 25mm—half the focal length. That allows magnifications up to 0.5, using just the lens. To get higher magnification, an accessory "spac-er" must be placed between lens and camera.

The spacer is called an *extension tube*. It's just an empty tube that is 25mm long. With it installed, the magnification range of the lens extends from 0.5 to 1.

100mm Macro Lens—With a 100mm macro lens positioned for a magnification of 1, image and subject distances are both 200mm. Some 100mm macro lenses have a focus travel of 100mm and provide magnifications up to 1 without accessories. Some have a focus travel of 50mm and require a 50mm extension tube to reach a magnification of 1.

Advantage of Longer Focal Length—Lenses with longer focal lengths provide more *working* distance between the front of the lens and the subject. If you are photographing an insect, greater working distance makes it less likely that the insect will fly or

An extension tube is just a spacer that fits between lens and camera body. It has no lens elements.

This attractive curl is a magnified part of a vine photographed in Mexico. Here, depth of field was no problem because the entire subject was in one plane, perpendicular to the lens axis. Photo by Thomas Ives.

flee. Greater working distance also makes it easier to get light on the subject.

LENS EXTENSION

Extension is the *total* distance between the film plane and the lens. In Chapter 2, I discussed how lenses of various focal lengths can fit on the same camera body. Lens-to-film distance is measured from an optical location called the *rear node*. For example, a 200mm lens is built so its rear node is 200mm from the film when the lens is mounted on the camera and focused at infinity.

When a lens is moved outward from that point, there is *added extension.* Added extension is the amount that is greater than the "built in" focal length of the lens.

Some added extension is provided by the focusing mechanism of the lens. If you install an extension tube between lens and camera, it provides additional extension.

HOW TO
CALCULATE EXTENSION

To make a larger image, you need to know two things:
● The magnification needed to produce the desired image size.
● The extension necessary to provide the desired magnification.

Use that amount of extension, and the image will be magnified the desired amount.

Calculating Magnification—Decide how much of the film frame you want the subject to occupy. The 35mm frame is 24mm tall and 36mm wide.

Suppose you decide to make the image 20mm tall so there is a small amount of space above and below the image. Measure or estimate the height of the subject. Suppose the subject is 10mm tall. Magnification is 20mm/10mm, which is 2. You need enough added extension to provide a magnification of 2.

Calculating Added Extension— Use this formula:

$$X = M \times F$$

X is the *added* extension; M is the desired magnification; F is the focal length of the lens.

Macro lenses are designed to have good flatness of field, which is useful when photographing flat objects such as this postage stamp.

Example—Suppose you want a magnification of 2 with a 50mm lens:

$$X = 2 \times 50mm$$
$$= 100mm$$

The amount of added extension with a 100mm lens would be 200mm. To provide added extension between lens and camera, you can use extension tubes or a *bellows,* described later.

LENS CONSIDERATIONS

Any lens can be extended for increased magnification. Lenses de-

When you magnify small subjects, you begin to see new things for the first time. For example, detailed views of plant parts can be wonderful subjects for graphic design. Because of its lines, shapes and colors, this picture arouses interest and attention, even if you're not a botanist. Photo by T.A. Wiewandt.

the extension tube duplicates the lens mount on the camera. A lens can be mounted on the front of an extension tube. Or, several extension tubes can be stacked and the lens placed at the front of the combination.

The essential specification of an extension tube is its length—the amount of added extension provided by the tube. There are several kinds of extension tubes.

Some have lengths chosen to work with macro lenses that need an extension tube to reach a magnification of 1. For a 50mm macro lens, the extension tube is 25mm long. For a 100mm lens, the tube is 50mm long. These tubes can also be used with any other lens from the same manufacturer.

Some tubes are in sets of three or four. A set of three may have lengths of 10mm, 15mm and 25mm. You can stack them in combinations to produce extensions of 10mm, 15mm, 25mm, 35mm, 40mm and 50mm.

With extension tubes of fixed lengths there are extensions that cannot be provided. For example, in the series just discussed you can't get an extension of 38mm. You can use the focusing mechanism of the lens to fill these gaps. For example, if you need 38mm of extension, stack extension tubes to provide 35mm and use the lens focusing mechanism to get the other 3mm.

To help solve the gap problem between extension tubes with fixed lengths, some makers offer a *helicoid* extension tube. It offers continuously variable extension.

It's possible to stack fixed-length tubes together with a helicoid tube. There are also telescoping extension tubes with variable extension, such as 50mm to 150mm.

Most extension tubes preserve the automatic features of camera and lens. They are usually called *automatic* extension tubes. The tubes have levers or other couplings to relay the mechanical signals between camera and lens.

Stacking more than three or four extension tubes is not recommended because of overall loss of rigidity.

REVERSING THE LENS

It would obviously make no differ-

signed for high magnification make better images than other lenses.

For the same amount of magnification, long-focal-length lenses require more extension—sometimes an amount that is difficult or impossible to provide. Longer lenses also give more working distance between lens and subject.

Extension Tubes

The back of an extension tube mechanically duplicates the back of a lens. It fits on the camera. The front of

ence if the simple lens shown in Figure 8-1 were reversed front to back. It wouldn't affect focal length or angle of view. The same can be true of lenses with more than one element.

All lenses designed to mount directly on the camera are corrected for aberrations on the assumption that subject distance will be considerably longer than image distance. In other words, of the two distances, the *longer* one is in front of the lens. That applies to both ordinary lenses and conventional macro lenses. It does not apply to special lenses designed for use only on the front of a bellows.

At a magnification of 1, subject and image distances are equal. At magnifications greater than 1, lens-to-film distance is greater than subject distance. Because the lens works better with the longer distance in front of the lens, image quality is improved by reversing the lens. That is done by using a *reversing ring*.

A reversing ring screws into the filter threads at the front of the lens. The other side of the reversing ring duplicates the mounting fixture on the back of the lens. With a reversing ring installed, you can attach the lens either way—normally or reversed.

HOW TO USE EXTENSION TUBES

Calculate or estimate the amount of extension you will need. The accompanying table shows added extension for a range of focal lengths and magnifications. With the calculated extension, or a value from the tables, magnification will be correct if the lens is not reversed. It will be approximately correct with 50mm lenses that are reversed. Reversed *wide-angle* or *telephoto* lenses will require either more or less extension for the desired magnification.

Assemble the needed extension tubes and attach them to the camera. Mount the lens on the front of the extension tubes.

Effect of Focusing Ring—If the lens is not reversed, the focus travel of the lens adds to the extension. The distance scale on the lens has no significance. Use the focusing ring to set magnification, not focus.

If a lens that visibly changes its length during normal focusing is reversed, a focusing ring doesn't affect magnification. It's a good idea to turn the focusing ring so the lens barrel extends past the back—now the front—of the lens to act as a lens hood.

A reversing ring allows you to mount a lens backwards. The ring screws into the filter threads on the front of a lens.

If a lens that focuses *internally* is reversed, look in the viewfinder to see what effect the focusing ring has on magnification.

Finding Focus—Find focus by moving the entire camera nearer to or farther from the subject. If the focusing ring does anything, the most noticeable effect is to change magnification. Think of it as a magnification control.

FOCAL LENGTH	ADDED EXTENSION IN MILLIMETERS										
	DESIRED MAGNIFICATION										
	.2	.3	.4	.5	.6	.7	.8	.9	1.0	1.2	1.4
20	4	6	8	10	12	14	16	18	20	24	28
24	4.8	7.2	9.6	12	14.4	16.8	19.2	21.6	24	28.8	33.6
28	5.6	8.4	11.2	14	16.8	19.6	22.4	25.2	28	33.6	39.2
30	6	9	12	15	18	21	24	27	30	36	42
35	7	10.5	14	17.5	21	24.5	28	31.5	35	42	49
40	8	12	16	20	24	28	32	36	40	48	56
50	10	15	20	25	30	35	40	45	50	60	70
55	11	16.5	22	27.5	33	38.5	44	49.5	55	66	77
70	14	21	28	35	42	49	56	63	70	84	98
85	17	25.5	34	42.5	51	59.5	68	76.5	85	102	119
100	20	30	40	50	60	70	80	90	100	120	140
150	30	45	60	75	90	105	120	135	150	180	210
200	40	60	80	100	120	140	160	180	200	240	280

This table shows the amount of added extension needed for various magnifications with various focal lengths. For example, with an 85mm lens, added extension of 170mm will provide a magnification of 2.0.

Camera Support—Anything that increases image size at the film plane also increases image blur due to camera movement during exposure. Provide a firm support for the camera, such as a tripod.

Light Problems—Adding extension reduces the amount of light that reaches the film. At high magnification, there may not be enough light to see the image clearly in the viewfinder. Long exposure may be required, even at maximum aperture. Also, the film is likely to be affected by reciprocity failure, making the required exposure time even longer. The brightness of the light reaching the camera's built-in meter may be below the limit of accuracy of the meter's light sensor.

Fast film shortens exposure time but doesn't help you view and doesn't extend the metering range of the camera. The best solution is to get plenty of light on the subject.

If you shoot outdoors, bright sunlight may provide enough subject illumination for magnifications up to about 4. At higher magnifications, or indoors, you'll need a strong light source close to the subject. Flash is ideal. It provides lots of light, doesn't get hot, and is convenient to use.

Exposure Metering—With automatic extension tubes, viewing and metering are done at open aperture. When you make the exposure, the camera automatically stops down the lens to the selected aperture.

If the extension tubes are not automatic, or if the lens is reversed, the camera cannot control aperture. You must use the aperture ring on the lens to change aperture size. Use open aperture to view and compose. To meter, stop down the lens to shooting aperture. That is called *stop-down metering*.

Some cameras meter stopped down with no special control settings. Others require you to make a control setting that "tells" the camera to meter stopped down, not at open aperture. Check the camera instruction booklet for details.

Setting Exposure—If there is enough continuous light to meter, set the exposure accordingly. Compensate for reciprocity failure, if necessary. For more information, see Chapter 3.

The meter can be "fooled" by unusually bright or dim backgrounds, just as in other kinds of photography. You can use the camera on aperture-priority automatic or on manual.

If the camera controls flash exposure with a sensor that "looks" at the film, flash exposure at high magnification is easy. That's one of the major advantages of camera-controlled flash.

If the subject is close to the lens, and the flash is in the hot shoe, the lens may shade the subject from the flash. It's best to use the flash off the camera, aiming it directly at the subject.

If you don't have camera-controlled flash, lighting problems are a little more difficult. I discuss some solutions later in this chapter.

Depth of Field—Whenever you increase image size, depth of field decreases. At high magnifications, depth of field is very small. It helps to use the smallest practical aperture.

HIGH MAGNIFICATION AT LOW COST

If you're not concerned about optimum image quality, you can get magnifications of about 2 or 3 with no extension tubes. All you need is a short-focal-length lens and a reversing ring. Flatness of field will not be superb but, if you are photographing a tiny flower or bug, it may not matter.

	ADDED EXTENSION IN MILLIMETERS										
FOCAL				**DESIRED MAGNIFICATION**							
LENGTH	1.6	1.8	2.0	2.5	3.0	4.0	5.0	6.0	7.0	8.0	9.0
20	32	36	40	50	60	80	100	120	140	160	180
24	38.4	43.2	48	60	72	96	120	144	168	192	216
28	44.8	50.4	56	70	80	112	140	168	196	224	252
30	48	54	60	75	90	120	150	180	210	240	270
35	56	63	70	87.5	105	140	175	210	245	280	315
40	64	72	80	100	120	160	200	240	280	320	360
50	80	90	100	125	150	200	250	300	350	400	450
55	88	99	110	138	165	220	275	330	385	440	495
70	112	126	140	175	210	280	350	420	490	560	630
85	136	153	170	213	255	340	425	510	595	680	765
100	160	180	200	250	300	400	500	600	700	800	900
150	240	270	300	375	450	600	750	900	1050	1200	1350
200	320	360	400	500	600	800	1000	1200	1400	1600	1800

At a magnification of 2.0, depth of field is acceptable although the button is slightly out of focus. At higher magnifications, when depth of field is very limited, you must select the point of best focus carefully, to give the image you want. The following three images show you why.

At a magnification of 4.0, the image doesn't have overall depth of field. The lens was focused on the fabric at upper right. Where the needle raised the fabric, it was out of focus.

Focusing on the needle improved the image, although the cloth is still out of focus in places.

The lens was focused on the red thread in the needle. The fabric on the left side, which is at about the same height as the needle, is sharp. The remainder is blurred.

Mount the reversed lens directly on the camera body. Because you can't make any adjustments, you'll get one basic magnification. Find focus by moving the camera.

Bellows

A bellows attaches to the camera at one end and the lens at the other. The ends are called *standards* or *mounting boards*. The black fabric between the standards is called the *bellows*. The standards move along a rail to change bellows extension. A tripod mount is on the bottom of the rail or on the bottom of the rear standard.

CONTINUOUSLY VARIABLE EXTENSION

Everything said so far about extensions applies also to a bellows. A bellows is just a convenient way to get variable extension.

The maximum extension is greater than that with a set of extension tubes. A common extension range for a bellows is about 25mm to 300mm. With a 50mm lens, that gives a range of magnification from about 0.5 to about 6. With shorter focal lengths, maximum magnification is proportionately greater.

A scale on the bellows shows the amount of extension used. The scale may also show magnification with a 50mm lens, both reversed and not reversed.

Auto Bellows—An auto bellows allows metering and viewing at open aperture. The lens is stopped down automatically to the set aperture when you make the exposure. Some bellows use a special, double cable release. One branch goes to the front standard. The other screws into the shutter button on the camera. Another design uses a standard cable release connected to the bellows and a separate cable between bellows and camera.

With a flash in the camera hot shoe, the camera lens may shade a subject that's very near. Ring-shaped flash units are available to fit on the front of the lens. They provide virtually shadowless illumination and are useful for photography at high magnification. Some ring flashes have four segments you can turn off individually. This enables you to create some shadow effects.

This photo was made at a magnification of about 1.0, using a Cokin close-up attachment. Depth of field was no problem because all coins were at the same distance from the camera. On coins, frontal lighting gives dark outlines against a bright base; side lighting gives bright outlines against a dark base. Here, the light came from the right side. The coin on the right was lit almost frontally and the coin on the left at a fairly sharp angle. Notice the difference in the effect. Photo courtesy of Minolta Corporation.

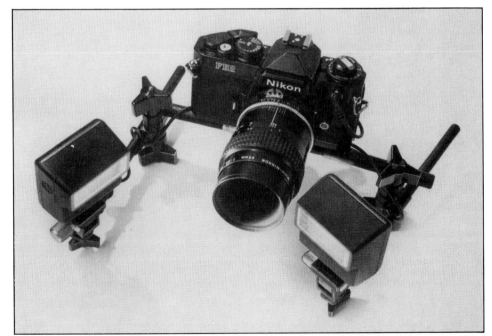

A macro bracket enables you to attach two flash units to the camera. Once you have aimed the lights at a subject at a specific distance, you can be sure they will remain that way. As you approach a subject for greater magnification, the lights also come closer. This minimizes the need for exposure compensation. The bracket shown, and other useful close-up/macro equipment, is available from Lepp and Associates, P.O. Box 6224, Los Osos, CA 93402. The flash units attached to the bracket can be swung in or out, and tilted, to achieve the required lighting effect.

With the lens wide open, meter in the usual way and set aperture on the lens. When you press the operating button on the cable release, it stops down the lens to the set aperture. Then, the other branch of the cable release starts the exposure.

Non-Auto Bellows—With a non-automatic bellows, you must meter with the lens stopped down to shooting aperture. If your camera requires a special control setting for stopped-down metering, make that setting.

Reversing the Lens—You can reverse a lens on the front of any bellows by using a reversing ring. Meter with the lens stopped down.

With an auto bellows, you can reverse the front standard with a lens attached. The cable release continues to provide open-aperture metering.

Bellows Lenses—Some manufacturers offer lenses without focusing mechanisms, designed specifically for use on bellows. Such lenses are designed for high magnification and do not require reversing for best image quality. Some are microscope lenses, adapted for this purpose.

This is a simple, non-automatic bellows. The only adjustment is bellows extension. There is a movable tripod mount on the bottom of the rail. Set magnification by adjusting bellows extension. To find focus, move the camera and bellows assembly toward or away from the subject, using the large adjustment knob on the tripod mount. The small knob on the near side locks the setting.

There are special bellows lenses, designed for use only on the front of a bellows. Lenses of this type don't have a focus control. Shown here is a Yashica 100mm *f*-4 bellows lens.

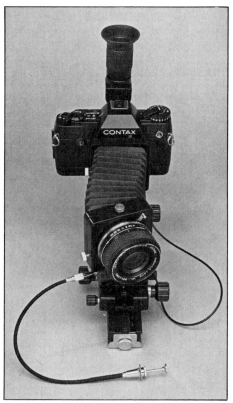

This copy stand has a baseboard and a sturdy, vertical column at the rear. The column has a camera mount that can be moved up and down. Some stands also have movable lights on supports, as shown. Copy stands are handy for high-magnification photography and to copy documents.

The cable release on this auto bellows stops down the lens before exposure. The cable between bellows and camera operates the shutter after the lens is stopped down. This bellows has "movements" in addition to simple extension: The lens can be tilted to "look" to the left or right and also shifted to the left or right.

The usual focal length of a bellows lens is 50mm. Shorter and longer focal lengths are available from some makers.

Firm Camera Support—Bellows have a tripod socket on the bottom of the rail. Use it to attach the camera assembly to a tripod. Don't use the tripod socket on the bottom of the camera. Instead of a tripod, you can use a sturdy copy stand.

Setting Up—Bellows can be difficult to set up because every change tends to affect something else. Use the accompanying graph to help you make a setup. Follow these steps:

1) Decide the magnification you need.

2) Construct a vertical line from the desired magnification to intersect all four curves.

3) From each curve, project horizontally over to the distance scale. Read four distances and record them. See the example below the graph.

4) To get actual setup distances, multiply each distance taken from the graph by the focal length of the lens you are using.

5) Establish the film-to-subject distance.

6) Adjust the bellows for the added extension. That also sets lens-to-subject and lens-to-film distances.

That setup is correct for an idealized lens whose rear node is at the back of the lens. In the real world, magnification will be almost correct with 50mm lenses, macro and bellows lenses, reversed or not. Wide-angle or telephoto lenses require more or less extension when reversed.

To find focus, move the entire camera and bellows assembly or move the subject.

Exposure Correction

The greater the image magnification, the more exposure you'll need to give under identical lighting conditions. In the following sections, I describe how to make exposure corrections under a variety of shooting conditions.

With a bellows, extension tubes or any other extension, light reaching the film is reduced by image magnifica-

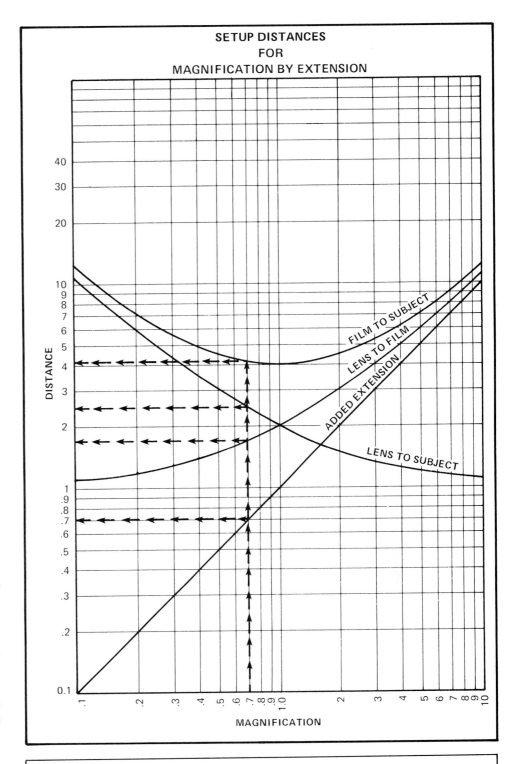

EXAMPLE		
Distances Taken From Graph:	Multiply By Lens Focal Length	Actual Setup Distances
Film to Subject — 4.2	x 50mm	210mm
Lens to Subject — 2.4	x 50mm	120mm
Lens to Film — 1.7	x 50mm	85mm
Added Extension — 0.7	x 50mm	35mm

tion. If the camera meter can make an exposure reading, you can use it—but remember to compensate for reciprocity failure, if necessary.

If the light is too dim to get an exposure reading, find correct exposure *without* extension and then correct the reading. Exposure without extension can be measured by a separate exposure meter or by temporarily removing the extension device from your camera.

To find correct exposure with extension, multiply exposure without extension by an *exposure correction factor (ECF)*. You can increase exposure by using a larger aperture, a slower shutter speed, or both.

The ECF depends on magnification, the type of lens used, and whether or not it is reversed.

NORMAL LENS

Most 50mm lenses and all special bellows lenses can be considered normal, meaning that they are not wide-angle or telephoto. For such lenses, reversed or not reversed:

$$ECF = (M + 1)^2$$

Example—For a magnification of 4.5,

$$ECF = (4.5 + 1)^2$$
$$= \text{approx. } 30$$

To correct for the light loss at that magnification, multiply exposure by 30.

The accompanying graph shows shutter-speed and aperture changes for a range of magnifications. The example shown by arrows on the graph is for a magnification of 4.5. As the formula I've just used shows, the exposure-correction factor for this magnification is 30.

You can multiply shutter speed by 30, or increase aperture about 5 steps, or some of each. To calculate aperture increase in *f*-stops, use this formula:

$$f\text{-stop increase} = 3.3 \times \log_{10}(ECF)$$

In the above example:

$$f\text{-stop increase} = 3.3 \times \log_{10}(30)$$
$$= 3.3 \times 1.47$$
$$= \text{approximately } 4.9,$$
$$\text{or } 5 \text{ } f\text{-stops}$$

Effective Aperture—Using the preceding example once again, with a magnification of 4.5 the ECF is 30. Making the correction with aperture adjustment alone requires opening the lens by 5 steps.

Suppose the measured exposure with no extension calls for an aperture of *f*-11. To compensate for extension, the lens must be opened 5 steps, to *f*-2.

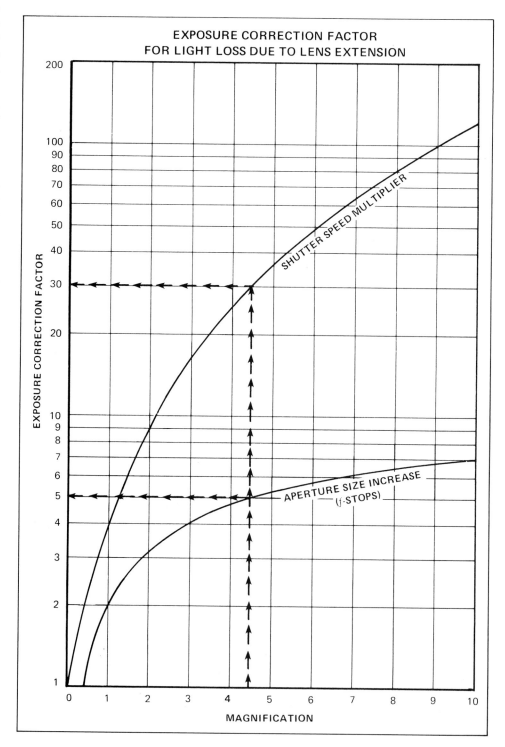

EXPOSURE CORRECTION FACTOR
FOR LIGHT LOSS DUE TO LENS EXTENSION

The combination of extension and an aperture of *f*-2 exposes film as though the aperture were *f*-11 with no added extension. With the lens set at *f*-2, the *effective aperture (EA)* is *f*-11.

Effective aperture is the actual *f*-number set on the lens multiplied by (M + 1). The idea of effective aperture is useful with flash.

Flash—If you don't have a camera-controlled TTL auto flash, you can use any flash in its manual mode. Determine flash exposure in the usual way, without concern for lens extension, using a guide-number calculation or the calculator dial on the flash.

The resulting aperture would work if there were no added extension. With added extension, you must set the *effective aperture*. To calculate the *actual aperture setting (AA)* that gives the required *effective* aperture, use this formula:

$$AA = EA \text{ needed by flash} / (M + 1)$$

Suppose a guide-number calculation suggests using *f*-11 but you are working at a magnification of 4.5. The *effective* aperture needed by the flash is *f*-11. The *actual* aperture at which you must set the lens is *f*-11 divided by 5.5, which is *f*-2.

Flash at Close Range—If the flash-to-subject distance is greater than 10 times the longest dimension of the flash window, a guide-number calculation gives valid results. When illuminating a subject under high magnification, you will often use the flash closer than that. The exposure calculation is then unpredictable. Shoot at the calculated aperture, then bracket widely.

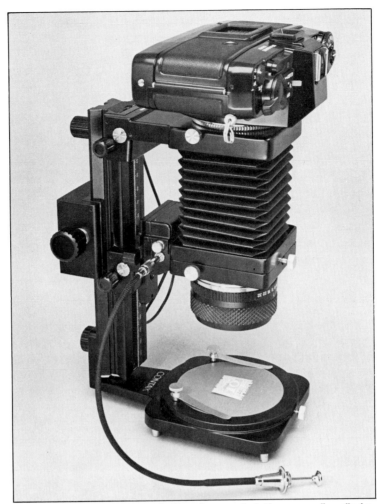

An accessory item for some bellows is a small platform, usually called a *stage*. It attaches to the front of the bellows rail. This arrangement is sometimes called a *macro stand*. The round insert in the stage is 18% gray to assist in setting exposure. A transparent insert is available so the subject can be backlit. The metal clips hold the subject in position, if desired.

This is a small lapel pin that is angled in respect to the camera. It is visible in the copystand setup shown on page 132. Because of the angle of the object to the camera, only the center of the badge is sharp in the left photo. In making the right photo, the camera lens was tilted, as shown in the setup on page 132. This provides overall sharpness without the need for a smaller lens aperture. Lens tilt is common with large-format cameras. Most 35mm cameras don't offer it, but some bellows do.

SUMMARY OF EQUATIONS: MAGNIFICATION BY EXTENSION, PUPILARY MAGNIFICATION AND REVERSED LENSES			
	With Normal Lens (P = approximately 1)	With Telephoto or Retrofocus Lens	With Reversed Telephoto or Retrofocus Lens
Exposure Correction Factor	$ECF = (M + 1)^2$	$ECF_p = \left(\dfrac{M}{P} + 1\right)^2$	$ECF_r = \left(\dfrac{MP + 1}{P}\right)^2$
Equivalent Aperture	$EA = f(M + 1)$	$EA_p = f\left(\dfrac{M}{P} + 1\right)$	$EA_r = \dfrac{f}{P}(MP + 1)$
Lens Setting To Get Desired EA	$f\ \text{actual} = \dfrac{EA}{(M+1)}$	$f\ \text{actual} = \dfrac{EA_p}{\left(\dfrac{M}{P} + 1\right)}$	$f\ \text{actual} = \dfrac{(EA)\,(P)}{(MP + 1)}$

A slide-copying attachment has been added to the front of this bellows' rail. To exclude stray light, a small auxiliary bellows fits between the slide holder and the front of the lens. Magnification is set by adjusting the main bellows. Focus is set by the auxiliary bellows. The trays on each side of the slide holder allow copying from film strips.

WIDE-ANGLE AND TELEPHOTO LENSES

Exposure correction and use of manual flash at high magnification with wide-angle and telephoto lenses is similar, but a little more complicated.

Lens Pupils—If you hold a lens at arm's length and look through it, you see the shape of the aperture. The area of light is called the *pupil*. Looking into the front of the lens, you see the *entrance pupil*. From the back, you see the *exit pupil*.

With lenses of normal design, the two pupils have about the same diameter. With wide-angle and telephoto lens designs, they are not the same.

Pupillary Magnification—Exposure correction is affected by the the ratio of pupil diameters, called *pupillary magnification (P)*.

P = Exit-pupil diam. / entrance-pupil diam.

Pupillary magnification is rarely stated in lens data, but the lens manufacturer can tell you what it is. Or, you can measure the diameters and calculate P yourself.

To measure the pupil diameters, close the aperture partway. With some lenses, you may have to move the aperture lever on the back of the lens to stop it down. Lay a scale across the front of the lens and measure the pupil diameter. Do the same at the rear of the lens.

The equations in the accompanying table are basically similar except that those for wide-angle and telephoto lenses incorporate pupillary magnification.

Duplicating Slides

You can buy slide-duplicating attachments that fit on the front of a bellows. The slide is held in front of the lens, usually with a small, additional bellows between slide and lens to exclude stray light. Markings on the main bellows and the slide holder show how to set up for a magnification of 1.

If the slide is mounted, the visible area is a little smaller than the full frame. To fill the frame in the duplicate, a magnification slightly larger than 1 is required.

If you anticipate needing several identical slides of a scene, it is probably best to shoot that number of original slides. You'll save the cost and trouble of duplication and probably get better image quality.

One of the best reasons for duplicating your own slides is to *change* them in some way. For example, shoot at higher magnification and alter the composition. Or, change colors by using a filter over the lens or between light source and slide holder.

For good color reproduction, use daylight-balanced color film and illuminate the slide with electronic flash or average daylight. Sunlight and skylight, reflected from a white card, gives about the right color temperature. Don't use direct sunlight and

This is a set of three close-up lenses with thread diameters of 55mm. The filter strengths are +1, +2 and +3 diopters. Threads on the front side, visible here, allow stacking.

Close-Up Lens Attachments

Accessory close-up lenses that screw into the filter ring on the camera lens are a simple and handy way to increase magnification. The amount of light reaching the film is not affected significantly, so you can use the camera in the normal way.

Image quality is usually not as good as with the camera lens alone—at the needed extension —especially at high magnifications. A rule of thumb is that it's OK to use close-up lenses for magnifications up to about 0.6. If you use close-up lenses to photograph non-flat objects, such as flowers, the results may be entirely satisfactory at even higher magnifications.

DIOPTERS

Close-up lenses are usually sold in sets of three or four, with labels such as 1, 2, 3, or 10. The labels express the power of the lenses in *diopters*. Diopters are the *reciprocal* of focal length, stated in meters (1 meter = 1,000mm).

For example, a close-up lens of 200mm focal length has a power of 1,000/200 diopters, or 5 diopters. Similarly, a 10-diopter close-up lens has a focal length of 1,000/10mm, or 100mm.

Stacking Diopter Lenses—You can stack close-up lenses by screwing them together to achieve higher magnifications. The reason for using the diopter scale is that the diopter power

When you copy slides, you can make creative changes. Here, the image was cropped more tightly in the copy. To achieve special effects, you can use filters, copy two slides sandwiched together, or tilt the image. The natural increase in contrast in a duplicate slide sometimes also helps to add graphic impact.

avoid blue skylight as the only light.

Copying increases contrast. Sometimes this can be an advantage, sometimes not. Special slide-duplicating film is available that causes a smaller change in contrast. If you need duplicates of the best quality, use Ektachrome Slide Duplicating Film No.5071 or have the duplicates made commercially.

FOCAL LENGTH OF CLOSE-UP LENSES		
LENS POWER IN DIOPTERS	FOCAL LENGTH mm	inches (approx)
1	1000	40
2	500	20
3	333	13
1 + 3	250	10
2 + 3	200	8
1 + 2 + 3	167	6.7
10	100	4

MAGNIFICATION WITH ACCESSORY CLOSE-UP LENSES								
Camera Lens	Close-Up Lens	Maximum Subject Distance		Minimum Subject Distance		Magnification		
		mm	inches	mm	inches	MIN	MAX	
50mm	1	1000	40	333	13	0.05	0.17	
	2	500	20	250	10	0.10	0.22	
	3	333	13	200	7.9	0.15	0.28	
	3+1	250	10	167	6.2	0.20	0.33	
	3+2	200	7.9	143	5.6	0.25	0.39	
	3+2+1	167	6.2	125	4.9	0.30	0.45	
	10	100	3.9	83	3.3	0.5	0.67	

of a combination is the sum of the individual powers. For example, a 3-diopter close-up lens stacked with a 1-diopter close-up lens has the same power as one 4-diopter lens.

Focal Length—What you need to know is focal length in millimeters, which requires a simple calculation:

Focal length (mm) = 1,000/Diopters

The accompanying table shows diopters and the equivalent focal lengths in both inches and millimeters.

Magnification—With the camera lens set at infinity, the subject must be in front of the lens at a distance equal to the focal length of the close-up attachment to be in sharp focus. Magnification, M, is easy to calculate:

$$M = F_C \text{ (mm)} / F_D \text{ (mm)}$$

F_C is the *camera focal length* and F_D is the *close-up-lens focal length*.

Using a camera lens with longer focal length increases magnification. Using a stronger close-up lens—one of *shorter* focal length—also increases image magnification.

Assume you are using a 200mm camera lens with a 4-diopter close-up lens. The close-up lens has a focal length of 250mm.

Magnification = 200mm/250mm
= 0.8

If the camera lens is focused closer than infinity, subject distance decreases and magnification increases. Magnification is then less simple to calculate. The accompanying table shows the range of magnifications and subject distances with various combinations of close-up lenses installed on a 50mm camera lens.

How to Use Close-Up Lenses—Decide the amount of magnification needed. Find a combination of camera lens and close-up lens that will provide that magnification, or a little less, with the camera lens focused at infinity. You can calculate magnification or use the graph of Figure 8-2.

Install the close-up lens or lenses on the camera. If you stack close-up lenses, place the higher diopter rating nearer the camera lens. Find focus by moving the camera.

If magnification is not enough with the lens focused at infinity, focus it closer. Use the focusing ring on the lens to control magnification, not focus. The distance scale on the lens is not valid.

To avoid image blur due to camera movement, use the camera on a sturdy tripod. Also, remember that depth of field is reduced at higher magnifications. Use the smallest possible lens aperture.

Meter the exposure and use the camera in the usual way. Light is not significantly reduced by the close-up attachment.

Split-Field Lenses

A split-field lens is useful when two objects are so far apart that they are beyond the depth of field of the camera lens alone. The split-field lens fits on the front of the camera lens.

One half of the attachment is close-up lens and the other is open space. The nearer of the two objects is focused by camera lens and close-up lens. For that part of the image, the subject will be in focus at a short distance, such as 20 inches. The other, more distant, half of the image—perhaps 30 feet away—is formed by the camera lens alone.

Split-field lenses are labeled with the diopter rating, just as other close-up lenses. Of course, the rating applies only to the half with the lens.

This is a split-field lens. Half of it is a segment of a glass close-up lens. The other half is open space. The close-up portion of this lens has a strength of +3 diopters.

This photo was made with a 50mm camera lens and a +2 diopter split-field lens. The background was focused by the camera lens alone. The flower was brought into focus by the split-field attachment. The close-up attachment has caused more distant objects in the lower half of the picture—such as the wall at right—to go out of focus.

9
Useful Accessories

This photographer is working with a long telephoto lens. His camera is on a sturdy tripod. To carry lenses, film and other accessories, he has a shoulder bag and is wearing a photographer's vest with many pockets. If you choose your accessories wisely and carry them in a convenient way, you can make your location photography much easier and more comfortable.

This chapter has brief descriptions of accessories that you may find useful. I regard some of the items mentioned as almost necessities. What follows should help you make your own choice.

Camera Support

More pictures are harmed by camera movement during exposure than by any other cause. The most important thing you can do to get sharper images is to provide rigid support for your camera and lens.

TRIPOD

Some people buy a lightweight, inexpensive tripod for good reason: They prefer to carry around less weight in the tripod and more in the wallet. Later, they discover that the inexpensive tripod is wobbly, won't support a camera with a long and heavy lens, and isn't tall enough even when fully extended. Eventually, they buy another model without those deficiencies.

All-Purpose Support—Your tripod is a workhorse that should be sturdy and tall enough for virtually any situation you may encounter. Unfortunately, it will be heavier than you would like it to be!

When shopping, begin by ignoring price. Find the features you want, then find the best price for a tripod with those features. Don't buy a tripod unseen. Hold it, adjust it, and test it, to be sure it suits you.

Adjustments—A tripod has three legs that telescope to adjust length. The legs are either tubular or U-shaped. In my opinion, tubular legs are more rigid.

Small-diameter tubes telescope into larger tubes. There may be three or four sections in each leg. To adjust length, you turn a collar to loosen or tighten the telescoping joints. Check to be sure the collar locks the legs firmly. Push down on the top of the tripod to see if any leg gives. Wiggle the tripod to check for loose joints.

The size and surface texture of the locking collars on the legs is important. They should be large enough to grip comfortably, so you can tighten them firmly and yet loosen them easi-

ly. The surface texture should aid in gripping the collars. Some are knurled metal with sharp points and edges that can be uncomfortable or even painful, particularly when your hands are cold.

The legs should have rubber tips that screw upward to expose sharp metal tips. Use the tips that are most suitable for the surface on which you're placing the tripod.

Center Post—At the top, the legs are joined together by a fixture that supports the center post. On top of the center post is the camera mount.

The center post can be extended so the camera is higher. The simplest arrangement is a clamping collar that holds the center post. When the collar is loosened, the center post slides through the collar. You have to support the camera with one hand while loosening and tightening the collar with the other.

With that type of tripod, small height adjustments are sometimes awkward to make. If you loosen the collar too much and don't have a firm

grip on the camera, the camera may slide down rapidly and crash against the tripod. When you inspect the tripod, check to be sure the center post doesn't wobble when clamped.

Another arrangement is a geared center post that moves up and down by turning a crank. Small height adjustments are easy to make. The camera can't get loose and come crashing down. But, the gear arrangement may allow the center post to wobble. Check to see if it does.

Some tripods are designed so the center post can be removed and installed with the camera mount at the bottom. This provides a low camera viewpoint.

Some center posts are in sections that screw together. To make the post longer, add a section. However, for greatest stability, I prefer long tripod legs and short center posts.

There are two ways to adjust the height of the camera. One is to lengthen or shorten all three tripod legs. The other is to change the height of the

This is a sturdy tripod, suitable for a wide range of photography. You pay a small price for this luxury—the tripod is relatively bulky and heavy. You must decide what you need and what you're prepared to carry. It depends largely on the kind of photography you plan to do and on the shooting location.

This is a relatively compact, lightweight tripod. I use it when I'm traveling or when weight is an impediment.

When you have to move around a lot while shooting but want some camera support, a monopod such as this Gitzo model is handy.

This clamp has a camera mount. It can give your camera steady support in many locations. The clamp is compact and can be carried in a camera bag or in your pocket.

center post. The main purpose of the center post is to make small changes in camera height conveniently, not to provide a taller tripod. A center post that adjusts over a range of 18 to 24 inches is long enough. More extension of the center post increases the likelihood of camera movement.

Tripod Head—The fixture that holds the camera is called the *tripod head*. It should provide three movements. The *pan* movement allows you to point the camera in any horizontal direction, such as north or east. The *tilt* movement allows you to aim the camera toward the ground or toward the sky. The *rotate* movement allows you to set the camera so its base is exactly horizontal, exactly vertical, or anywhere in between.

Each of these three movements must have a control and a lock to hold the setting. There are a variety of designs. Before buying, check how each of the three movements is controlled and locked. Try different designs to see which is more convenient for you. Think about making adjustments when your hands are cold.

When composing, you may spend some time getting the camera level, meaning exactly horizontal. Then, you may decide to rotate the camera 90° to make a vertical-format shot. It's convenient to have a stop on the tripod head that stops rotation at exactly 90°, so you don't have to level the camera again.

Interchangeable Head—Some manufacturers offer interchangeable heads of different design. Each head screws onto the top of the center post. One type allows you to pan the camera without tilting it. Another, called a *ball head,* allows all three movements simultaneously.

A good, sturdy tripod will last for years and meet most of your needs. It will be suitable to carry in an automobile, and in your hands for short distances. It may be awkward to carry on an airplane and entirely too heavy for backpacking.

Travel Tripod—When traveling, especially on foot or by air, you may be willing to make some compromises in sturdiness and height in favor of less weight. Check everything discussed in

the preceding section and decide which compromises you are willing to make.

U-section aluminum legs are less rigid than tubular legs, but lighter. They telescope and are locked with a lever. Check to see if the lever will be easy to operate, even when your hands are cold. When locked, the lever applies friction to the telescoping joint. Look it over to see how it works and how durable it seems.

To save weight, the tripod may not extend high enough to use without stooping. Are you willing to stoop? For comfortable viewing, it may require the center post to be fully extended. Does it wobble?

Both size and weight are important. You may want to put the tripod in a suitcase. Will it fit? If the head has a long handle, can it be folded down so it is parallel to the legs? How long is the tripod when fully collapsed?

OTHER SUPPORTS

Here are some additional camera supports that are very compact and yet effective.

Bean Bag—This is simply a bag of sturdy material, filled with beans, buckshot or ball bearings. When using an available support for your camera, such as the top of a fence or rock, the camera may tend to slide around. In such situations, a bean bag is useful between camera and support. The bag will conform to the surface below it and form a depression to hold the camera.

Supporting a Long Lens—Lenses that are physically long and heavy usually have a tripod socket of their own. Use that, instead of the camera's tripod socket. It will give you a more balanced setup.

If you use a long lens without a tripod mount on a tripod-mounted camera, the lens is likely to vibrate during exposure. To prevent that, some photographers place a second tripod under the lens, near the front. Accessory, V-shaped tripod heads are available for that purpose. Without one, you can improvise. A bean bag or folded piece of cloth can adapt the tripod head to support a lens.

Monopod—A monopod is has only one leg. It telescopes and has a camera mount on top. Monopods are a compromise between mobility and stability. They are used by photographers who move around a lot, such as at sports events, yet want some form of camera support.

Mini Tripod and Clamp—There are tiny tripods with short legs, sometimes called *table-top* tripods. They are easy to carry but you need an elevated surface to put them on.

Small clamps, with a camera mount attached, are also available. They enable you to clamp a camera to a tree limb, a fence, or the back of a chair.

CAMERA CASES

Camera cases are available with rigid exteriors and interior foam padding or soft exteriors with sewn-in padding.

People feel vulnerable to thieves when transporting cameras. There are theories about how best to protect equipment from theft. Some suggest carrying cameras in bags that don't look like camera bags and are shabby enough to suggest that their contents

A tripod is useful for formal portraiture. When you shoot close-up portraits like this, a firm camera support is particularly handy. It helps you compose the image exactly as you want it. This image was softened with a Cokin diffusion filter on the lens. Photo courtesy of Minolta Corporation.

A tripod is very helpful for close-up shots like this. It enables you to frame the image precisely. It also ensures that, once focused, the image stays sharp. Often, to get adequate depth of field, you'll need to use a relatively slow shutter speed. A tripod ensures pictures that are unblurred by camera motion. Photo by C. Allan Morgan.

This compact shoulder bag doesn't impede your mobility while you're shooting.

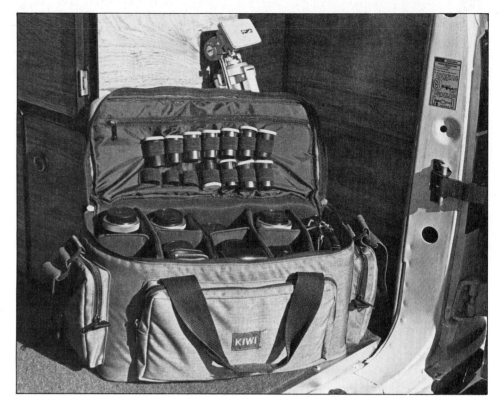

A large camera case, such as the one shown here, is useful to carry a lot of equipment to the shooting location. While you're shooting, you may want to carry a smaller case, such as the one shown on the left, containing only the items for which you have immediate need.

are worthless. However, if it doesn't *look* like a camera bag, it probably doesn't *work* very well to carry photographic equipment. If you carry your gear in a violin case for camouflage, it may be stolen by someone who needs a violin!

I suspect that more cameras are stolen in residential burglaries than from travelers. I think the best defense is a good insurance policy and a detailed list of your equipment items. Then, use your equipment with reasonable care, enjoy it—and carry it in a good camera case!

Main Case—I find it useful to have a large bag or case that holds a lot: Camera bodies, lenses, flash, motor drive, filters, film, gadgets, and a cleaning kit for lenses. Cleaning supplies are discussed in the next chapter. Some large bags have external straps to attach a tripod.

I use my main bag to carry all my equipment when traveling. When I reach my destination, I select the items I'll need for a specific shooting situation and pack them in a smaller case, that's easy to carry.

Other Carrying Methods—The

Until you try one, you won't believe how handy a photographer's vest can be. It's comfortable because the load in the pockets is distributed across both shoulders. This design, by Bazooby, has large and small pockets everywhere—a total of 22!

small case I use on location must have a wide and comfortable shoulder strap with a non-skid pad for the shoulder. I prefer not to carry anything in my hands.

Another useful carrying method is a photographer's vest. It has several pockets for medium-size lenses and other pockets for film and gadgets. Some have a pocket on the back to carry a small tripod or long lens.

Also useful is a bag that attaches to your belt. It is usually carried at the back. Typically, these bags are shaped

to hold a lens or a camera with lens attached.

Lenses that are physically large are usually sold in a cylindrical case with a shoulder strap. These straps are usually too narrow for comfort. If you intend to carry a lens that way, I recommend that you replace the strap with one that is wide and padded.

With a combination of shoulder bag, vest, belt bag and lenses slung over your shoulder, you can be very well equipped and still have your hands free.

REFLECTORS AND BACKGROUNDS

These accessories, some readily transportable, can help you make better pictures.

Portable Background—When photographing people outdoors, you can usually find a pleasing background. In case you can't, you can carry a plain, portable background. Lightweight background cloths are available in various colors, packaged in small carrying bags. When unfolded, they are reasonably wrinkle-free. To avoid showing possible wrinkles in your pictures, put the cloth out of focus by using limited depth of field.

Reflector—Often, you'll want some control of the light. Probably the most useful accessory for outdoor portraits is a reflector to fill shadows. Virtually anything white that reflects light will do—even a newspaper. However, be sure to avoid colored reflectors when using color film unless you're aiming for a special color effect.

Professionals use large reflector panels with stands. You can make smaller panels of white cardboard or crinkled aluminum foil that fit in a car trunk. A piece of cloth, suspended from a tree branch or some other suitable support, will also do. Ingenuity can replace pounds of weight.

Flash—An alternative to a reflector is

Several manufacturers offer stands and umbrella reflectors for flash or tungsten lights. These are made by Lowel-Light.

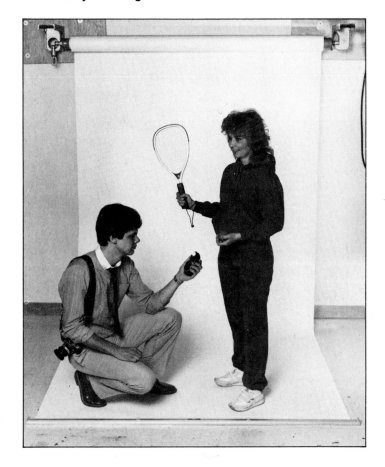

Both portable and wall-mounted holders are available for rolls of seamless background paper. Photo-Tech of St. Paul, MN, offers these wall-mount holders in various widths, along with paper in a variety of colors.

electronic flash. Flash can be converted into a large source, suitable as fill light, by bouncing the light. There are accessory umbrellas that you can mount on a stand or attach to the flash. Point the flash into the umbrella so the reflected light strikes the subject.

Seamless Background Paper— Special photographic background paper is available in rolls of various widths and in many colors. Accessory upright poles with crossbars are available to support the rolls, enabling you to convert your living room into a studio. For a permanent setup, you can buy supports that bolt to a wall.

Camera Accessories

A great variety of camera accessories is available. Here are some that can increase your photographic capabilities.

MOTOR DRIVE AND FILM WINDER

These attachments fit on the bottom of the camera to advance film rapidly and automatically.

There are two main differences between an accessory motor drive and a film winder. A motor drive advances film at speeds up to about five frames per second and can generally be preset to expose a certain number of frames and then stop. A film winder advances film at speeds up to about two frames per second and generally cannot be preset to expose more than one frame.

Because motor drives and film winders must wait for an exposure to be completed before advancing the next frame, their frames-per-second capability depends on shutter speed. With a camera on automatic, you can hear the film-advance rate change if you pan the camera to lighter or darker areas while exposing a burst of frames.

A motor drive has a control that selects continuous or single exposures. On continuous, it exposes frames as long as you hold down the shutter button, until the preset number of frames has been exposed or the end of the roll is reached. When set for single shots, it exposes one frame each time you press the shutter button.

Some film winders advance single frames only. Others advance film as

This is a Chinon motor drive. The shutter button is at the top of the handgrip. Other controls are on the back. The slide button marked by a triangle prepares the camera for rewinding film manually. A pin emerges from the motor drive to depress the rewind button on the camera. The dial at right has off, single-frame and continuous-burst positions. The center dial sets the number of frames for a continuous burst, up to 24. The left dial is an *intervalometer*. It puts a time interval between each frame, up to 30 seconds.

long as you hold down the shutter button. Because of the slower rate of film advance, it's easy to make single shots just by pressing and quickly releasing the shutter button.

Other features of some accessory motors are automatic film advance to frame 1 after loading and automatic film rewind back into the cartridge.

The main advantage of a motor drive or winder is to make a rapid sequence of exposures of a moving object. The purpose may be to record a pattern of movement, such as the swing of a golf club, in sequential frames. Another purpose is to get one good shot that would be difficult to capture by manual control of the shutter button, such as a rodeo cowboy demonstrating involuntary dismount.

REMOTE CONTROL

Controlling the camera without pressing the shutter button is possible with two general types of remote-control devices. One requires a cable connection to the camera. The other uses radio waves or a beam of light to control the camera without an interconnecting cable. With such devices, you can operate your camera from considerable distances.

Cable Release—The simplest remote-control gadget is a cable that screws into a threaded socket in the camera shutter button. Instead of pressing the shutter button on the camera, you press a button on the end of the cable release.

Whenever you have the camera mounted on a tripod, a copy stand or some other support, you should use a cable release. Because you don't have to touch the camera, you eliminate one possible cause of camera movement during exposure.

Common cable releases are mechanical. They have an outer sheath and an inner cable. When you press the release button on the cable, the inner cable slides in the sheath and forces a pin out of the threaded end. The pin mechanically trips the shutter mechanism in the camera. Because of friction inside the cable, mechanical shutter cables are limited in length to about 18 inches.

Squeeze Bulb—A way to provide mechanical shutter release at greater distance is a squeeze bulb at the far end of a hollow rubber hose. When you squeeze the bulb, a pin emerges from the other end of the hose and trips the shutter. Releases of this kind have a range up to about 50 feet. There is a short, unavoidable, time delay between the pressing of the bulb and the operation of the shutter. This is due to the time it takes to build up the needed air pressure in the hose.

Electrical Control—Most cameras control the shutter electrically. When you press the shutter button, it closes a switch that signals the shutter to open. Some cameras have an electrical remote-control socket on the body. An electrical remote-release cord screws into that socket. A pushbutton on the end of the cord provides the switch closure to open the shutter. There is virtually no limit to the possible length of such cable releases.

When you release the shutter from a distance, it is necessary to advance film before making another exposure. With a short cable, it is convenient to advance film manually.

With a long cable, you must either go to the camera to advance the next frame or use a motor-drive to do it automatically. For that reason, most motor drives and auto winders have an electrical remote-control socket that can be triggered from a distance.

Intervalometer—When a motor drive is controlled electrically from a distance, the gadget on the far end of the cable may be a simple pushbutton. However, some manufacturers offer a control box for use at the distant end.

The control box, called an *intervalometer,* can be set to make a continuous sequence of exposures or single shots. It can be set to make a series of exposures with a specified time interval between the exposures.

The camera is used in an automatic-exposure mode so changes in the light are compensated for automatically. Some remote-control boxes will turn on an electronic flash at the camera location and allow time for it to charge up before each exposure. Between exposures, the flash is turned off to conserve battery power in the flash.

If you are near the camera, you can use a mechanical cable release to trip the shutter. To operate the shutter from a longer distance, you can use a rubber squeeze bulb with an air hose. The fitting on the end of the hose is screwed into the threaded socket on the camera shutter button.

Radio and Infrared Remote Control—There are control systems that use radio waves or a beam of infrared radiation. The signals originate from a control box at the desired distance from the camera. A receiver is near the camera. The receiver connects by a short electrical cable to the remote-control socket of a motor drive. Some receivers have a mounting foot that fits in the camera hot shoe. No electrical connections are made to the camera hot shoe.

Disadvantages of radio remote control are the need for whip antennas at both locations, the possibility of radio interference and the possibility that some other radio signal may trip the camera.

Advantages are that radio waves will travel relatively long distances, pass through non-metallic objects such as walls and foliage, and are omnidirectional.

A disadvantage of infrared remote control is the necessity for a direct line-of-sight between the transmitter and receiver, and relatively shorter range. Infrared doesn't pass through opaque objects. You have to point the transmitter at a lens on the receiver.

Advantages are that no antennas are needed and the possibility of interference is reduced because control

For remote control by radio, the receiver mounts on or near the camera. The receiver is connected by cable to an electrical shutter-release socket on the camera body. The transmitter, shown at right, is handheld at the distant location.

Infrared remote control requires an unobstructed line of sight between the handheld transmitter and the receiver mounted on or near the camera.

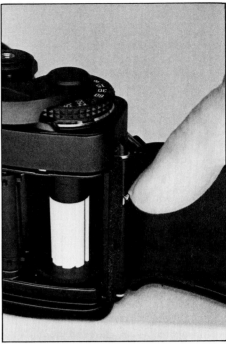

To install an interchangeable accessory back, remove the standard back cover. On this camera model, you do this by sliding the pin on the hinge downward and tipping the back out of the upper attachment point.

is over a direct line-of-sight path.

Infrared transmitters send coded pulses of light. Several different codes, called *channels,* are provided at both transmitter and receiver. That allows selective control of more than one camera by using different codes at the camera locations and selecting the appropriate code at the transmitter.

ACCESSORY CAMERA BACK

Accessory camera backs replace the standard camera back and provide a variety of functions. The standard function is to imprint data at one corner of the film frame—usually the lower right corner of the image.

The back has a built-in flash tube, called an exposure lamp, with cut-out masks to form letters and numbers. Usually, the exposure lamp is trig-

gered by the X-sync signal from the camera. Some backs have a sync cord that plugs into the X-sync flash connector on the camera body. Others have electrical contacts that mate with contacts on the camera body to receive X-sync without an external cord. Some accessory backs have a pushbutton to make the exposure.

Simple accessory backs have control dials that are used to select the characters that will be exposed onto the film. A typical use is to imprint the date.

Many Features—The trend is to include a wonderland of features in accessory backs, using built-in electronics similar to those in a digital watch. In addition to preset symbols, some backs can be set to imprint the date and time of day, changing date

and time automatically. Date and time may also be displayed externally, so you don't need a wrist watch.

Some backs have built-in intervalometers. You can set them to expose a preset number of frames at preset intervals. Some provide automatic bracketing, using motor-driven film advance to shoot a preset number of frames with a preset difference in exposure of the frames. Some backs for use with programmed automatic cameras can even change the program temporarily.

The features of accessory backs vary among camera brands and models. Cameras with more electronic features can use backs that do more electronic tricks.

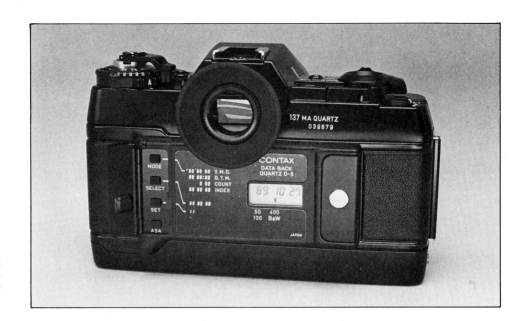

This Contax Data Back has five modes. It imprints date, or time of day, or a sequence of numbers such as frame numbers, or any six digits of your choice, or nothing.

This Chinon Info Back allows you to type any message up to 30 characters long and imprint it by pressing the white button on top.

Some automatic cameras set exposure using a light sensor in the viewfinder housing. If you press the shutter button when your eye is not at the viewfinder eyepiece, stray light entering the eyepiece may cause incorrect exposure. An accessory eyepiece cover, usually packaged with the camera, can be used to cover the eyepiece in that situation. Some attach to the camera strap for storage.

10
Equipment Care

When this killer whale, showing off at Sea World in San Diego, lands back in the water, it creates an enormous splash. Spectators in the front rows can expect to get wet. This may be fun for you, but it isn't for your camera. In this chapter, I give you some advice on taking proper care of your equipment.

With reasonable care, photographic equipment will give many years of good service. It's important to use cameras and all accessories correctly, as intended by the manufacturers. Read all operating directions carefully.

CHECK OUT YOUR CAMERA

You will not harm your camera by operating it without film. Get acquainted with its operation and practice using the controls by firing "blank shots" as much as you wish.

Open the back and trip the shutter a few times while looking into the camera. You'll see the shutter open and close. At different shutter speeds, you should see that the shutter operates faster or slower. Don't touch the shutter or interfere in any way with its motion.

While the shutter is open, look at the rear pupil of the lens. At different aperture settings, the pupil will be of different sizes.

If the camera is new, or you haven't used it for a long time, test by exposing a roll of film. For tests that you will send out for processing, color slide film is best. Make test shots under a variety of lighting situations.

Send the film for processing through your local camera shop. Carefully inspect the finished slides. If you see something that doesn't look right, it could be your shooting technique, incorrect use of the camera controls, a fault in the camera, or a problem resulting from processing error. If you can't figure out which, your dealer will be glad to help you.

THINGS THAT CAN HARM YOUR EQUIPMENT

Cameras and lenses can be damaged by incorrect storage and use. Here are some "natural enemies" and what you should do about them.

Dust and Dirt—Under normal shooting conditions, dust is not a problem. However, cameras and lenses are not totally dustproof. Where dirt is blowing in the air, protect your equipment by keeping it enclosed as much as possible. Use a camera case, a plastic bag, or even an article of clothing wrapped around your camera. Keep a lens cap on the lens except when you are actually taking pictures.

Protect lenses that are not on a camera with front and rear lens caps. When no lens is on the camera body, close the opening with a camera body cap.

Be particularly careful to protect your camera from sand. A lot of damage can be done to your equipment on a windy beach.

Water—Cameras and lenses are not waterproof. Protect them from rain or splashing water. If the camera exterior gets wet, dry it immediately with a clean, soft cloth.

In rain or damp weather, you can shoot with the camera in a plastic bag. Cut an opening for the lens and use a rubber band to hold the opening around the lens. Use a skylight filter to protect the front lens surface. It won't affect color balance.

If a camera gets thoroughly wet due to being submerged or left out in the rain, be sure it gets the earliest possible attention at a camera-service facility.

Salt water is particularly harmful. Keep your camera dry when on a beach or boat.

Condensation—When camera equipment is exposed to a sudden temperature rise, condensation may form on and inside lenses and cameras. If you store them in such a way that they can't dry out quickly, problems may result. Leave camera and lens uncovered at room temperature for two or three days.

Lenses that are not on a camera should be protected by front and rear lens caps.

When there's no lens on a camera, protect the camera interior by using a body cap.

By the ocean, your camera doesn't have to get soaked to be damaged. Salt spray, carried by the wind, also settles on the camera. If it isn't cleaned off, it can cause corrosion. Prevention is always better than cure. Carry your camera in a plastic bag or a suitable housing to protect it. Provide an opening for the lens to "see" through. You can protect the lens by using a UV filter on it.

Amateur Repairs—Repairs by well-meaning but unskilled people can cause more damage than they cure. Never take a camera body or lens apart. Never attempt to lubricate camera parts yourself. If a camera seems to have mechanical damage, visible or invisible, take it to a camera repair center authorized to repair that brand.

Lengthy Storage—Like people, cameras need regular exercise. If you are not using a camera, it will survive the inactivity better if you exercise it every two or three months. Operate the shutter at various speeds. Operate the camera controls to free them up and redistribute lubricants.

If you won't be using a camera for several weeks, its a good idea to re-move the batteries. Remember to re-place them before using the camera again.

Don't store a camera with the shutter cocked, ready to make an exposure. Make a point of depressing the shutter button just before you put the camera away.

Poor Storage Conditions—Store cameras and lenses in a cool dry place. A shelf or drawer in a room occupied by people is much better than a base-ment or attic where there may be temperature and humidity extremes.

Store the equipment in plastic bags and cases. In each plastic bag, include a small bag of desiccant that absorbs moisture. New camera equipment usually has desiccant bags in the packaging. Don't throw them away.

Other Hazards—A short camera strap around your neck, instead of a long one over your shoulder, is good insurance against inadvertent bangs and knocks that can damage your camera.

When carrying a camera in a vehicle, keep it in the passenger compartment and pad it so it does not receive steady vibrations. Vibration can loosen screws and possibly cause other damage. The floors of some cars become hot because of catalytic converters mounted under the car. Keep your equipment away from such heat sources.

Always use a lens hood, except with lenses that don't use hoods, such as a circular fisheye. A lens hood not only helps you make better photos, it pro-

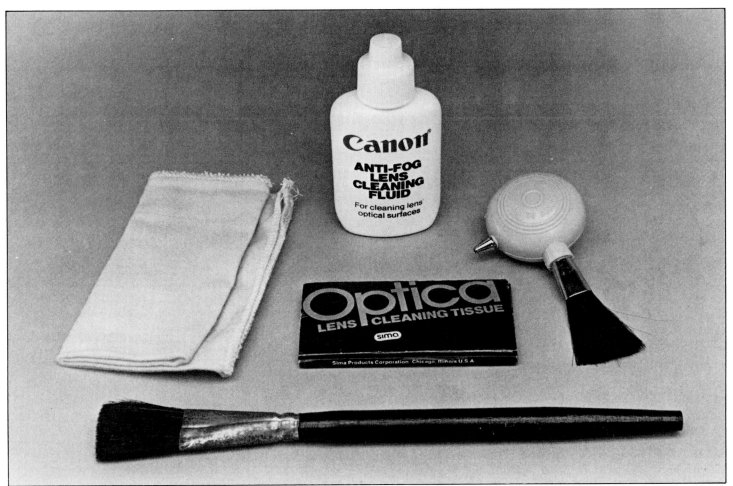

A cleaning kit should include a soft cloth, lens-cleaning fluid, lens-cleaning tissue, a blower and brush for glass surfaces and a separate brush for other surfaces.

tects the front of the lens.

If you are outdoors in cold weather, keep the camera under your coat when you're not actually shooting. That will help keep the battery functioning and, when you return to a warmer area, there will be less worry about condensation forming on or inside the camera.

If your camera becomes thoroughly cold, seal it in a plastic bag before taking it into a warm room. Don't take it out of the bag until it is at room temperature. Otherwise, condensation will form. That is especially important if you are going to go back outside again. Condensation inside a camera may freeze when you go outside, jamming the camera mechanism.

If you're planning an expedition to a severely cold climate, consider having an authorized camera service center lubricate and prepare your equipment for such frigid conditions.

In hot weather, protect the camera from heat. High temperature is harmful to both camera and film. Don't leave your camera in direct sunlight. Don't leave it in the trunk or glove compartment of a car, on the dashboard or the back-window ledge.

If you must leave your equipment in a parked, closed car, put it in the shade on a cool part of the floor or seat. Place a jacket or blanket over it. That protects it from the sun and makes it less visible to potential thieves.

CLEANING

Put together a small cleaning kit and keep it handy. Include lens-cleaning tissue intended for camera lenses, lens-cleaning fluid, some cotton swabs and *two* brushes. Use one brush on lens barrel and camera body *only*—never on glass. That *body* brush can have fairly stiff bristles, such as a medium-size artist's paint brush. Keep the second brush exclusively for glass surfaces. This *lens* brush must have very soft bristles. Buy a brush intended for cleaning lenses.

A commercially available can of pressurized air is useful to blow dirt particles off glass surfaces and out of crevices. A handy alternative is a squeeze bulb combined with a lens brush, available at camera shops.

Clean lenses only with lens-cleaning tissue intended for camera

lenses. Don't use the tissues sold to clean eyeglasses. They are often impregnated with silicone—fine for your glasses but not for your camera lens. Don't use facial or bathroom tissue, either.

How to Clean a Lens—With lens cap in place, or both caps if the lens is removed from the camera, use a blast of air and the *body* brush to clean dust from the lens barrel and the crevices around controls. Use this brush on non-glass surfaces only.

Remove the front lens cap and blow loose dust off the front glass surface. Use your *lens* brush to gently *lift off* any remaining dirt particles. Don't scrub them into the surface because they may scratch it. Use the lens brush on glass surfaces only.

If dirt, smudges or fingerprints remain on the lens, apply a drop or two of lens-cleaning fluid to a piece of lens-cleaning tissue. Lightly wipe the lens with the moistened part of the tissue. Start at the center and spiral outward to the edge of the lens. Lift up the tissue occasionally and resume cleaning with a different part of the moistened tissue.

Don't use more than a drop or two of lens-cleaning fluid. Never apply fluid directly to the lens. Don't rub hard.

The rear lens element can be cleaned the same way. It should not require frequent cleaning because it is protected by the camera body.

Clean a lens only when it actually needs it—when it has visible dust or smudges on the surface.

How to Clean the Camera Body—Either a lens or a body cap should be on the camera at all times. Use your *body* brush to clean loose dirt off the body and out of crevices. Work around all controls to remove dirt.

Then, open the back of the camera and use the same brush to clean out any dust or film particles. You can also use a puff of air. Be very careful not to direct a stream of air against the shutter curtain and not to touch it.

Using a small piece of lens-cleaning tissue dampened with lens-cleaning fluid, clean the pressure plate on the inside of the back cover and any other metal surfaces than need cleaning.

If you see dark specks in the view-

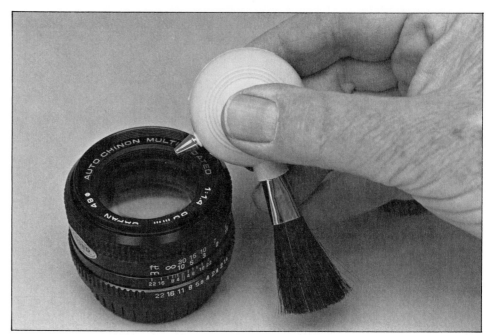

To clean the glass surface of a lens, begin by blowing off dust particles. You can use a blower brush or "canned air."

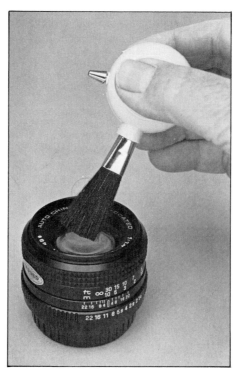

If dust particles remain on the lens, *lift* them off gently, using a lens brush with soft bristles. Don't scrub dust into the lens surface.

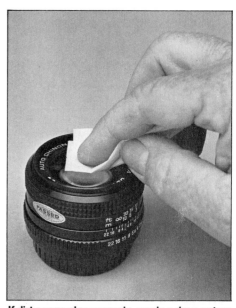

If dirt or smudges remain, apply a drop or two of lens-cleaning fluid to a piece of lens-cleaning tissue. Start at the center of the lens and clean the surface gently, using spiral motion to the outside.

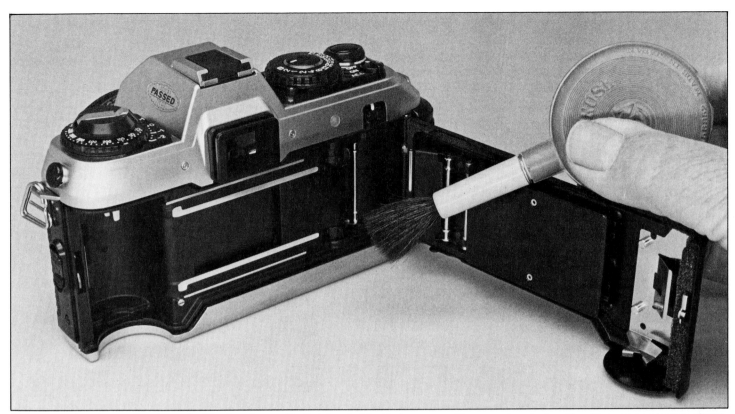

The camera interior can be cleaned with a brush specifically intended for that purpose. The same brush should not be used on lens surfaces.

finder, they may be on the mirror. If so, it's probably better to leave them there. The most you can do is attempt to dislodge them with a puff of air. However, that may blow them into the interior of the camera, where they may cause other problems.

The mirror is front-surfaced and easily damaged. Don't touch it with anything. If it must be cleaned, have it done by a camera-repair shop.

How to Clean the Viewfinder Eyepiece—The eyepiece lens gets dirtier and greasier than the camera lens and needs cleaning more often. Blow out the dust first, then use a slightly dampened cotton swab to lift off any remaining dirt or smears.

TROUBLESHOOTING

Through use, even the best camera may develop problems. Many are not serious and are easily corrected.

Film Advance—Normally, when the film stops advancing, you have reached the end of the roll. You may have loaded a cartridge with only 20 exposures but thought you had loading 36 exposures. Or, you may have advanced the film farther than necessary when loading.

Never use force to advance the film—or on any other camera control. If the film stops advancing before you think it should, rewind into the cartridge and remove the cartridge. Then operate the camera without film and look for the problem. If everything seems OK, try another roll of film.

Battery—If the battery fails, the exposure display in the viewfinder will be inoperative. Most modern cameras depend on battery power to operate the shutter. If so, the shutter won't operate. The mirror may lock in the up position, which makes the viewfinder dark.

Some cameras have a way to check the batteries. If there is any doubt, try new batteries.

Stoppages—When using your camera, be aware of how the controls feel when you operate them. If there is any binding or unusual friction, something is wrong. Get it fixed by an expert before further damage occurs.

How to Test Exposure Accuracy—If you consistently get bad exposures with one lens but not others, the trouble is probably the aperture mechanism of the lens that gives bad exposures.

If you get bad exposure on a few frames in a roll, it's probably your shooting technique. If an entire roll, shot with different lenses, has bad exposure, maybe you shot it at the wrong film-speed setting or with the exposure-compensation control not set at zero. It's unlikely, but possible, that the roll was processed incorrectly at the lab.

If you get consistently bad exposures on more than one roll, it may be the camera. Exposure errors due to the camera metering system will usually occur at all shutter speeds and apertures. One check is to compare the meter readings by your camera to those of another camera that is making good exposures. They should agree within about a half step. Test at different scene brightnesses and different film-speed settings.

To test with film, use color slide film. Find a brick wall or other uniform, textured surface. Put the camera on a tripod and focus carefully on the wall. Make a series of "good" exposures, starting at the largest aperture and going down to the smallest. If your camera has one or more automatic modes, make some shots on manual and some on auto. Make notes of the mode and exposure-control settings for each frame.

Send the film out for processing. It will be easier to check results if you enclose a note asking that the slides not be mounted. You'll get back a continuous roll of film. Hold the film strip up to a suitable light source and examine each frame.

All frames should have reasonable exposures of the scene. All exposures should look the same. If some are lighter or darker, look for a pattern or some clue as to what may be wrong.

How to Test Focus—If you are consistently getting images with bad focus, the problem may be with your vision and not the camera. If your vision is fuzzy, it's difficult to tell good focus from bad.

Put the camera on a tripod and point it at a flat, textured surface such as a brick wall. Use the largest aperture, so depth of field will be minimal. Ask another person with good vision, to focus the camera. Then, you do it. If you have to refocus, one of you did it wrong. If necessary, repeat the test with another person.

To test with film, shoot at four or more different distances from the wall. Focus and shoot carefully at each distance. Make notes.

Check the returned film with a magnifying glass. Every frame should be in good focus. If some or all or not, it's either your eyesight or the camera. Have one or both checked. A simple dioptric correction lens over the eyepiece may solve the problem.

CAMERA REPAIR

Camera manufacturers usually have one more service centers that they operate themselves. In addition, they authorize independent repair shops to work on their equipment. Those repair shops receive technical data, training, consultation and parts from the manufacturer. They can usually make repairs under the manufacturer's warranty, if your equipment is covered.

Not all repair shops are authorized to repair all equipment. If a shop is not authorized to work on your camera brand, it is not a reflection on their abilities as service people. It just means that they don't have direct factory support for that brand.

It is always best to use a repair service that is authorized to service your specific equipment.

When you purchase photographic equipment, save receipts that show price and date of purchase. Save the warranty cards, and register your equipment with the manufacturer if there is a return-card packaged with the equipment. If you take your equipment in for repair, take along your receipts and warranty cards to indicate whether the equipment is still under warranty. If you mail or ship equipment to a repair facility, include *copies* of your receipts, not the originals.

If you take reasonable care of your camera equipment, it should give you years of trouble-free service. This doesn't mean you should always have foremost in your mind the preservation of your equipment. Your first concern should be good photography. However, give your equipment all the care and thought you can muster. This photo of snow geese at sunrise was taken in New Mexico. Photo by C. Allan Morgan.

INDEX